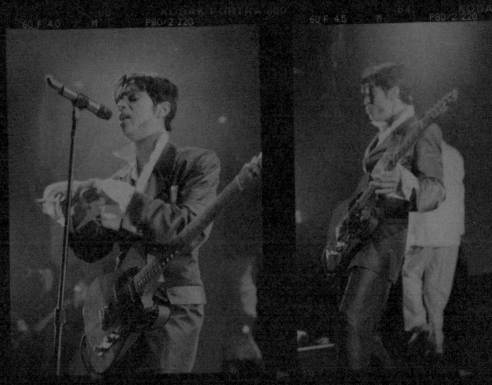

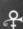

PRINCE

A PRIVATE VIEW

AFSHIN SHAHIDI

PRINCE

A PRIVATE VIEW

ST. MARTIN'S PRESS ⚬ NEW YORK

www.stmartins.com

Designed by Jonathan Bennett

The Library of Congress Cataloging-in-Publication Data is available upon request.

ISBN 978-1-250-13443-1 (hardcover)
ISBN 978-1-125-13444-8 (ebook)

Our books may be purchased in bulk for promotional, educational, or business use.
Please contact your local bookseller or the Macmillan Corporate and Premium Sales
Department at 1-800-221-7945, extension 5442, or by
email at MacmillanSpecialMarkets@macmillan.com.

First Edition: October 2017

10 9 8 7 6 5 4 3 2 1

THIS BOOK IS DEDICATED TO MY WIFE, KERI, AND OUR
CHILDREN, YARA, SAYEED, AND EHSAN. YOUR UNWAVERING
SUPPORT AND ENTHUSIASM FOR ALL MY CRAZY IDEAS
REALLY MADE ME BELIEVE I COULD MAKE THIS BOOK!

THE BREEZE AT DAWN HAS SECRETS TO TELL YOU.

DON'T GO BACK TO SLEEP!

—RUMI

FOREWORD
by
BEYONCÉ KNOWLES-CARTER

Prince...
To describe Prince as an icon is completely expected, for it would be accurate. Truth be told, the word "icon" only scratches the surface of what Prince was and what he remains to me.

Prince was an innovator, a disruptor, an independent thinker, a revolutionary, a businessman, a masterful musician, a multi-instrumentalist, a singer, a songwriter, and my mentor.

He dared to fight for what was rightfully his: his freedom, wrapped up in words and music he created.

When he wrote "slave" on his face in 1993, eleven years before we would perform together, I became curious about the world behind the stage, the business of show. That single statement taught me a valuable lesson about ownership, entrepreneurship, and independence.

"People think I'm a crazy fool for writing 'slave' on my face," he said in 1996, two years before the debut release of Destiny's Child. "But if I can't do what I want to do, what am I?"

I was a huge Prince fan and admirer of his sense of style on and off stage long before the fall of 2003, right after my twenty-second birthday, when we said yes to performing together at the 46th Grammy Awards in 2004.

We set our rehearsals together for one week before the show. Toward the end of January, I traveled to Los Angeles to settle in to a soundstage to prepare for our performance.

When Prince walked into the rehearsals, dressed impeccably from head to toe, he greeted everyone with a shy, almost mischievous smile and a commanding presence.

There were many teachable moments during those rehearsals and Prince proved to be a generous teacher. Most of the earned gems I will keep only in my heart, but I will say that preparing for that performance and taking it to the Grammy stage on February 8, 2004, will continue to be a highlight of my career.

Prince's timing was genius and his sense of humor, spontaneous and unexpected. At the end of the "Purple Rain"/"Let's Go Crazy"/"Crazy in Love" medley, I had no idea he would say what he did. We did talk about making a face but when he blurted out, "Don't hate us 'cause we fab," it took everything I had to keep my composure.

—June 2017

INTRODUCTION

It was 1993 when I first set foot inside Paisley Park. I was young, ambitious, and trying to break into the film business after graduating college and doing a short stint in Seattle shooting pool and taking odd jobs. Back in Minneapolis, where I grew up, I jumped at the opportunity to enter Paisley Park, Prince's white palace, his self-designed sanctuary, his big, billowing musical cloud above the fray.

I will never forget the day I received the page (pre–text messages!) that changed my personal and professional life. I was twenty-three and had recently moved back to Minneapolis, my childhood home, eager to get moving on my post-college life. I was sitting at home when my pager started buzzing. Since I didn't recognize the number, I called it right away hoping it was a work opportunity. The voice on the other lines said, "Hey, we need a loader for a music video, do you know how to load film?" Music video? "Who is it for", I asked. "Can't say. Do you know how to load or not?" I didn't, but a challenge never deterred me plus I had a few days to learn . . . I thought. So I said, "Yeah, I can load film." "Great, we'll need you out here as soon as you can get here," "Wait, what? Today? Where?" I panicked and thought I should cover my inexperience by telling her I was already working that night . . . when she said: "CHANHASSEN."

This was a defining moment for me. The second she said "Chanhassen" I knew who the music video was for. Not many people were doing music videos in Minnesota at the time and definitely not in Chanhassen. I didn't know how to load film, but what I did know was that I had to go. I knew that this opportunity was once in a lifetime. So I let her know I would be there as soon as possible.

When I arrived I found myself in the middle of a flurry of activity as the crew was getting ready for that night's shoot. I gathered myself, took a deep breath, and stepped inside Paisley Park. And at that moment I saw Prince. The man I encountered was painfully shy. Yes, he had sold millions of records, traveled the world, starred in a highly acclaimed feature film, and even won an Academy Award. He was maybe ten years older than me, and had the word "slave" artfully written, in black eyeliner, across his high cheekbones. He looked at me with a smirk and asked, "What's your name?" I couldn't fathom then that this moment would be the beginning of a more than twenty-year professional and personal relationship with a man so unique, so unimaginably creative, and so passionate about the arts that he defied category, and instead created and occupied his own universe.

Ten of my twentysome-odd years within Prince's universe were spent traveling, photographing, shooting, and directing a variety of projects for him. He became my mentor, business partner, travel companion, collaborator, and—most important—my friend. He took it upon himself to encourage me, as he had so many others, to see the world as a place of opportunities, not limitations. He taught by example. I knew I had to grow as a photographer, both technically and artistically—I had no choice. I was following in the footsteps of iconic photographers who had photographed Prince. My subject was, unequivocally, the most talented musician of our time. Our work relationship was casual and flowing, with much of the work organic and unplanned. I would think of an idea and call to describe it to him; many times, he would travel somewhere exotic and ask me to come along, no set plans, just inspiration. My decades of working with Prince were also a time of personal change and growth for myself. I found the love of my life, married, and had three amazing children, all of whom Prince knew well. I lost my biological father, moved to the West Coast, tackled the highs and lows of growing up . . . and through it all, Prince—his friendship and artistry—were right next to me.

Standing in Paisley Park that first time, I watched him perform live, so close to me that I could reach out and touch the stage. I was immediately taken back to the mid-eighties, when I was just an awkward Iranian teen, trying to fit in at my high school in Minneapolis. Minnesota, at the time,

was not the most diverse place. Everyone was nice enough, but I always had the sense that I didn't belong; it was a far cry from my grandfather's fruit orchards in Iran, where I had spent my childhood on horseback. I tried to fit in by listening to classic rock or playing hockey (I couldn't really skate). But the more I tried to disappear, the more I stood out. It was during those awkward adolescent years that I discovered Prince's music. His album, *1999*, had just been released and the title track was on heavy radio rotation. I just assumed he was a local phenomenon since he was a kid from North Minneapolis. I had no idea the world was tuned in, too. That album and his music were such a departure from all that my young ears had heard, that it made me put the classic rock aside and delve deeper into what Prince had to offer. *Controversy* and *Dirty Mind* soon became my soundtracks, and Prince and Michael Jackson became daily discussions with my neighbor and friend Vince, who claimed both as his cousins. One day Vince and I had been kicked off the school bus for some now forgotten reason. Talking about music occupied our time and kept us warm as we walked to school through the snowy Minnesota winter. His music and sexually free lyrics were like nothing I had ever heard, and knowing that enigma of a young man who was the mastermind grew up near my childhood neighborhood gave me hope and more courage to be my authentic self. I stopped trying to conform. I always knew a conventional career path was not for me. Prince and his music gave me that courage.

I had worked my way up from film loader to cinematographer, shooting music videos for Prince, many of which ended up in his legendary vault. Prince recognized my passion and drive and gave me early opportunities to step up and have a more independent and creative role on his projects. Still photography was a passion of mine. My mother was a hobbyist and I grew up with a darkroom in the basement, but I hadn't pursued it professionally. One cold Minnesota evening in 2001 I was at Paisley Park gearing up for a music video shoot. I brought my still camera inside with me so it wouldn't freeze in my car. Prince saw the case and, ever curious, asked what was in it. When I told him it was my still camera he asked, "You're a photographer, too?" As I mumbled my way through a "Yes, kind of, I'm trying," he walked away.

The next day, his producer called me and said that Prince would like to see my photo portfolio. As I tried to explain to her, panicked, that I didn't have a photo portfolio, she ended with, "He's expecting you tomorrow." I stayed up that entire night, printing photos of my wife Keri (at the time a commercial actress and model) and the few other photos I deemed worthy enough to show Prince. Completely stressing out with each photo I printed, I looked at them through the lens Prince saw art, and at that moment I was sure that my images were not up to par to show him.

By midday the next day I was exhausted, but with portfolio in hand and false courage, I headed to Paisley Park to meet with Prince. He said hi and reached for the portfolio. He thumbed through it quickly, made a few faces, handed it back, and walked away. As I headed out, his producer stopped me and said, "Prince would like to know if you can come photograph his band." WHAT? Not at all what I had expected after his quick thumb-through of my portfolio, and being totally honest, it wasn't what I wanted to hear. I knew that the true pressure would be creating an image Prince would approve of. Before I could say no, I heard myself saying "Yes, of course." She said, "Great, come up with some ideas." Come up with some ideas?

Two days later, my wife and I headed to Paisley with a car full of rented equipment and lights to photograph the band. Prince would pop in every now and then to comment, but he let me do my thing. Two days after that, we made selects and headed back to Paisley. At this point, Prince had already flown out two photographers, one from New York and the other from L.A., to photograph him. He showed me a couple of those images as I got out my presentation. To say I was nervous is an understatement; he had just shown me pictures by world-renowned photographers and here I was about to show Prince some snaps from my rented camera. He smiled, pointed, and even chuckled a few times as he looked at the contact sheets. He told me "Good job," and left. It had gone as well as I could have hoped for, and I was glad it was over. As I headed out, his producer stopped me again and said, "Prince would like to know if you can come back and photograph him." "But I thought he already did that with the L.A. and New York photographers," I said, trying to wiggle out of it. "He did, but he wants you to take his picture," she told me. It ended with the same "Come up with some ideas." At that moment, I decided that I had to start avoiding this producer.

Again, we returned to Paisley with even more rented gear, and a handful of ideas and prayers to complete my first official shoot with Prince. He was everything a photographer hopes to have in a subject. Prince was fun, full of energy, and in his element. He put me at ease as he looked at the Polaroid test shots my wife was holding and then he showed them off to his band, who had also gathered to be photographed with him. I think for almost a year he thought my wife was just my assistant, not realizing we were married. It was an amazing day and an extremely creative shoot. I went back the next day with the film and contact sheets. I was proud of this work and Prince liked it, too. His producer later told me that Prince said he liked the way I photographed people of color and that I didn't stare at him (he must have forgotten the day we met). As we looked over the images and made selects, Prince asked me something that changed my life. "Can you come on the road with us?" How could I say no?

. . . But back to that first day at Paisley Park, standing a few feet away from Prince as he effortlessly delivered a breathtaking guitar solo for the music video I'd been hired to work on. He saw me, a twentysomething-year-old kid who looked different from the rest of the crew—a little lost and in awe at the same time—who couldn't stop staring even though he'd been told at least fifteen times not to stare or make eye contact with Prince. A kid who was nervous because he bent the truth to be there, who still looked and felt like he didn't belong. Maybe he recognized something familiar in me that made him put down his guitar and walk up to me, out of all the people there, and ask me my name. I looked around. Could he really be talking to me? He was! He dropped his chin and gave me that Prince look that I came to know so well when he was awaiting a response. After all, I was standing in his house, a new face . . . not that he knew anyone else's name, but he wanted to know mine. I told him—Afshin—not realizing at that moment that I would hear him say my name countless times over the next twentysome years, and that each time, it would lead to a new adventure.

This book is a glimpse at our collaboration during the years I had the privilege of photographing Prince. It spans almost a decade and five continents. As I selected these images, which range from live concert shots, to snaps at his famous parties, to art-directed shoots for magazines or late-night portrait sessions just because, Prince's voice was in my head,

guiding me. Having sat with him for a myriad of hours over the course of ten years, looking at and discussing my work, I know he would be proud of the pictures I have chosen and I hope that I am passing on the gift Prince gave to me: the ability to witness through pictures, his greatness, his creativity, his passion, and his vision. Each image has brought back vivid memories and emotions for me. These photos of Prince are also a time line of my youth and a reminder of adventures I thought and hoped would never end. This book is my small attempt to honor the memory of a man who gave his heart and soul to so many people around the world and changed the course of countless people, communities, and musicians through his music and philanthropy.

Prince changed how I interact with the world. He gifted my family with the knowledge that his support was never waning. He surrounded me with equally passionate artists, many of whom I am still friends with. His absence is overwhelming. His death, still a bad dream. I hope this book will make you smile, that it will inspire you to continue sharing his spirit and his music with others and feel comforted in knowing that Prince's energy lives in our creative souls. I was forty-six when I stepped out of Paisley Park with my camera for the very last time. ∎

I reluctantly wake up in a Dallas hotel room to the jarring symphony of the alarm clock—the wake-up call I've asked for from the front desk—and my phone's alarm all going off at the same time. I worked late the previous evening and I have a flight to catch that I am determined not to miss! I'm out in front of the hotel a few minutes after four. The car service pulls up a little bit late, but I've planned some cushion. The driver insists on talking, but I just want to get to the airport. I board the flight to Minneapolis, my emotions teetering on edge. It's been over a year, maybe two, since I've been in that city, and I'm returning now for a memorial for a friend. I've lost family members to old age and disease, which hasn't been easy, but this is the first friend who has passed away, and it's hit hard. I try to gather myself as I find my seat, afraid that my face is betraying me. It's been almost four months since Prince left us, and I've been looking everywhere for closure and have not found it. I'm hoping this small memorial service, put together by Prince's family at Paisley Park, will help. I sit in my seat and close my eyes, trying to sleep and not think about the reason for my flight. I go in and out the same day, heading back to my family in Los Angeles after the memorial. My friends and family in Minnesota don't know I'm coming. I'm anxious about walking into Paisley Park: I've never been there before when Prince didn't come strutting around the corner. As much as I try to clear my mind, the memories come flooding back, one leading to another. It is bittersweet nostalgia; for me it is a suffocating feeling, thinking about a beautiful past that is now out of reach, days that seemed to go by effortlessly and now are only a whisper. I close my eyes as we take off and I give in to these memories, floating along with them wherever they may take me, as the plane breaks through the clouds on our way to Minneapolis.

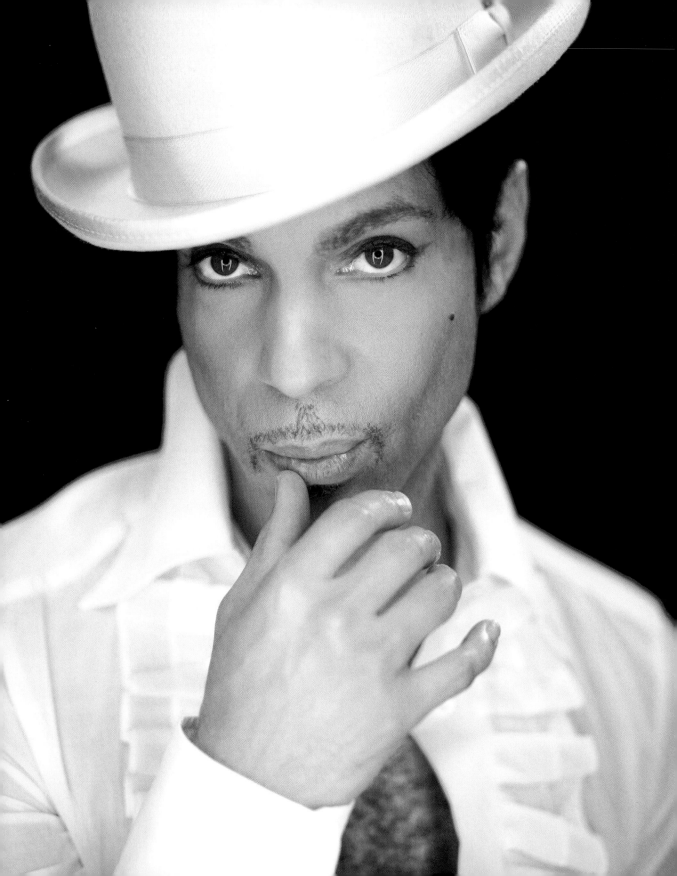

PRINCE

A PRIVATE VIEW

When I went to photograph Prince for the first time, they took me to meet him in Studio A. I was escorted in, he looked up, smiled, and thanked me for coming. He was sitting at the board mixing a song. I hadn't heard it before or since but it was slow with really sad lyrics. He said he wanted one of the shots to convey the emotions of the song and asked me what I thought. I told him I thought the song was about longing and despair. One of the ideas I had was him waiting for a call that never comes. When we started shooting it felt so real, and I felt so bad that he never got that call.

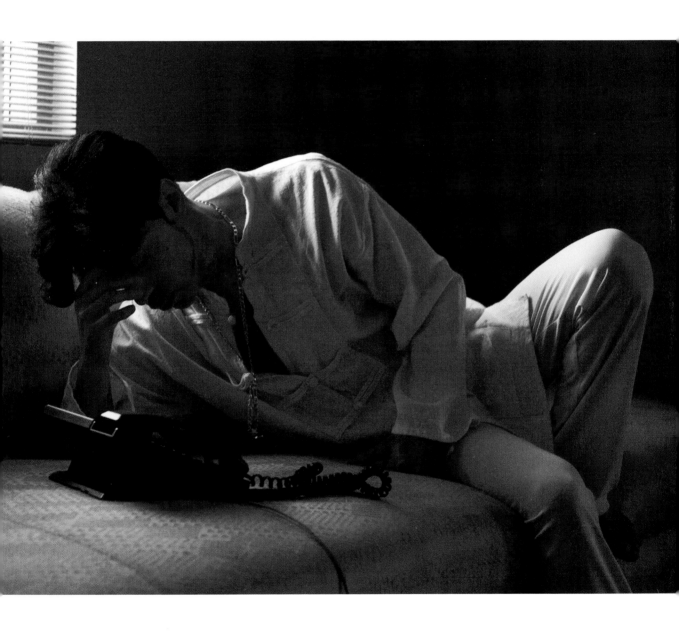

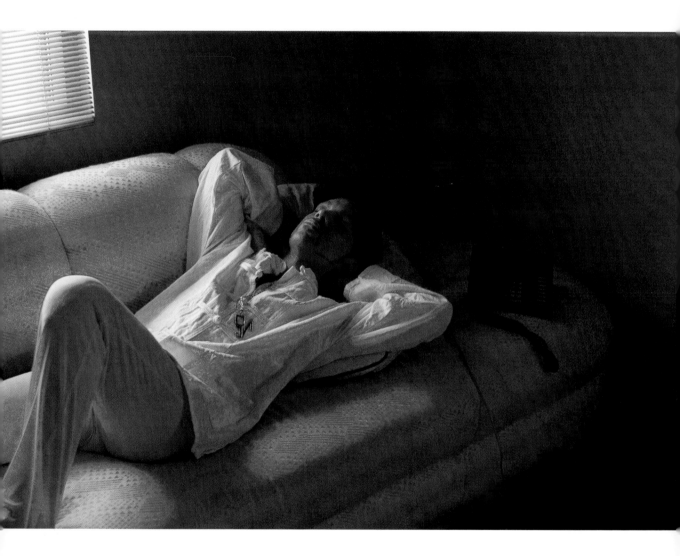

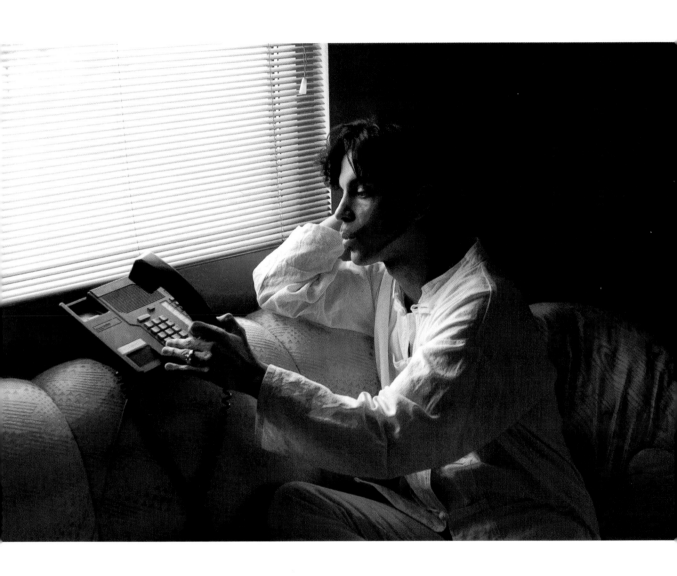

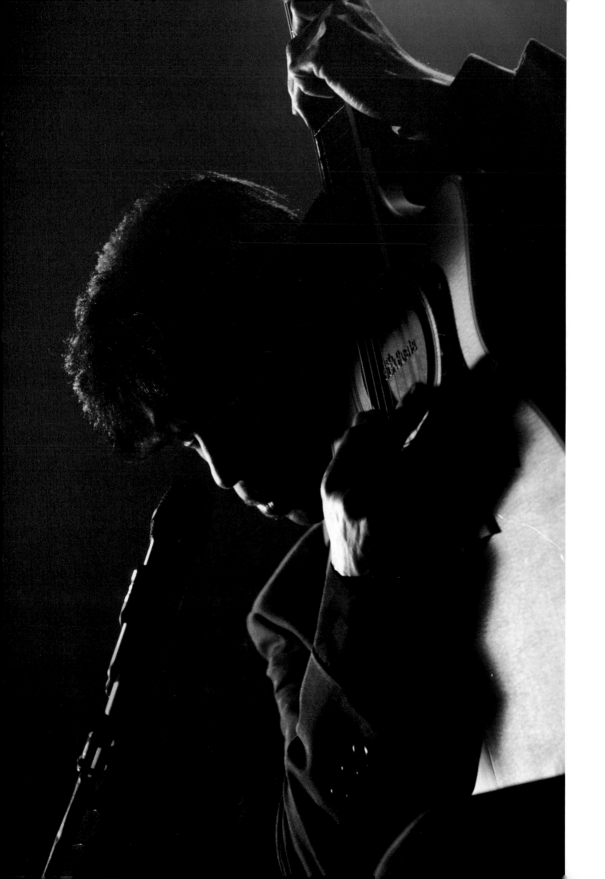

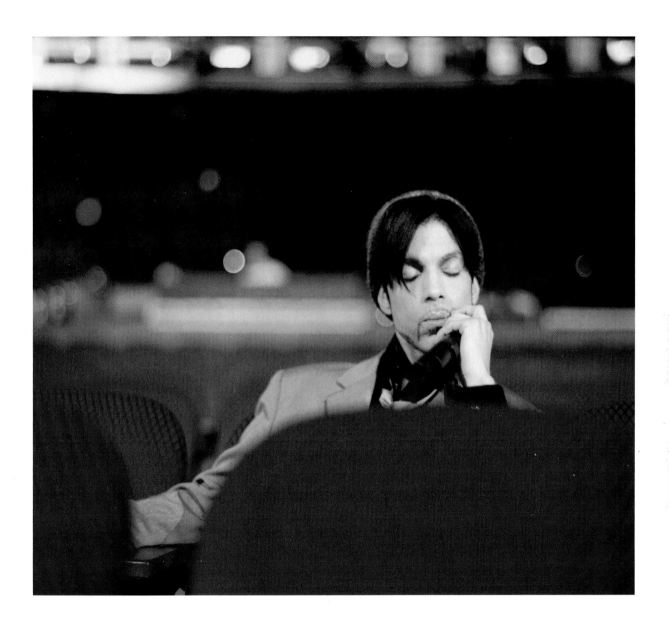

These were some of my favorite moments to shoot. If the sound was good, Prince was relaxed and in a great mood. Here he is relaxing after sound check at the Kodak Theatre in Hollywood, during the One Nite Alone tour.

This man could
wear a hat
almost as well as
he played guitar.

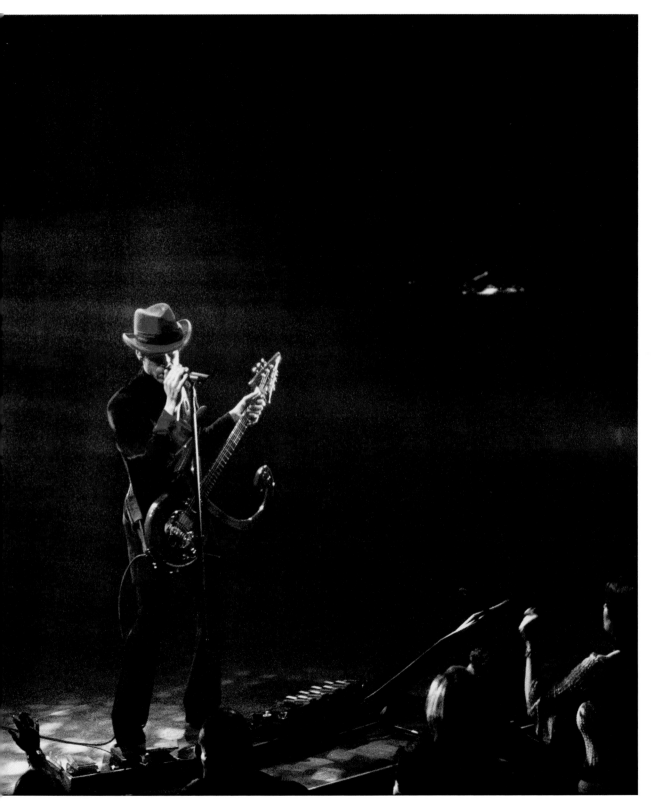

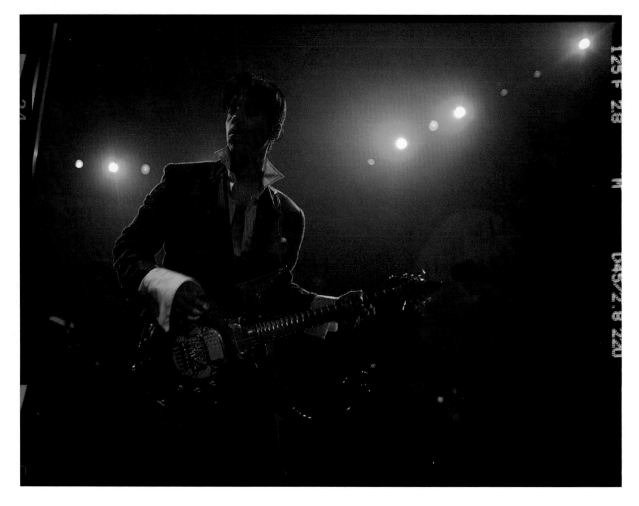

When Prince asked me to go on tour with him, I thought about
what I could do to stand apart from the other photographers that
he'd worked with before. I foolishly chose to shoot the shows with
the larger Medium format film instead of 35mm film. Seemed like a
good idea at the time, but the technical realities of the films available
and the capabilities of the cameras made shooting Medium format
during a fast-moving, low-light, live performance a nightmare. I did,
however, get some gems—at times.

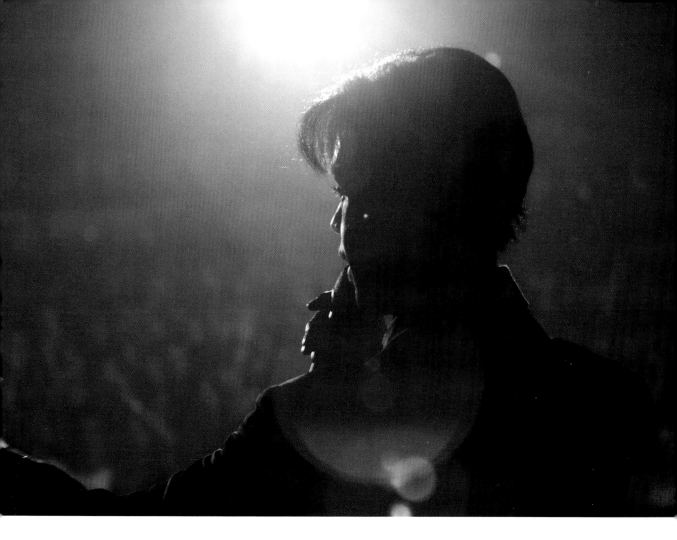

I had only photographed Prince playing live a handful of times up to this
point. I was cautious about bringing attention to myself or distracting him
while he was on stage performing, but I felt like I needed to find better
angles. I hesitantly went onto the stage and started shooting from behind
him looking out toward the audience. I slowly moved up closer and closer
until I was standing right behind him while he sang. When he saw this
picture he said he'd never known I was there and joked that next time I got
that close he was going to put a guitar in my hands.

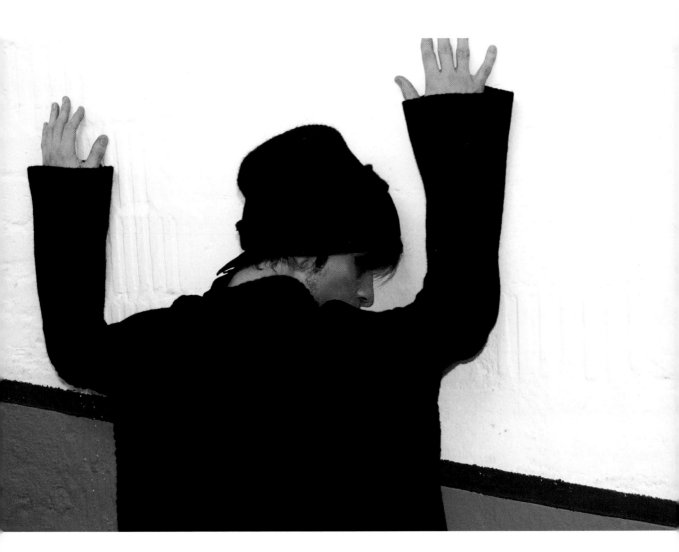

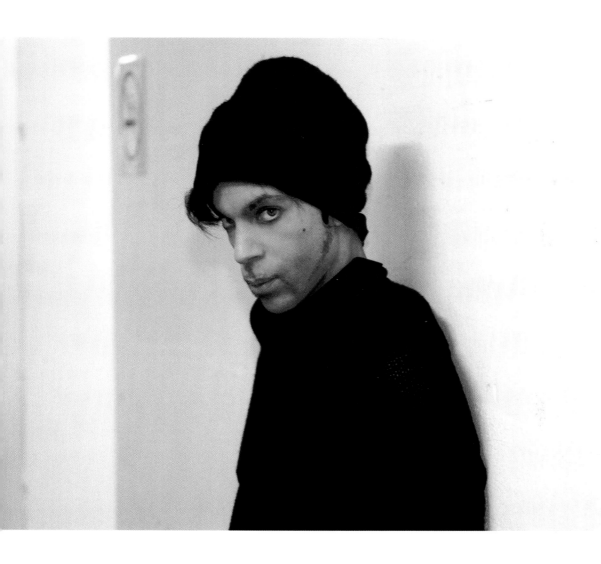

Prince would give me this look at times early on that made me think he
didn't want me photographing him at that moment. But I grew to think
it was his sexy look because as soon as I lowered the camera he would
smile and make a joke.

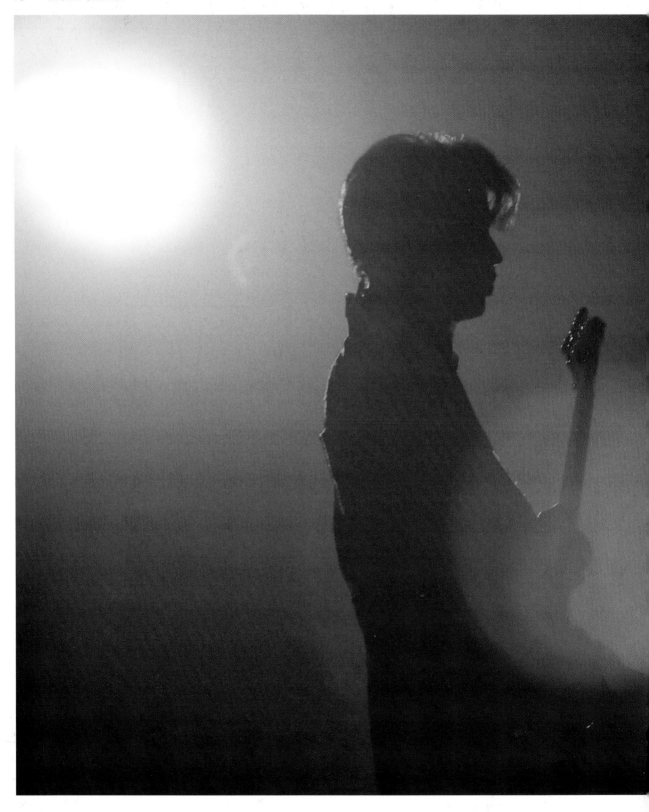

I loved flares and silhouettes. I'm not sure if some of the band members appreciated them because you couldn't see their faces, but Prince always dug these images—as long as I had a few that showed *his* face.

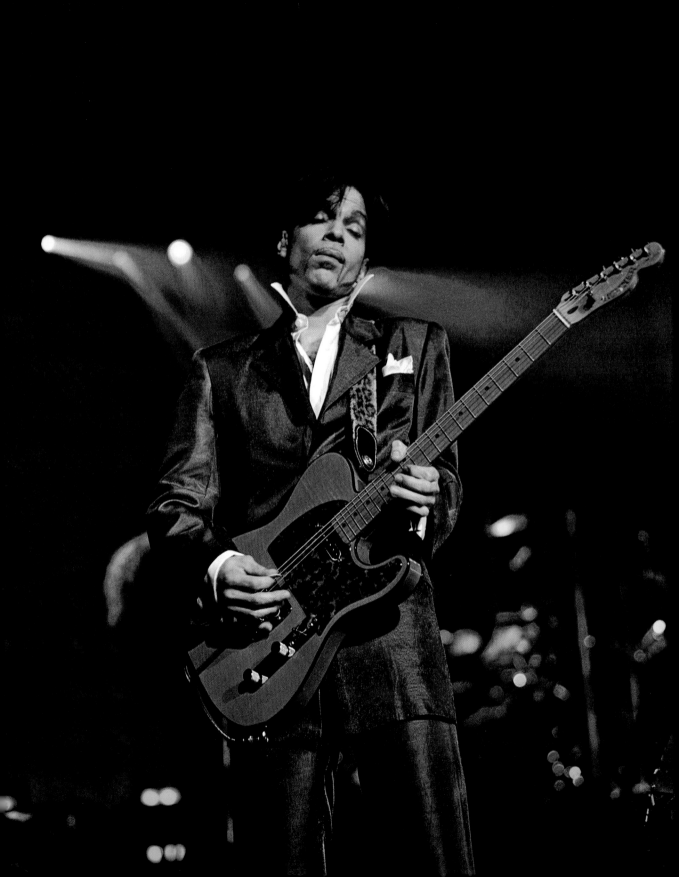

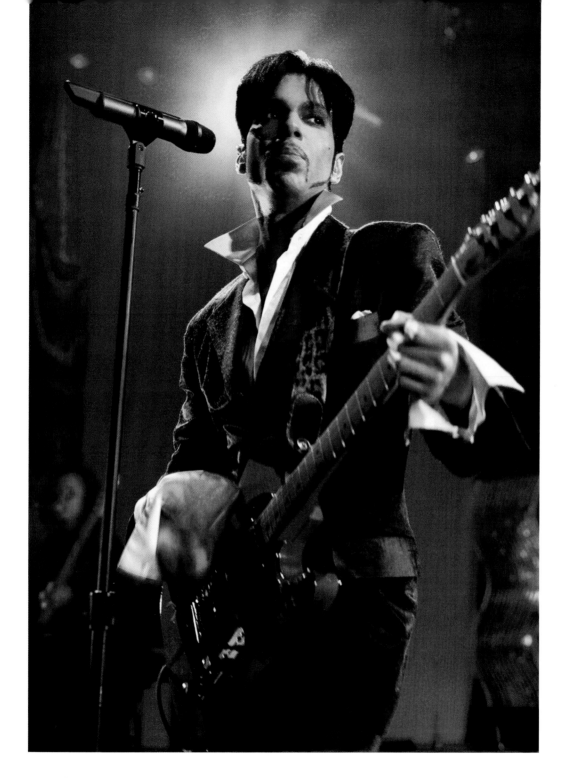

One of the first pictures (above) I had taken that Prince turned into a poster.
I was walking the perimeter of an arena in Europe when I came across the
merchandizing booth and saw this as a poster for the first time.

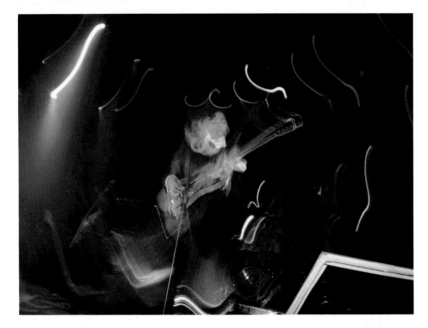

Having come from a cinematography background I had a hard time coming to terms with single still images. In certain instances. I know and have seen the power of a single still image but I always felt like there was something missing when I photographed Prince playing live. The still image didn't convey the energy of the moment and didn't allow the viewer to feel the full impact and electricity of Prince's persona and performance. So I started messing with longer exposures, dragging shutters, multiple flash bursts, and remote camera placements. I would occasionally sprinkle a few of these images in with the ones I selected to show Prince. At first he would skip over them, thinking they were a mistake, but I kept including them until he finally asked me why I had so many messed-up shots. I explained my idea behind them; he looked amused but didn't seem to buy it. I kept on shooting those images but left them out of the selects that I showed Prince. After two different reviews of images where I didn't include anything that wasn't perfectly sharp and in focus, Prince asked me where the cool artsy shots went. I told him I didn't think he liked them. He gave me that Prince smirk and said "We can all learn things at times. I learned to see the beauty in those pictures after you described the reason and technique behind them." I must have been glowing. I asked "You learned something from me?" Prince smiled and sweetly said "Don't let it go to your head."

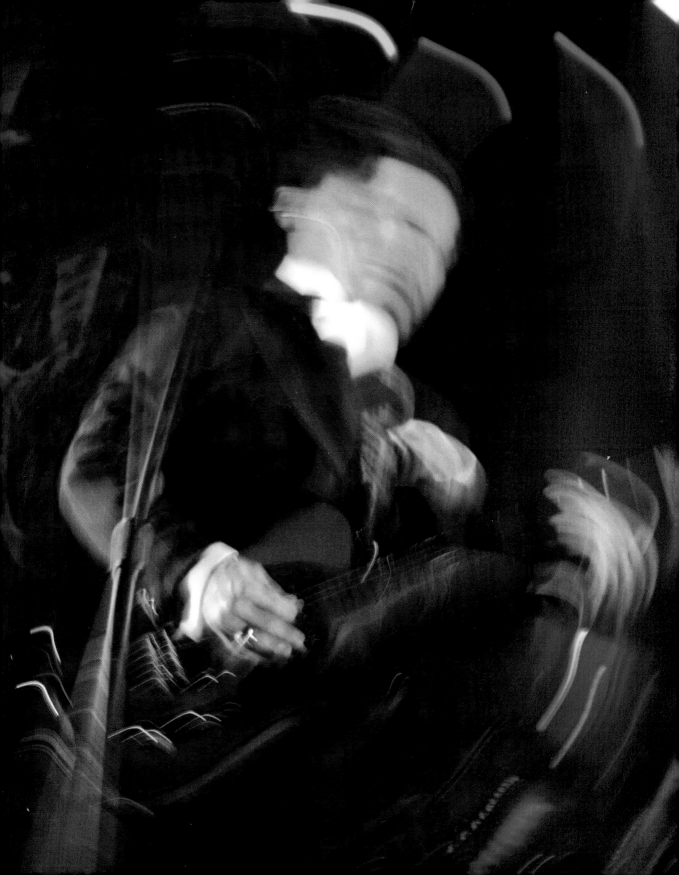

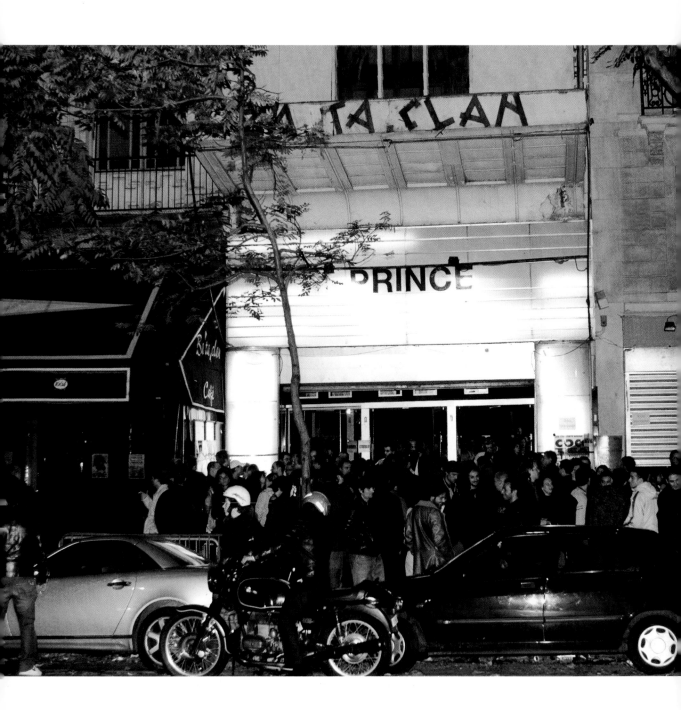

This was probably taken at 2 or 3 in the morning in Paris after
Prince had played a concert at the Zenith and was going to play an
aftershow here. I love the simplicity of the Marquee. All it had to
say was PRINCE for half the city to show up.

I had rejoined Prince and the band a few nights earlier in Oberhausen, Germany, as they were nearing the end of the European leg of the One Nite Alone tour. After the London shows I had to go back to the States because I had booked a couple of commercial jobs previously and I wasn't ready yet to burn any bridges.(I did so later.)

As we pulled into Zurich around 5:30 a.m. the city was just waking up. (We had left Paris late in the afternoon the day before and driven through the Alps that night.) It was still dark and there was a bone-chilling wind that hit me like a shovel to the face as I got off the tour bus and headed to check into our hotel across the street from the Limmat River, which splits Zurich in two.

I hadn't gotten used to sleeping in the small bunks on the tour bus and since I was the new guy riding in the band bus, I had to take the topmost bunk. Besides feeling like I was lying in a coffin, being at the top of the bus was like being in a cradle with an overzealous aunt who rocked you a little too far. We had made the most of Paris and I hadn't slept at all the two days we were there; I actually almost missed the bus as I sat in a restaurant across the street from the hotel eating mussels. I threw some money down on the table as I ran out of the restaurant, and chased after the bus. It finally stopped a half a block later and let me on.

When we arrived in Zurich, the band was sleepy. The schedule that was later slipped under my door informed me I had less

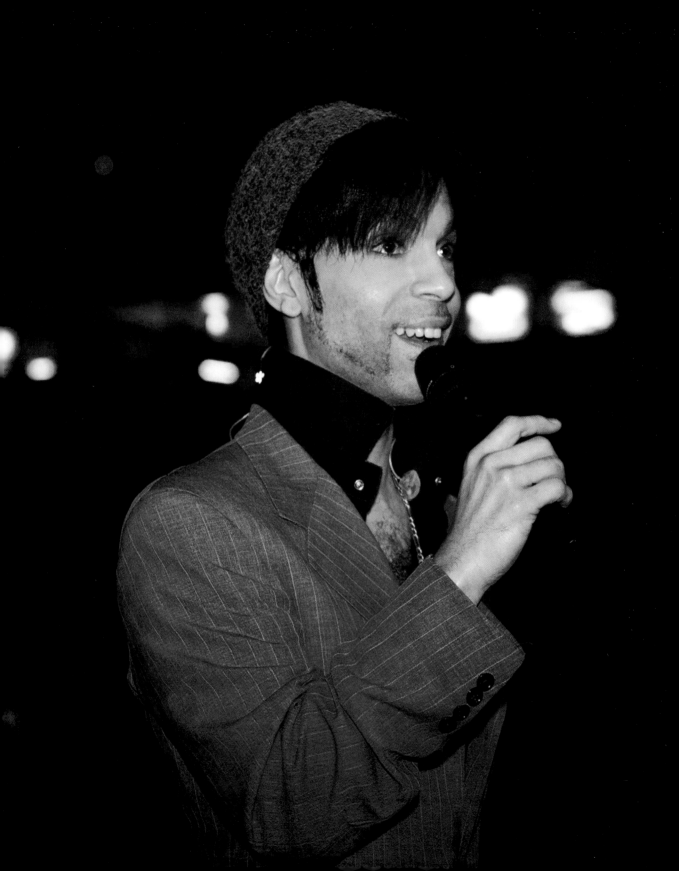

than five minutes to be back on the bus to head to the venue. I was slowly discovering that Prince's camp moved with military precision and I had better figure it out quickly if I didn't want to be left behind. I ransacked my suitcase to find something appropriate to wear and once again found myself running to make it to the bus.

The sound check was smooth and Prince was in a great mood. I think he had slept in Paris the night before instead of traveling by bus, and had just flown in and come straight to the sound check. His music club fans were already outside waiting when we got to the venue and after Prince made sure the sound was on point, they let them in. Everyone rushed in in an orderly fashion to get to the front. Everything went smoothly from there. The show was another phenomenal foray into Prince's jazzier side, with a few hits sprinkled in, and even the even-keeled Swiss fans couldn't help but get up and shake something. I think Prince sensed his band's fatigue from the past few nights so he didn't plan an aftershow. We just went next door to a small club that seemed to be attached to the theatre where Prince had just performed, and besides making an appearance for the enthusiastic fans that had come over, the band and Prince just chilled in the balcony area and talked about the last few days. I put down my cameras and joined in, having a few drinks myself as the work had ended and it was relaxation time. After maybe an hour, Prince got up and left. A few moments later his bodyguard came back into the club, came up to me, and said Prince wanted to know if I wanted to come back to the hotel. I'd only been on the road with Prince a handful of days, we hadn't really bonded or talked much yet besides work-related things, so this felt like a big deal. I knew the band had been hanging with him after the aftershows and I only imagined what went down at the after, after party, but I certainly had never been invited before. His bodyguard Trevor said that the car was going to drop them off at the hotel and would come back to the club and get me in twenty minutes.

I had another drink and pondered what might be happening in a rock star's hotel room in Switzerland at two in the morning. I wondered if the groupie clichés were true, if sex, drugs, and rock 'n' roll still lived on. But whatever was going to go down, I had my cameras to capture it. Precisely twenty minutes later the driver found me in the club and we headed to Prince's hotel. I was held up at the front desk as they called up to make sure I

was invited. I saw two couples get off the elevator; they had been drinking and were falling over each other. They must have just left his room. With anticipation I knocked on the double doors of his suite, cameras in hand. I heard music coming from inside. A minute later Trevor opened the door and led me in. The front rooms were empty but I was sure everyone was in the back part of the expansive suite. I realized the music was Miles' *Kind of Blue*, which is a great album but seemed like an odd choice for a party. I went ahead of Trevor to get to the back room and he said Prince was this way. He took me to the living room and asked me to wait there, Prince was finishing a phone call and would be in shortly.

I took a seat in a large armchair in the middle of the room and looked around trying to figure out where all the people were hiding. Finally Prince came out maybe five minutes later and I realized there was no party and there were no other people there. Prince asked me about my beliefs and we ended up having an in-depth discussion about the nature of good and evil, right and wrong. He told me about Jehovah and the teachings of the Witnesses and I slowly realized he'd invited me to talk about God. I was completely exhausted from the past few days, but this conversation was intriguing and it was flattering to think that Prince cared enough to preach to me, jumping around, very animated, occasionally looking to Trevor for an amen. This went on for about two and a half hours until Prince was obviously tired but very happy. He wished me the best and offered to be there whenever I had any questions. I have my own beliefs but I'm always willing to listen to a different perspective. By the time the driver took me to the hotel, the same bone-chilling wind that hit me twenty-four-hours earlier as we arrived into Zurich hit me in the face again as I got out of his car and rushed to my room. It was 5:45 a.m., I had to be on the bus at 6 a.m. for our trip to Milan. Once again I found myself rushing as I threw everything back into my suitcase. I was tired, but happy. I learned a few important things that morning: drinking on tour is not a good idea, there is not ever enough time for rest on the road, so put that idea aside, and that an invitation to a rock star's hotel room at 2 a.m. could actually save your soul. I lay down in my cocoonlike bunk thinking about the past few days and the past few hours and for the first time ever I felt comfortable enough in there and fell into a deep sleep.

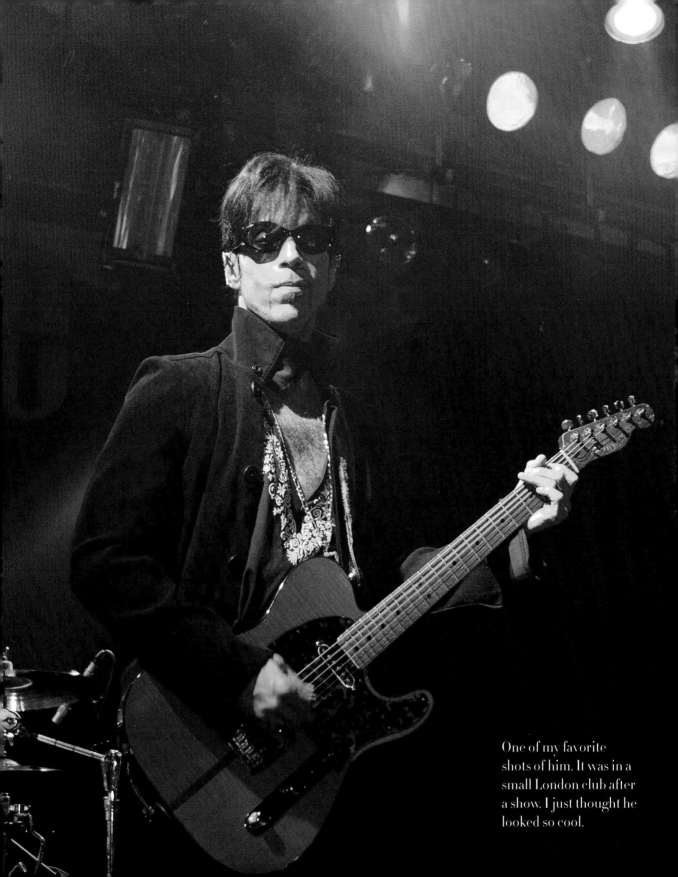

One of my favorite shots of him. It was in a small London club after a show. I just thought he looked so cool.

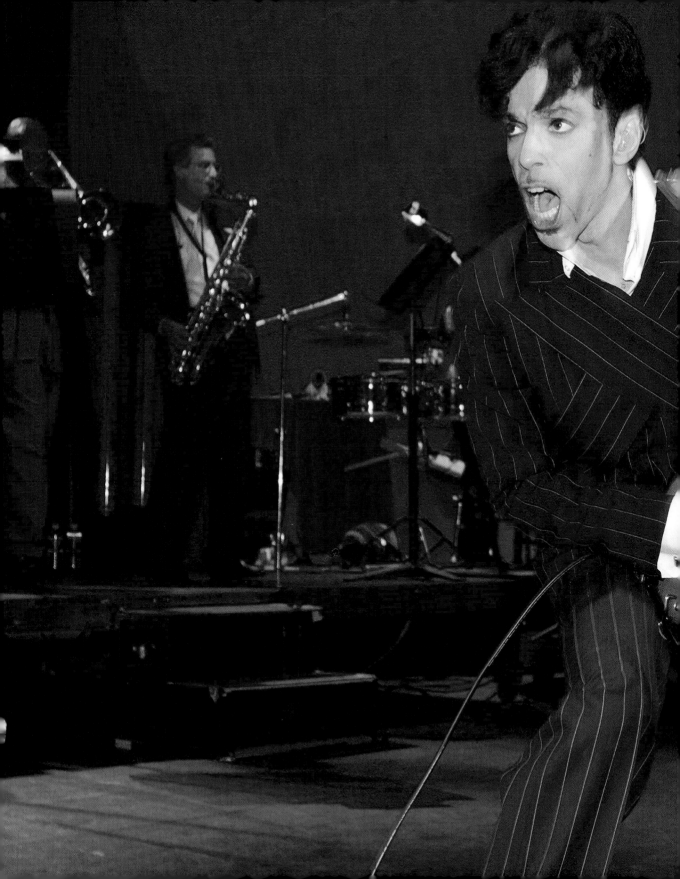

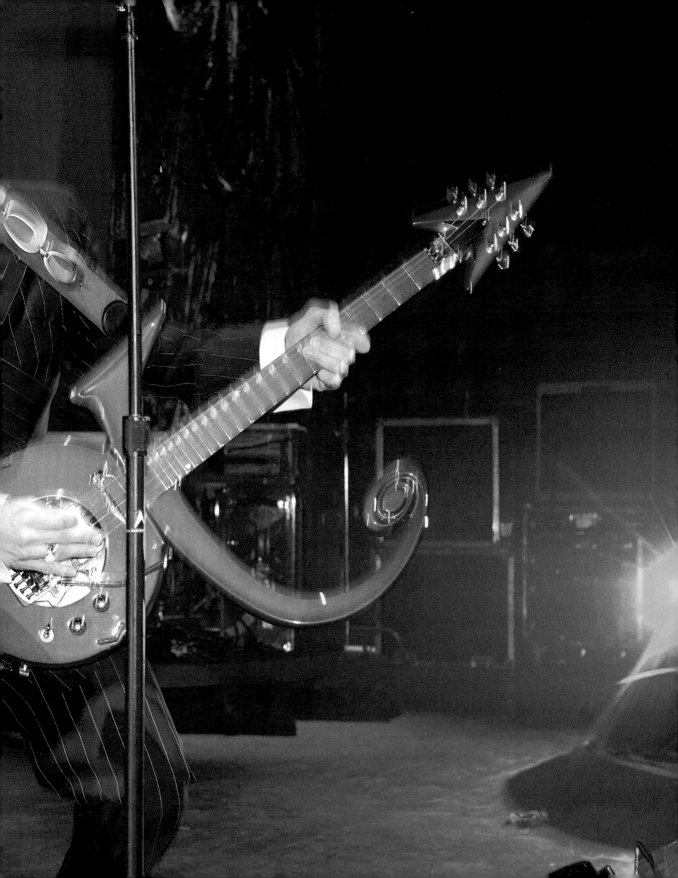

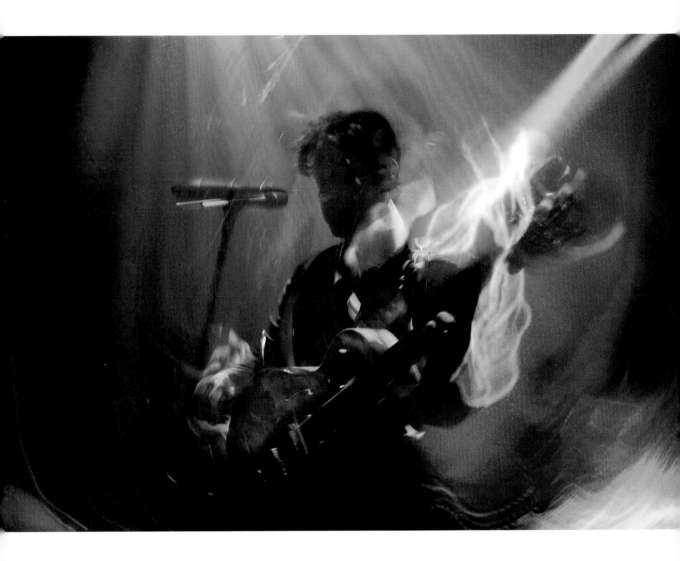

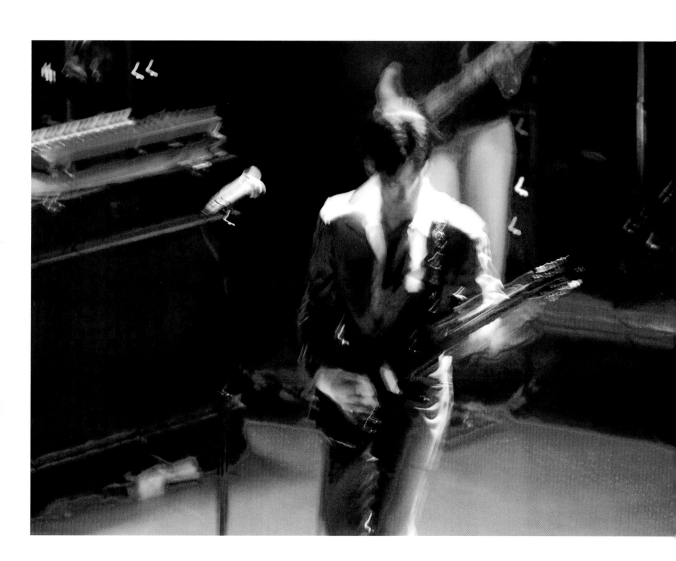

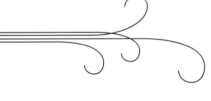

Backstage in Milan. I saw Prince walking down the white curtain hallway and pulled my camera out and got a couple of shots off before he got to the end and rounded the corner. Not sure that I had gotten anything, I asked if he wouldn't mind walking down the hall again. He chuckled and said, "You know I don't do *anything* twice!"

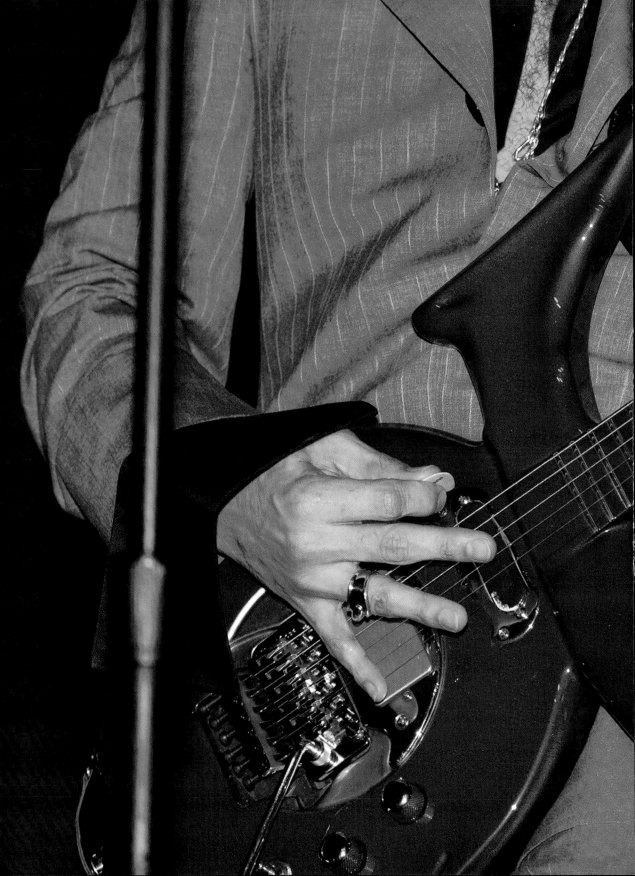

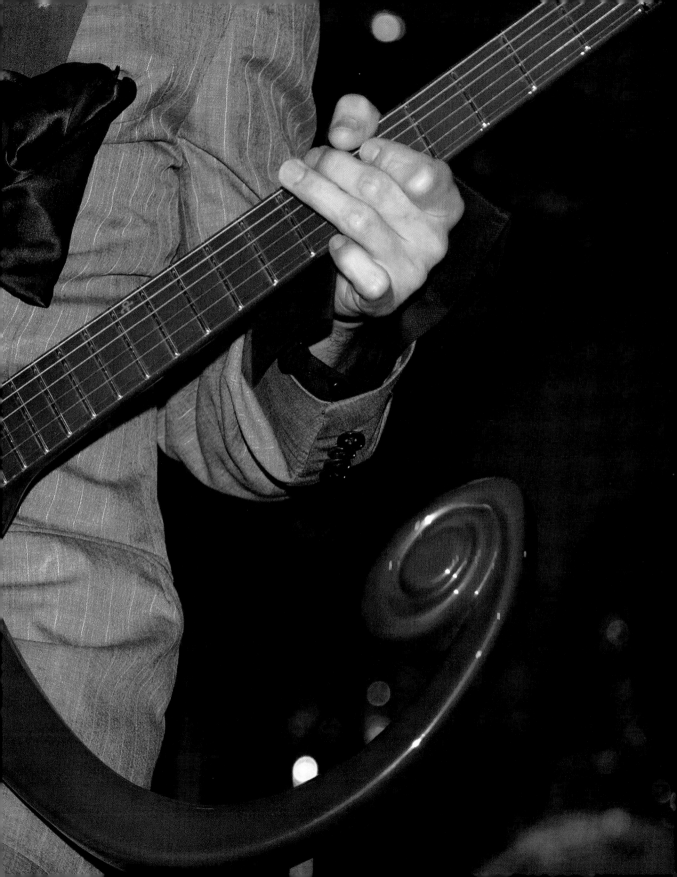

A very rare moment when Prince stops to catch his breath. He was truly a dynamo with more energy than the band and entire crew put together and with the uncanny ability to energize those around him!

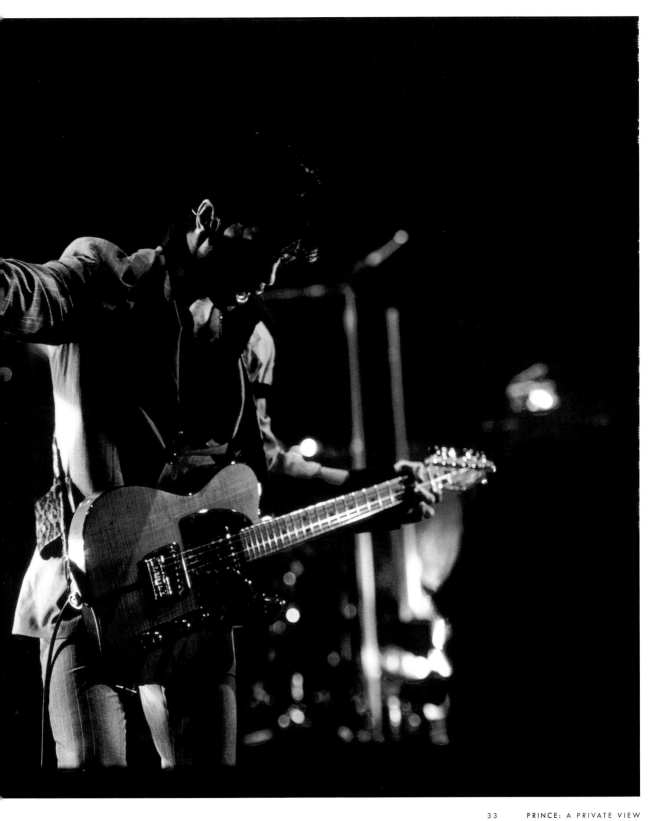

One of my fondest memories of going to Japan with Prince for the first time has nothing to do with music. Prince had just finished playing a show in Sendai and as I was showing him a few of the digital pictures from the show he asked me if I wanted to go to Tokyo. We had a few days off before his show in Sapporo so I agreed. We took the bullet train to Tokyo that night and when we arrived we went straight to the Blue Note to see Chick Corea play. We got to meet Chick after his set, which was incredible for me being the jazz-head I am. When we neared the hotel after leaving the Blue Note, Prince asked me to be up early the next morning and to put on a suit. I told him I would but had no idea what was going to go down. The next morning his bodyguard knocked on my door bright and early and I quickly got ready and headed down to wait for them at the limo. I tried to find out from the limo driver where we were headed, but he didn't seem to know either. Prince came down looking sharp and in a great mood even though we had gotten four hours of sleep tops the night before. I asked where we were headed and he said I'd see soon enough. We arrived at a nondescript building, a few people hovering around outside. We pulled up and walked in without fanfare. Prince and I sat next to each other in maybe the fourteenth or fifteenth row of what turned out to be a Japanese Jehovah's Witness Kingdom Hall. This was the second time after Zurich that religion had come up between us. The surreal quality of being in that place at that time with that person was not lost on me. What was also surprising was that no one acted like there was anything different or special about his being there. I know Prince appreciated being able to worship in peace, and even though I did not understand a word that was said it was one of the most enjoyable early mornings I have ever spent.

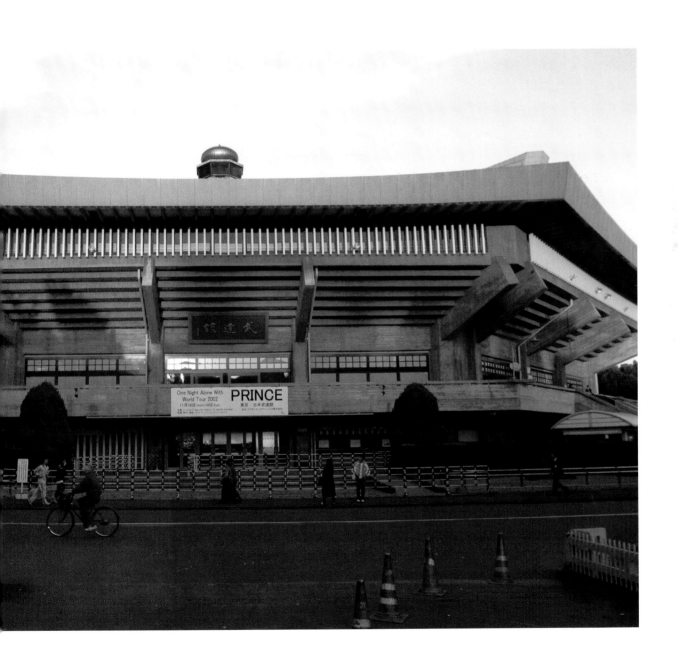

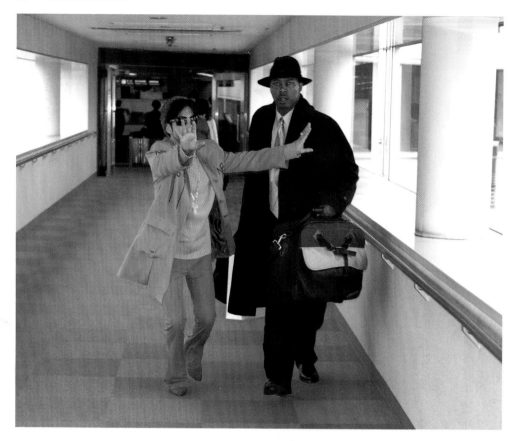

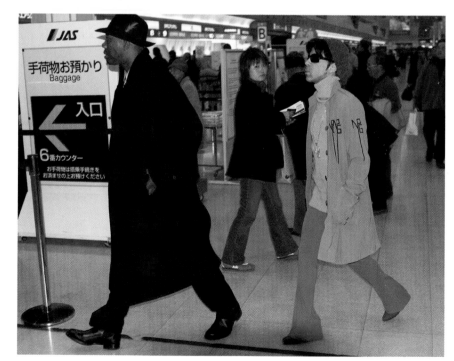

Catching a flight from Tokyo to Sapporo in Japan. It always amused me to see Prince out and about in public, and then the second we were alone, he would show his goofy side.

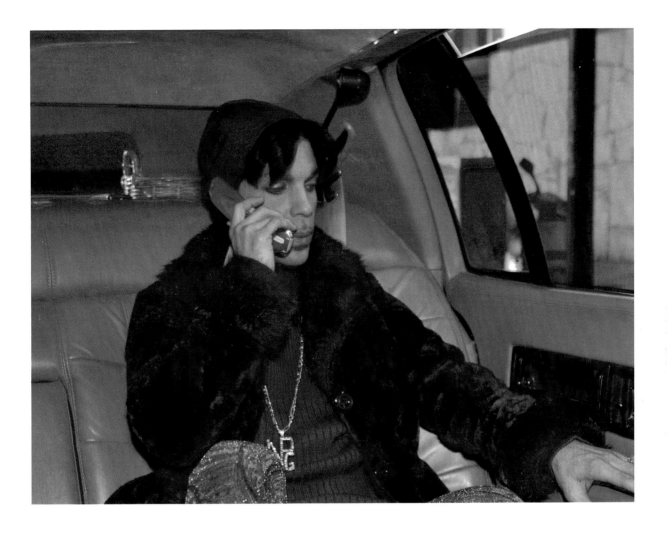

Prince notoriously did not have his own phone: He would always use phones belonging to the people around him. We were in his limo going back to the hotel from sound check in Tokyo. He looked cool sitting there, but it felt weird to photograph him just sitting there so I pulled out my phone and told him the call was for him. As soon as he took it I snapped away. He figured out quickly what I was up to but gave me a couple more seconds to get a few more shots. He said, "Good one, but the next time, the call won't be for you." There was a smile on his face.

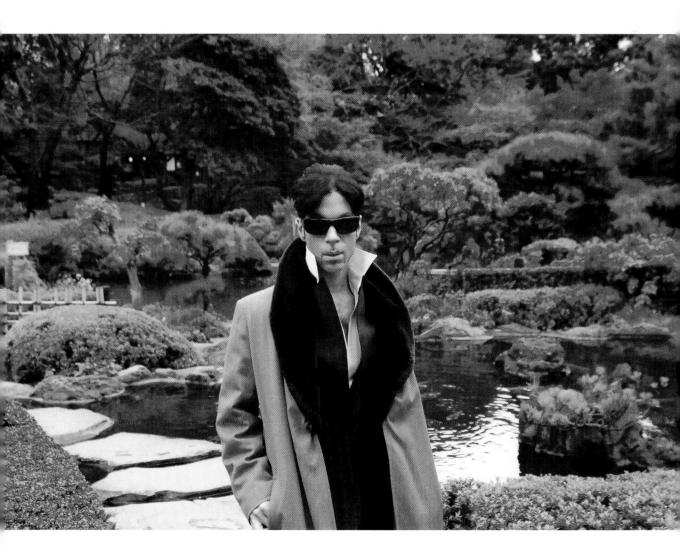

Japanese Garden outside the New Otani Hotel in Tokyo. We were about to leave for the next town; I had seen the garden and asked Prince if I could photograph him there. Someone had already packed his suitcases and by mistake all his shoes and they were already gone. Prince put on the puffy white hotel slippers and we went and shot. I just had to promise him not to shoot too wide.

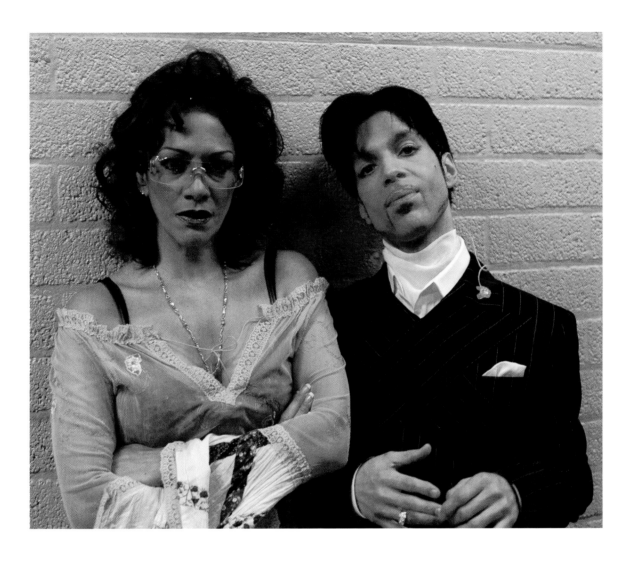

Sheila E. and Prince backstage. One thing I always observed was the calm that came with the familiarity between those two. It was always electric on stage when they performed together, but the moments before or after the shows were extraordinary and peaceful.

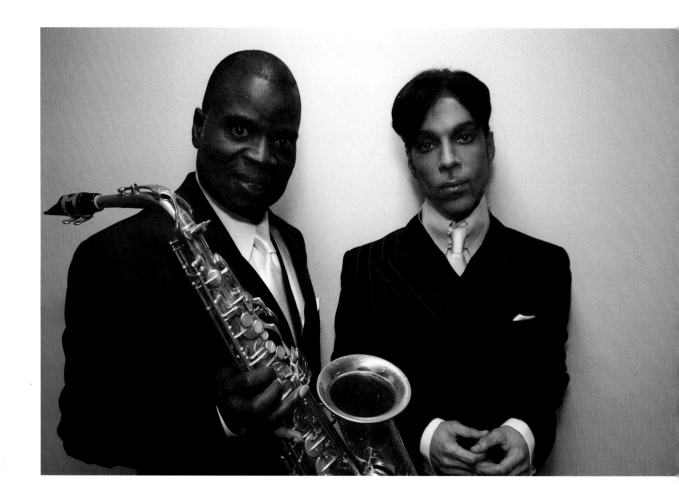

Not that being able to travel with Prince wasn't a big enough gift, the fact that Maceo Parker was in the band and that I got to hang out with him every day and listen to his stories was the second gift. Prince had immense respect for Maceo and vice versa and to see them perform together was magical.

Prince would watch and review each and every
one of his performances if it was possible. He was a
perfectionist and always found something either he
or the band could improve.

I was extremely nervous about this shoot as my wife and I had put the whole thing together ourselves, including going to antiques stores to gather the props.

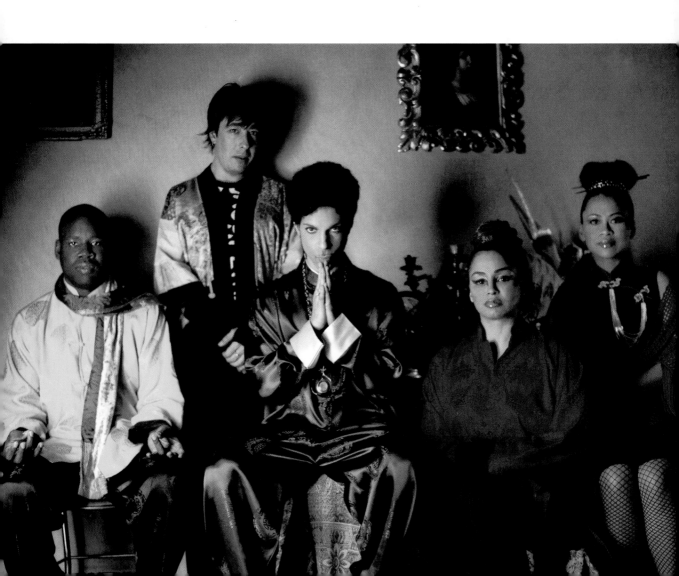

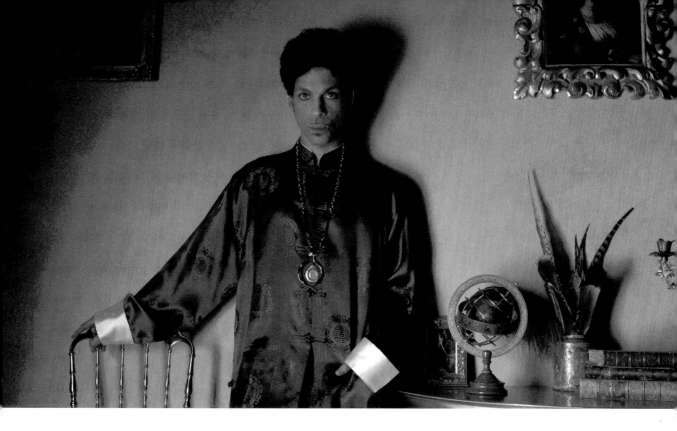

The props included a small picture frame with a white family sitting
on the table. I had planned to Photoshop them out, but forgot. I saw my
mistake when he looked at the shot and started shaking his head. I thought
my photo career was about to end, but Prince laughed and said to leave it
and see if anyone else noticed.

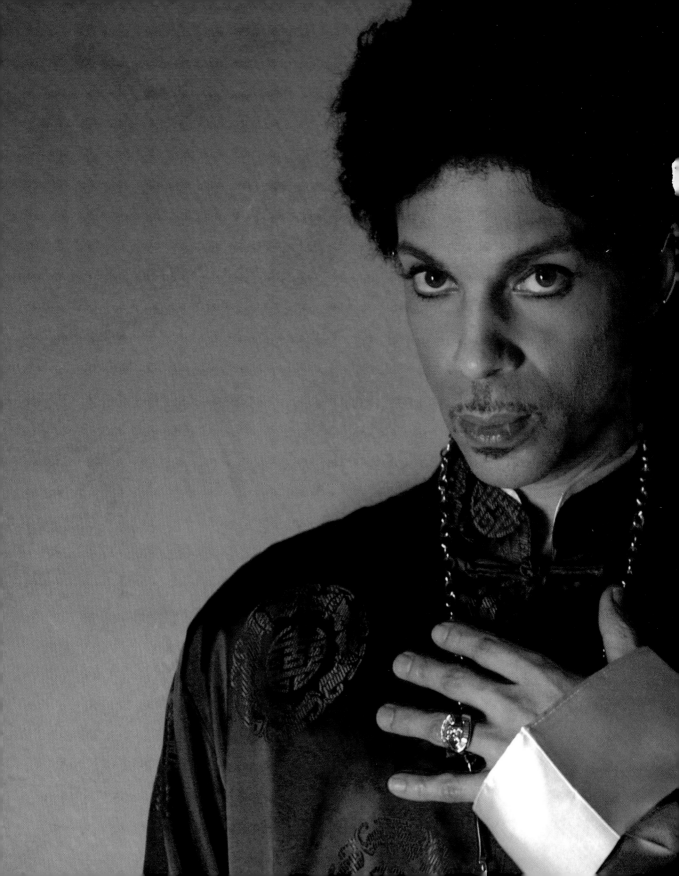

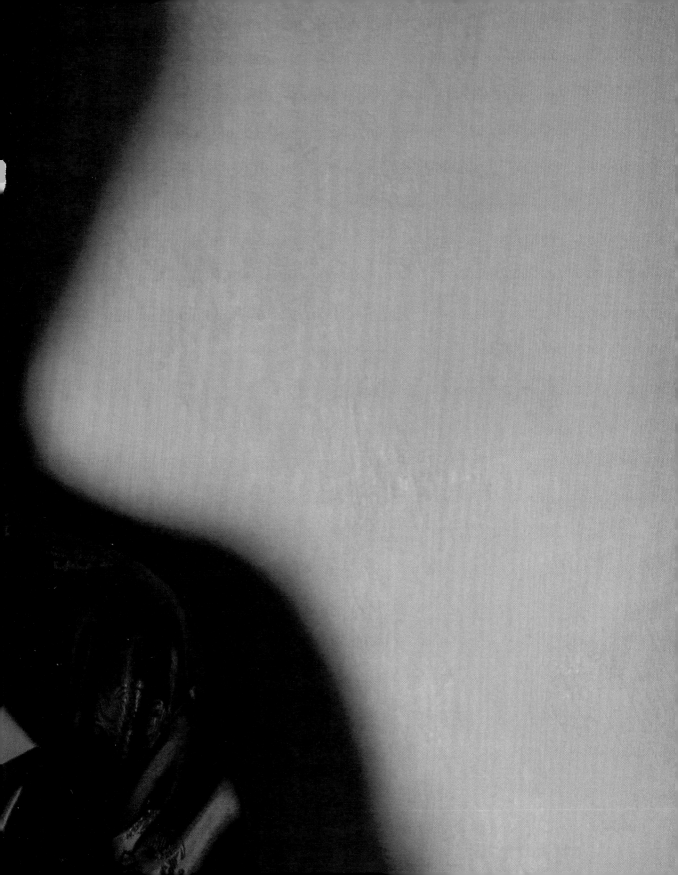

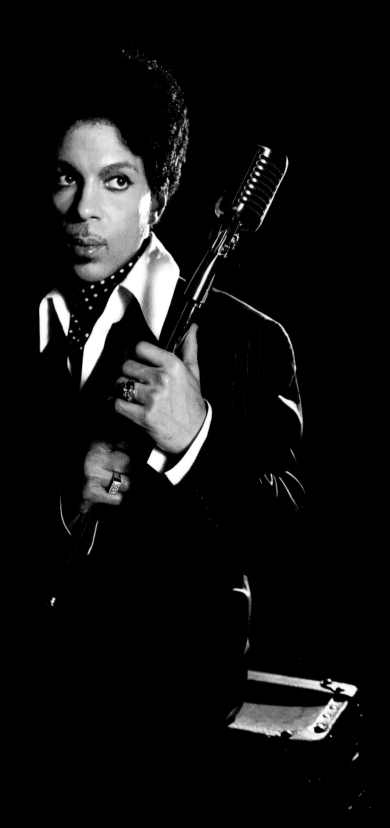

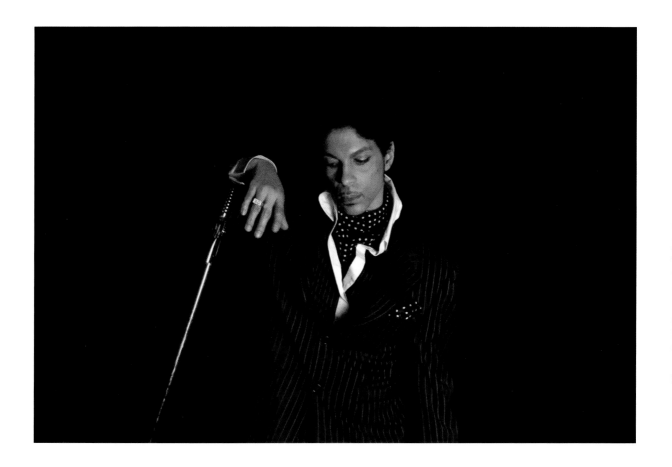

We had just finished shooting the shots with the green wall and Prince asked me "What's next?" I showed him the props I had brought and told him I wanted to shoot on a black void. I started telling him what I thought the wardrobe should be but before I got half a sentence out, he interrupted me and said "Got it." He returned a little bit later dressed perfectly and almost exactly for how I had pictured the shot.

Dream no. 1

*I'm flying in a helicopter in the
backseat, the doors are open, and a
warm wind thrashes around the cabin
and is the only noise drowning out the
rotors. I'm looking out of the doorway
opening, one foot dangling out over the
ocean. We are flying over a scattering
of desert islands floating like pearls
in a turquoise sea. It's all so serene
until the helicopter turns wildly almost
ninety degrees on its side and I grasp at
what I can so I don't plummet into the
ocean. Then it rights itself and pitches
ninety degrees the other way, I fall over
and almost out of the other side. It
rights itself again; I catch my breath
and composure. I look forward and see
Prince laughing. He is the pilot. He
winks and tells me to hold on.*

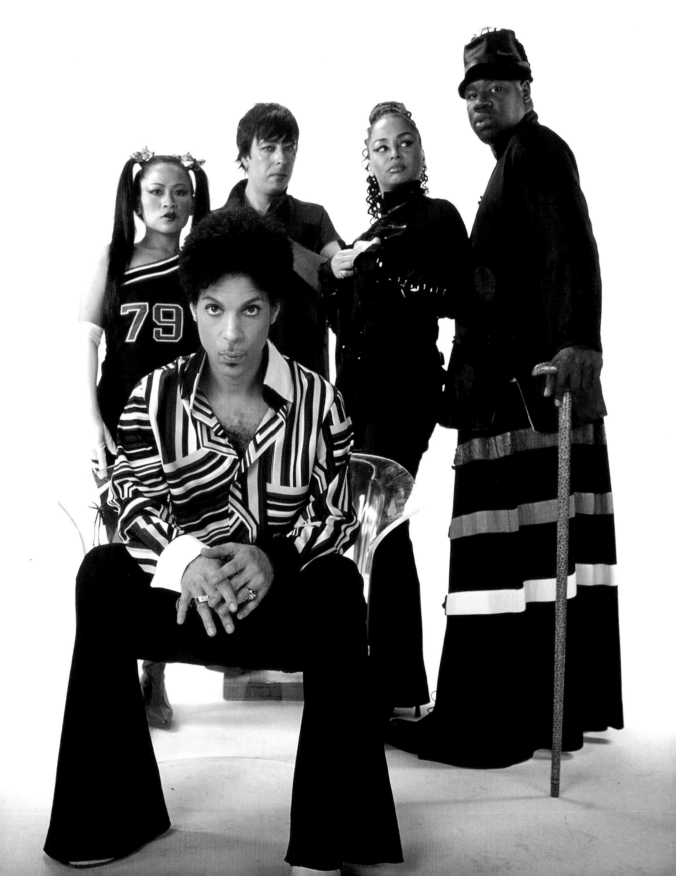

Maui, Hawaii. Prince had a home here and was going to play some shows. He asked me if I wanted to come and bring my family, which I did. Of course, I brought my cameras, too, and photographed him when I could.

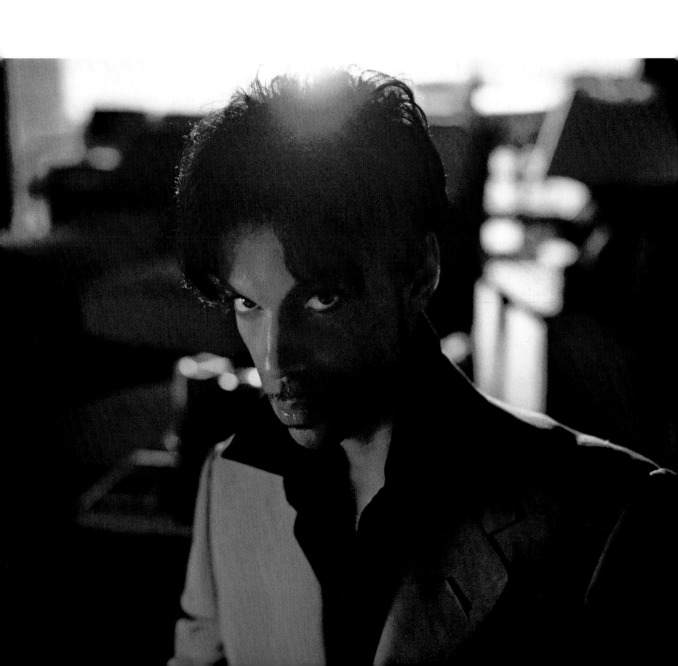

After playing a sold-out show in Maui, we went to a small bar in a strip mall on the island and Prince and the band continued playing into the early morning. I don't think I ever saw him get tired of playing music.

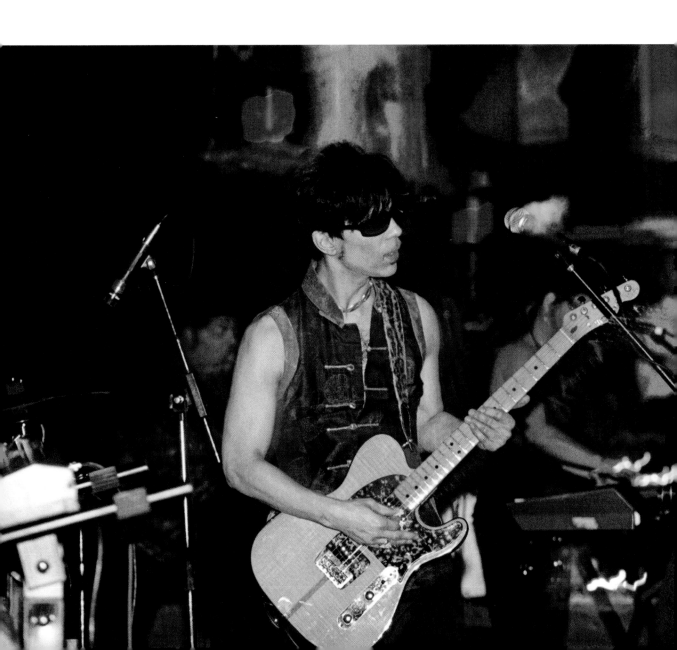

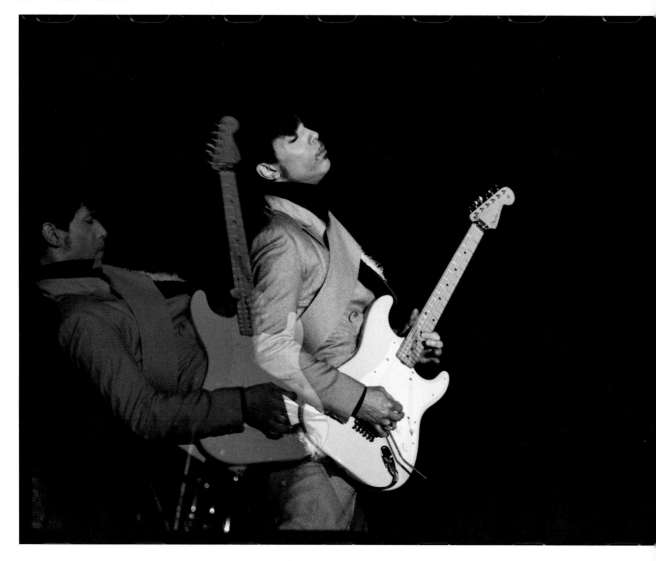

I had been trying for a while to get a shot that could speak to the
transcendental nature of his guitar playing but hadn't nailed it. As I
was taking these two shots I knew they'd be the ones once I put them
together. When I showed him the image he asked me if that's how
I saw him. I let him know that was how everyone saw him when he
gets lost in his guitars.

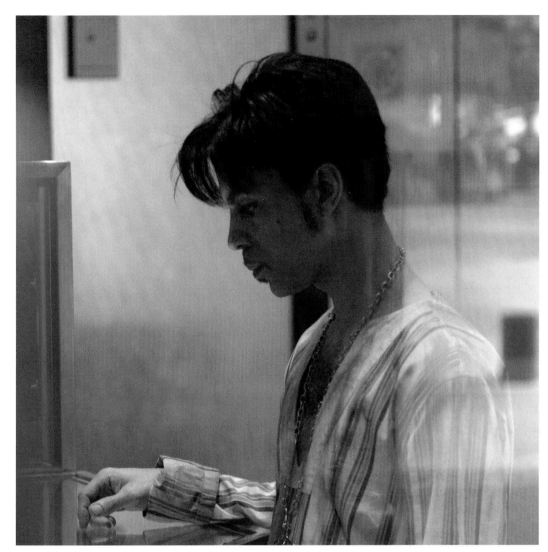

We were driving around the island and he wanted to stop at a store. I asked him if he wanted me to come in with him, but he said "No, that's cool." I waited a little bit and then went up to the window of the store and started taking some pictures. His bodyguard thought I was a paparazzo and came up to the window to block my camera until he realized it was me. When I showed Prince the pictures later, he said he didn't realize I had been taking them. He seemed intrigued by the fact that he could have control over these voyeuristic shots of him.

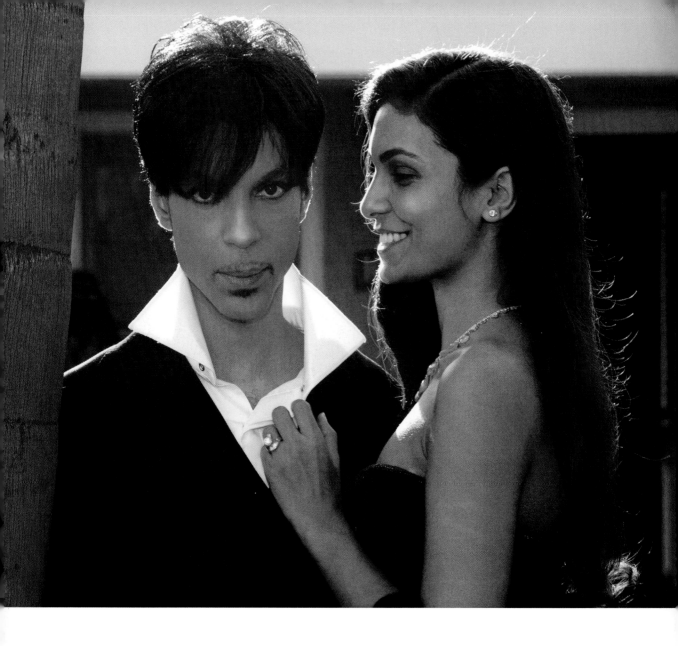

Prince and Manuela at the Beverly Hills Hotel before leaving for the Oscars.
It was a privilege to witness their love and friendship.

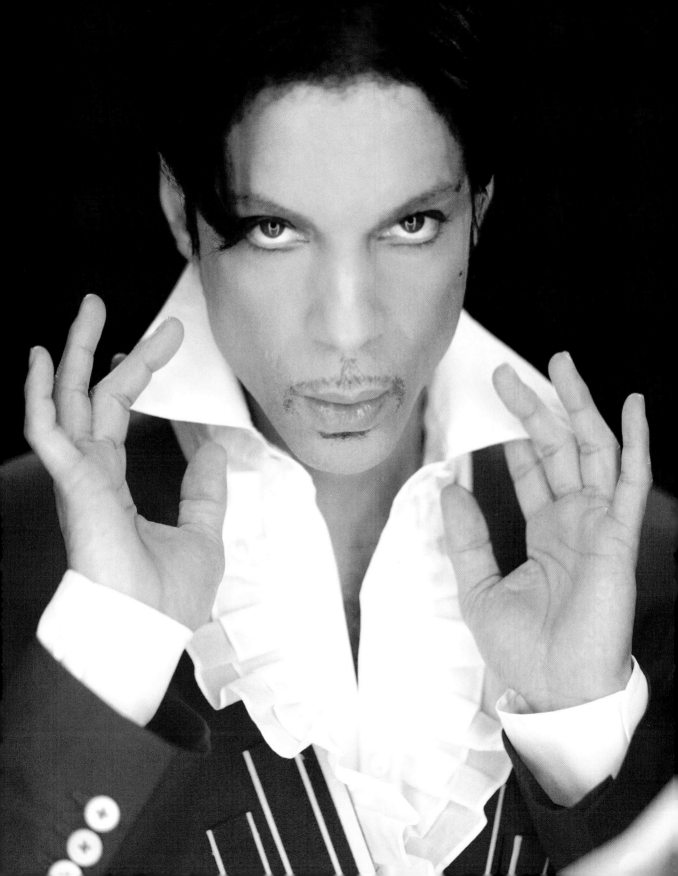

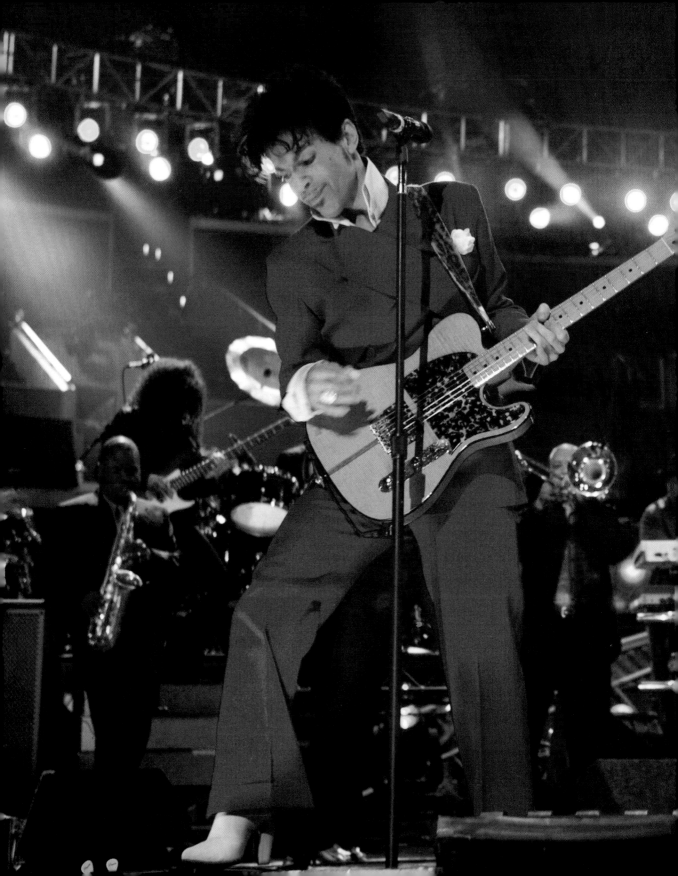

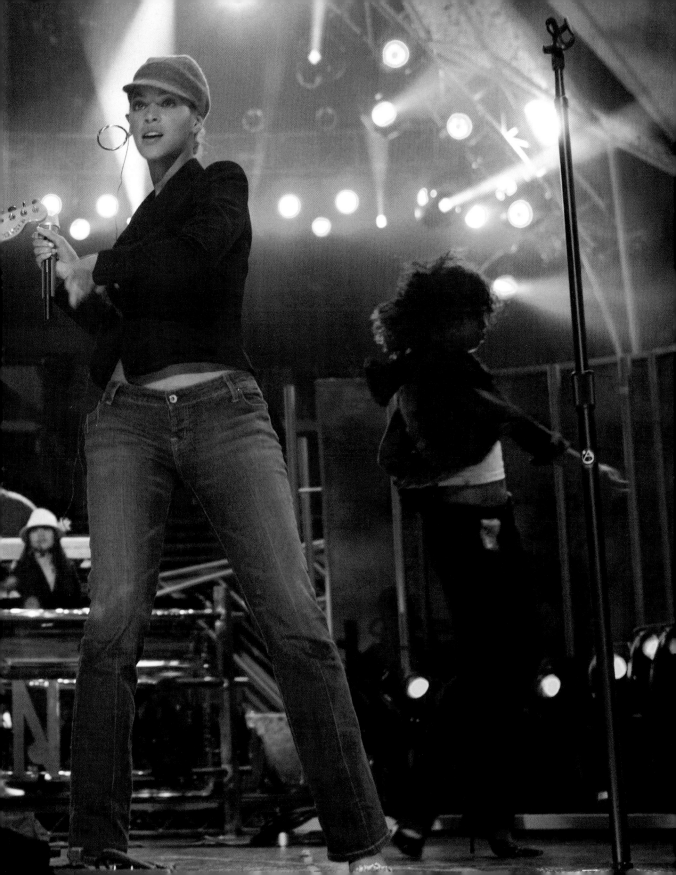

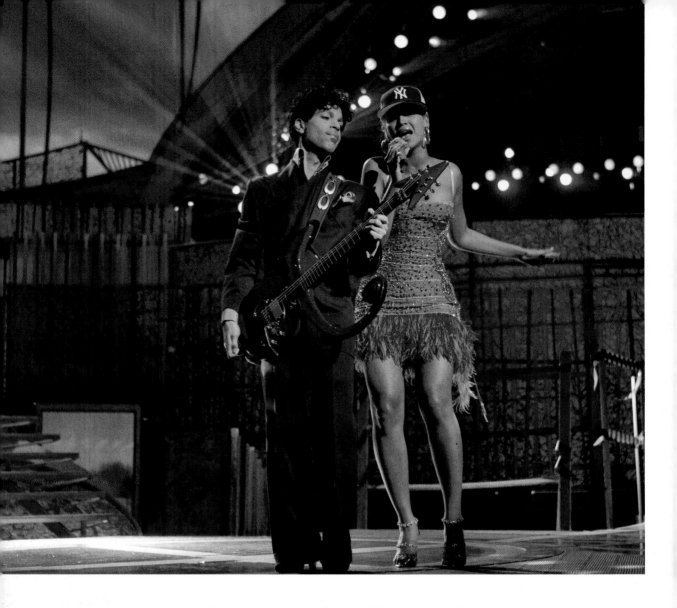

Many times Prince would want me to come along with him instead of meeting him at wherever the destination was, so often I had no idea where we were going. This day, he brought me to the rehearsal for his surprise Grammy appearance with Beyoncé. It was so sweet to see her admiration for him and to see the admiration and deep respect Prince had for Beyoncé's immense talent. "Real music by real musicians," he would often say. "She's one of the real ones," he told me on more than one occasion, which was a huge deal because he didn't hand out complements easily. Their energy together was so electric, they brought down the house during the rehearsals.

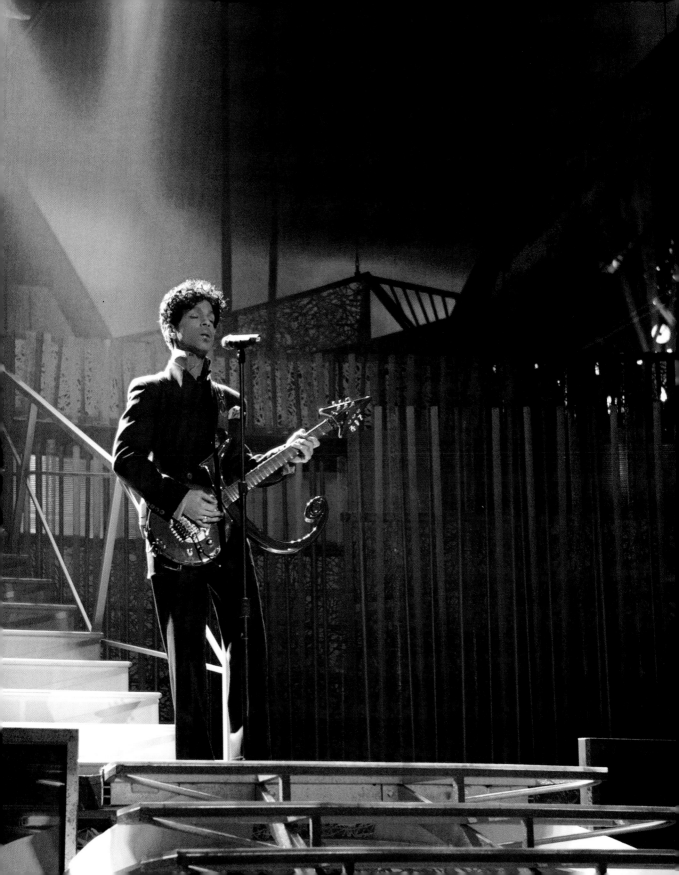

The band shot. Whenever I could get them all together at the same time—and dressed—I would attempt a band shot. It was hard to plan because before the show everyone was so busy getting ready. It was only right before they hit the stage that there was an opportunity to have them all together, but it was only for a sliver of time.

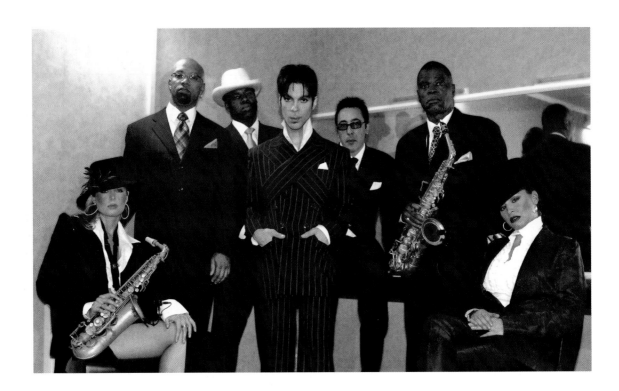

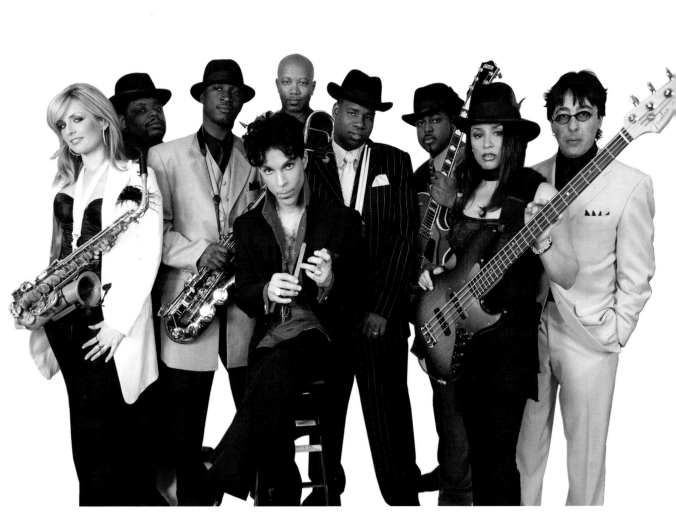

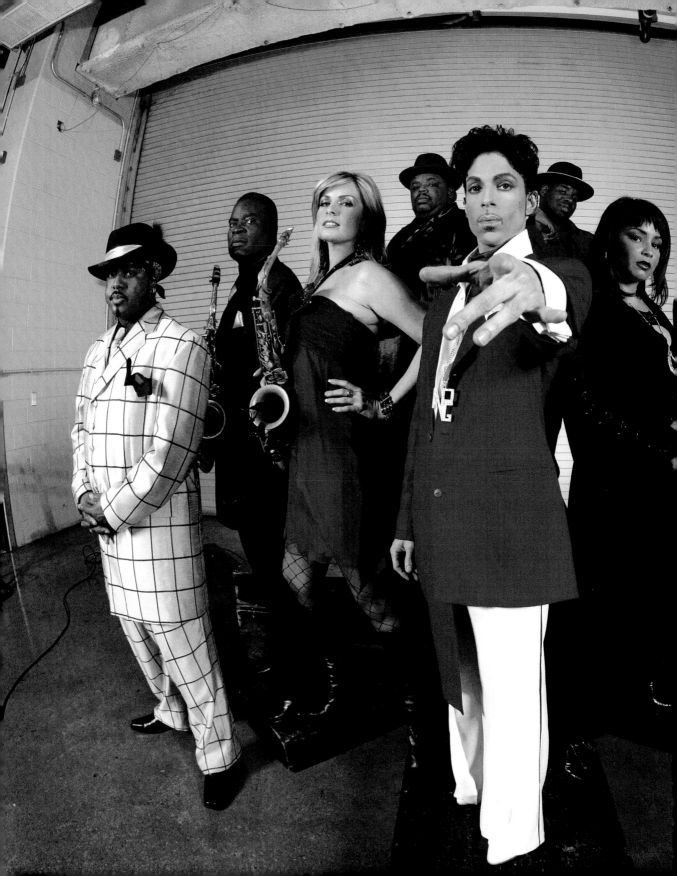

I love symmetry, so I always put Prince front and center. No one ever had a problem with that. Then I would have to figure out how to distribute the other band members evenly around Prince. Since I was always short on time, often I would recruit the stagehands to stand in as I sorted them so when I finally had Prince and the band, I could place them, take the shot, and let them go do what they came to do!

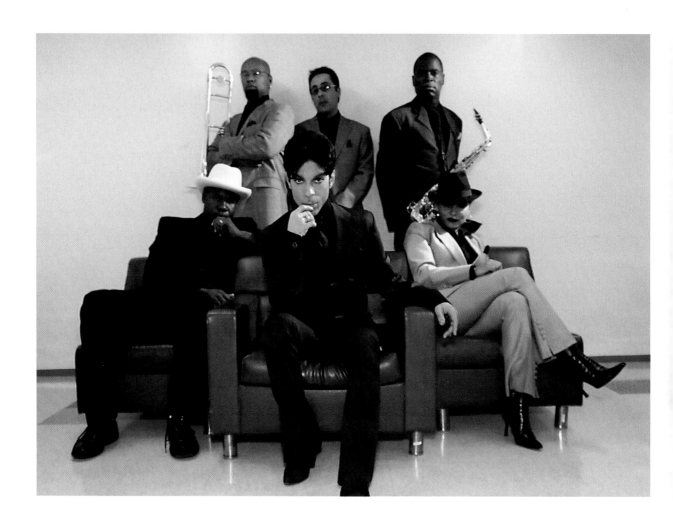

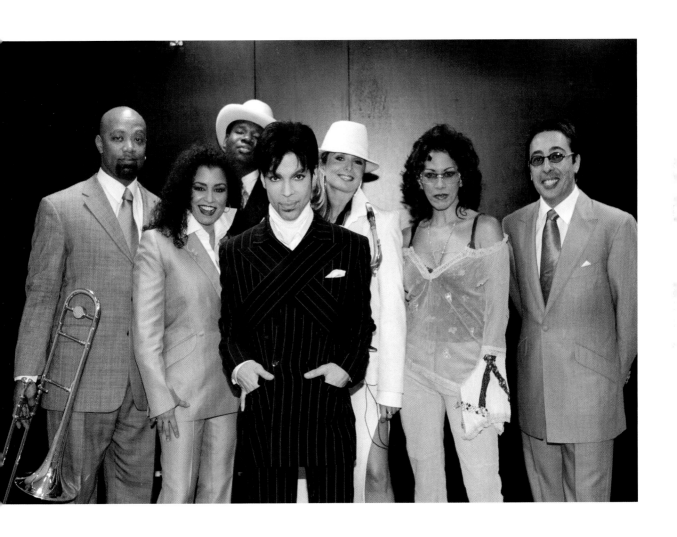

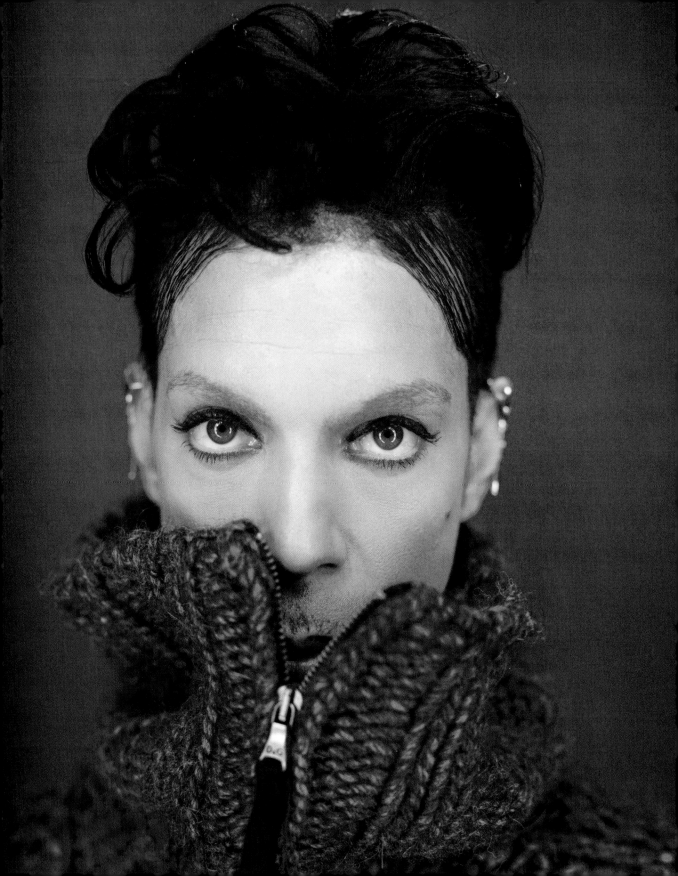

Shooting portraits of Prince felt cathartic and meditative. It was almost always just the two of us. No photo assistants, no wardrobe or makeup people, no lighting technicians. We would take our time, and if it was going well, there was a zone we hit, no words were exchanged, no discussions were had. He would look at the first Polaroid or first digital image and that was it. I could tell he was happy because he would keep coming back in different outfits.

Most of my adventures with Prince started with a phone call. Most of the time I didn't recognize the number because he would use the phone of whoever was closest to him at the time. When I answered there would be a slight pause and then I would hear his distinctive deep voice, "Afshin?" "Hey, Prince, Hi." There would be a little bit of small talk, not really much, but he was always interested in how my kids were doing. Then, "Can you come to Panama City?" "What are you doing in Florida?" "Can you come?" "When?" "Tomorrow." "Ok, yeah I'll work it out." "I'm in Panama!" "Ok, wow, that's a little different than Florida, but I think I can do it. What are we doing?" "Just come down!"

So I head down to Panama the next day and go straight to Prince's suite. He has a big spread on the table and asks me if I'm hungry. I nibble on some tropical fruit as he starts telling me he wants to shoot part of the 3121 film we had started shooting in Los Angeles not long ago, down here. Ok, I'm thinking maybe we are down here to scout the locations, come up with a game plan, etc. I start asking some questions and he jumps in because he knows I sometimes get caught up in the details. He says he wants to shoot with two full 35mm camera packages in two days. I start asking questions and trying to tell Prince he could have told me on the phone when he called that that's what he wanted to do and I start getting lost again in the details. All he replies is "I know you can make it happen!" With that, I call my friend Steve in Minneapolis. I've worked with Steve on many projects and I know he's down for an adventure. I ask him if he can meet me in Miami the next day. Somehow he can tell where this is all coming from and he says he'll be there. I leave Panama and meet him in Miami where we prep a couple million dollars' worth of 35mm camera equipment and fly back to Panama that evening with everything in tow. The next day we are shooting a movie in Panama: no script, no plan, just off the cuff. We work hard during the day and every evening we go out to a dinner, a live band, a rented-out movie theatre, a disco. We were returning from one such evening when I asked the van to stop. We jumped out and I took this shot.

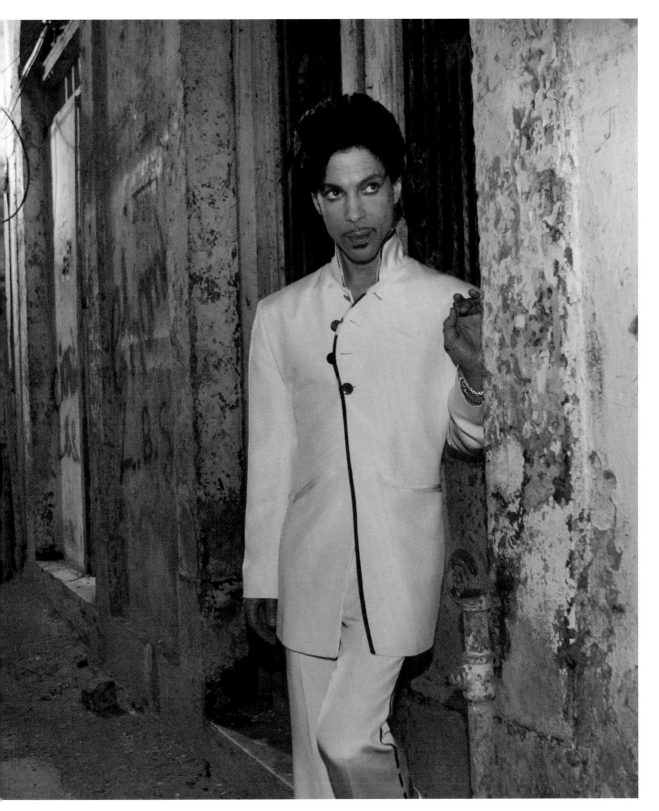

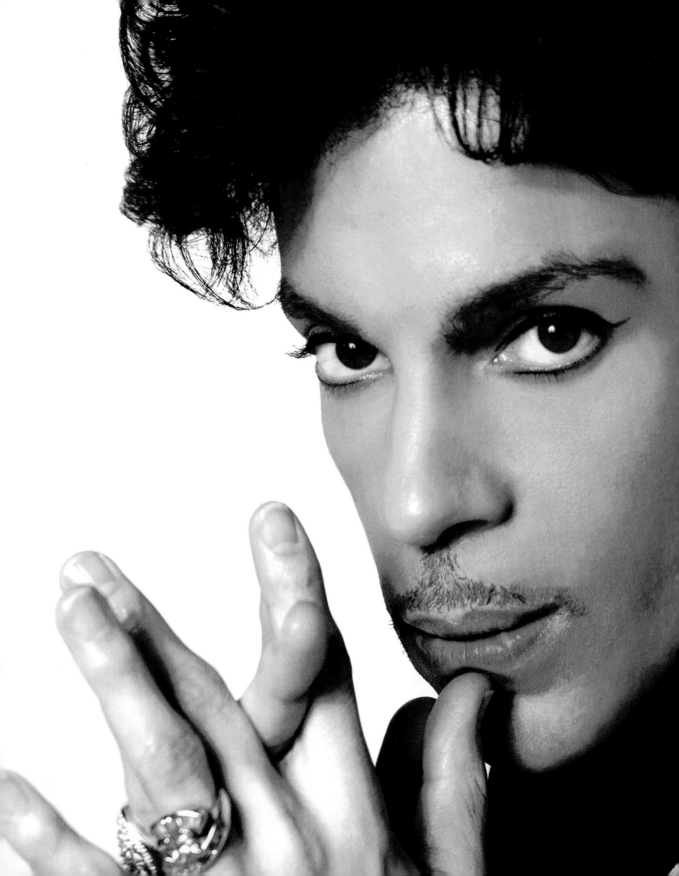

NYC hotel room. Oftentimes, we would work late into the night after the band had gone to sleep. Prince and I would chat as I edited photos and got his opinion, or we would do a shoot. This night, I was already asleep in my room when Prince called. I acted like I'd been awake. He clearly hadn't slept yet and still had some creative energy bubbling over. I headed over to his room at 4 a.m. and we did this shoot. Most of my memorable photos and moments were from late-night sessions, often with just the two of us present.

Dream no. 2

I'm sitting at the end of an uncomfortably long table; Prince sits at the other end. We are sitting there and he is talking to me but I can't understand a single word he says. His voice is both faint and muffled, but what he is saying seems to be very important as he's gesturing wildly and is quite serious. I put my hands behind my ears to show I can't really hear him. Somehow I'm planted in the chair, not sure why I don't just get up and go closer. He finishes talking and looks to me for a reply. I'm at a loss and he feels this. He looks around and then gestures to something on the table next to me. It's a tin can. I pick it up and he picks one up at his end of the table; they are connected by a long piece of white twine. I can finally hear him. He tells me to smile.

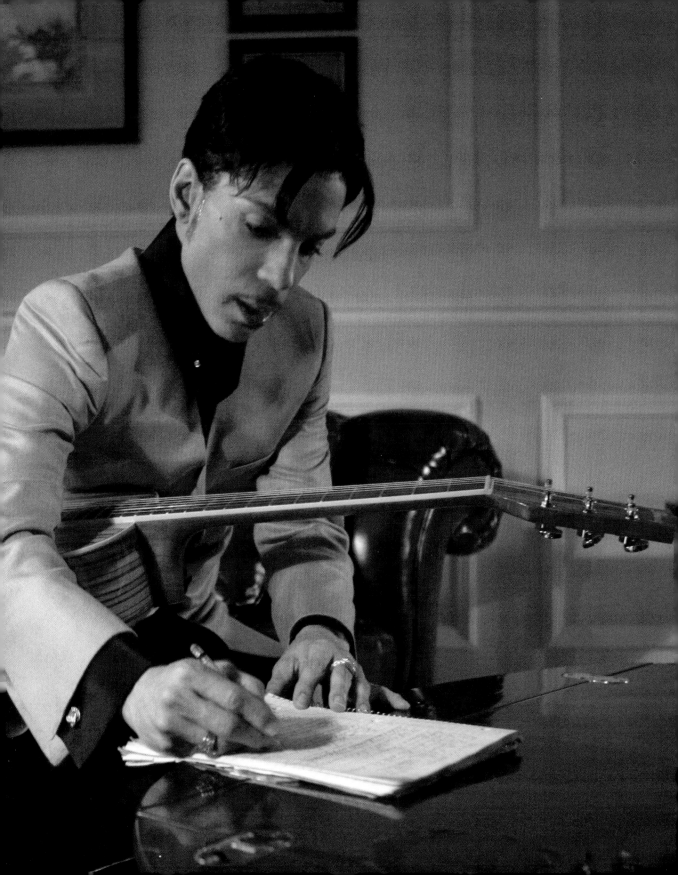

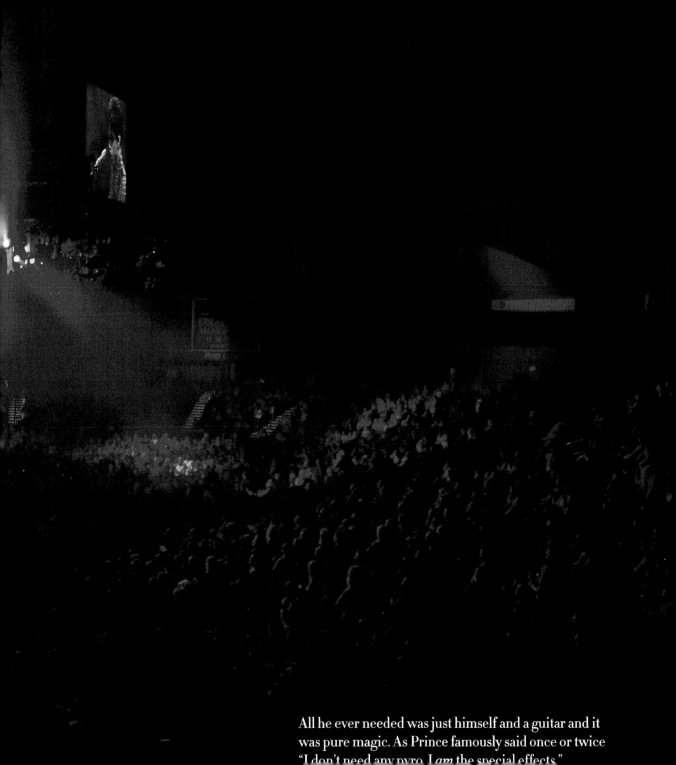

All he ever needed was just himself and a guitar and it
was pure magic. As Prince famously said once or twice
"I don't need any pyro. I *am* the special effects."

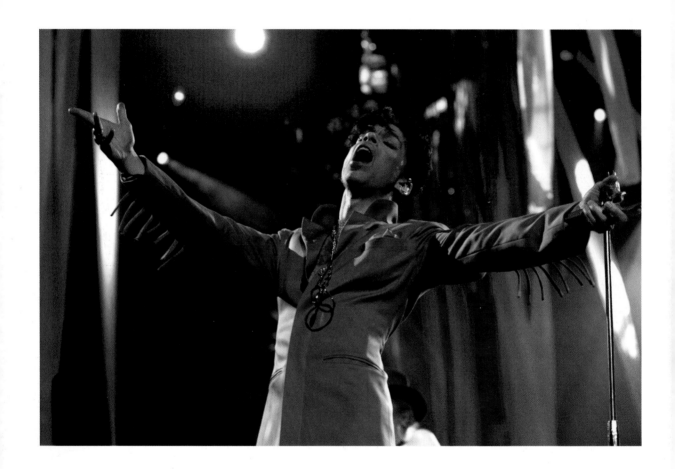

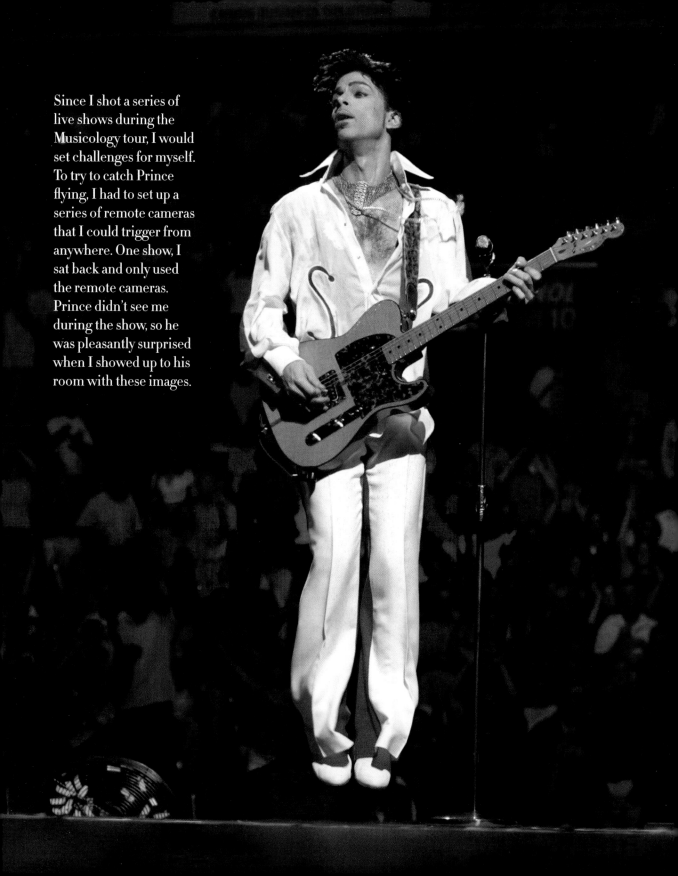

Since I shot a series of live shows during the Musicology tour, I would set challenges for myself. To try to catch Prince flying, I had to set up a series of remote cameras that I could trigger from anywhere. One show, I sat back and only used the remote cameras. Prince didn't see me during the show, so he was pleasantly surprised when I showed up to his room with these images.

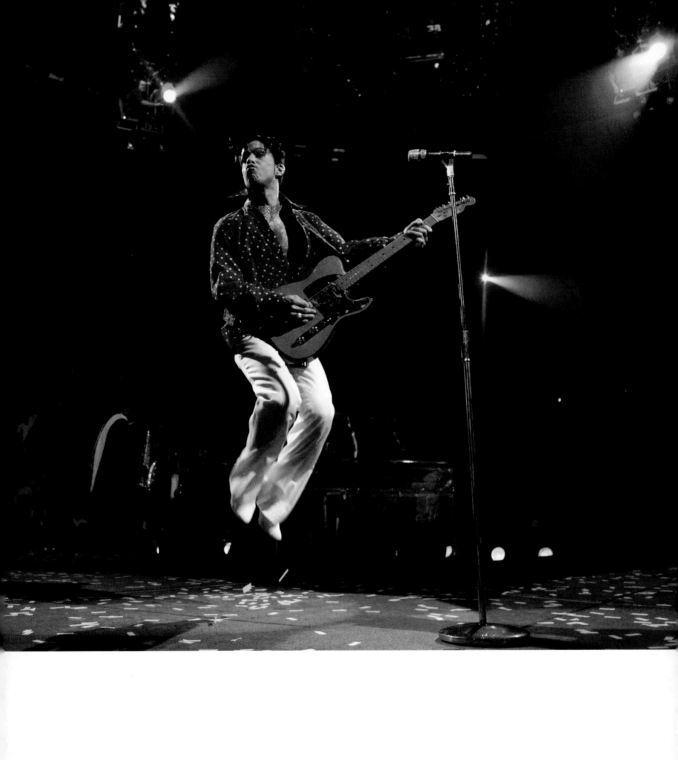

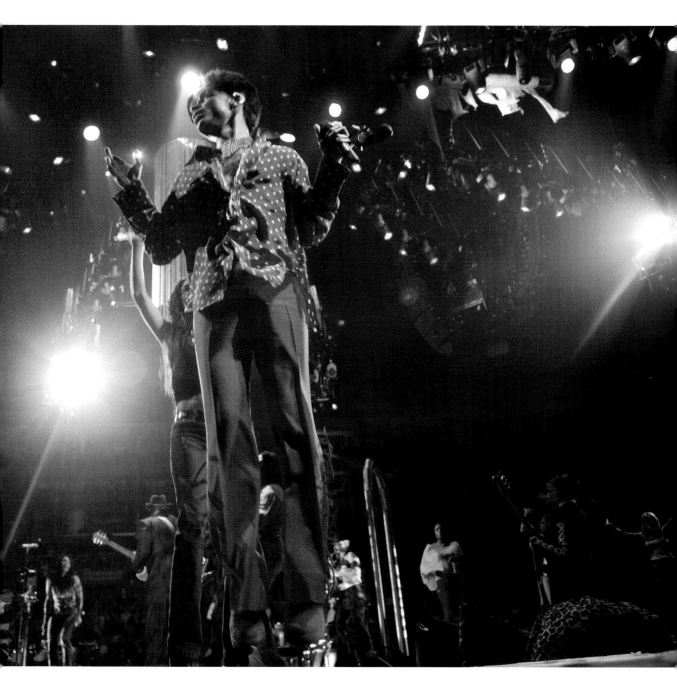

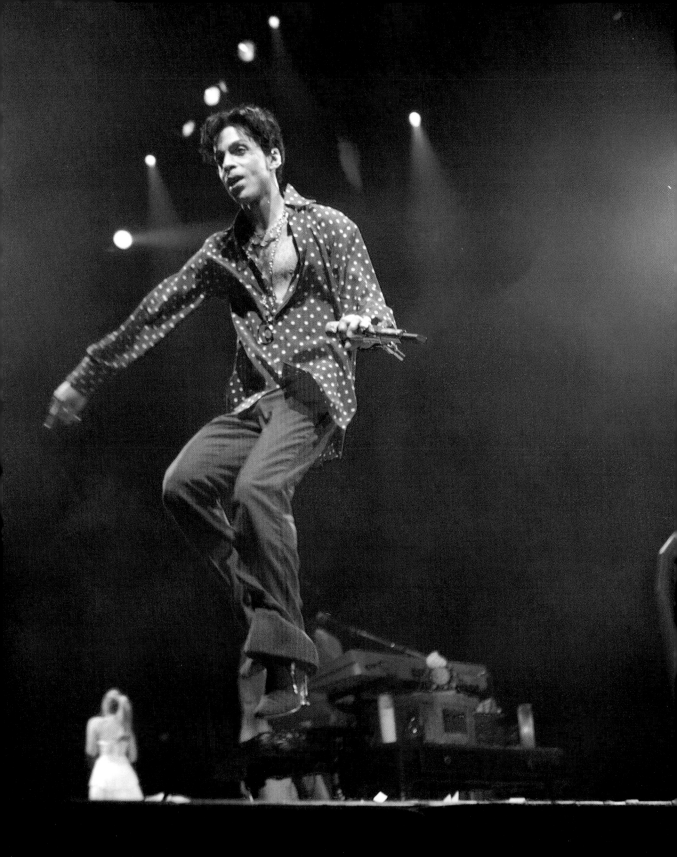

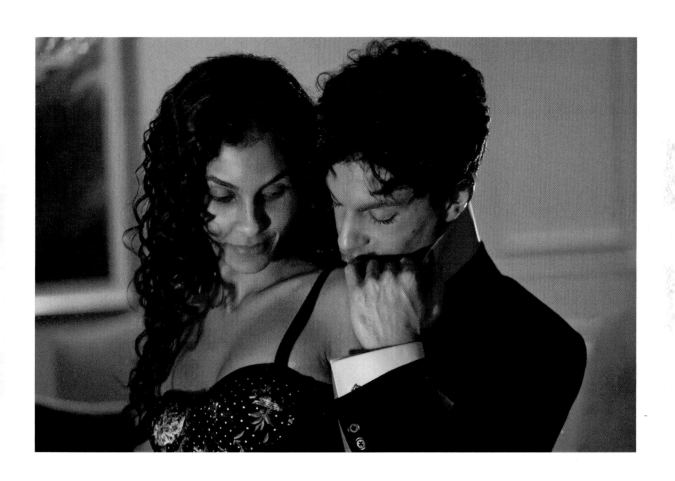

A beautiful moment after a Vegas show.

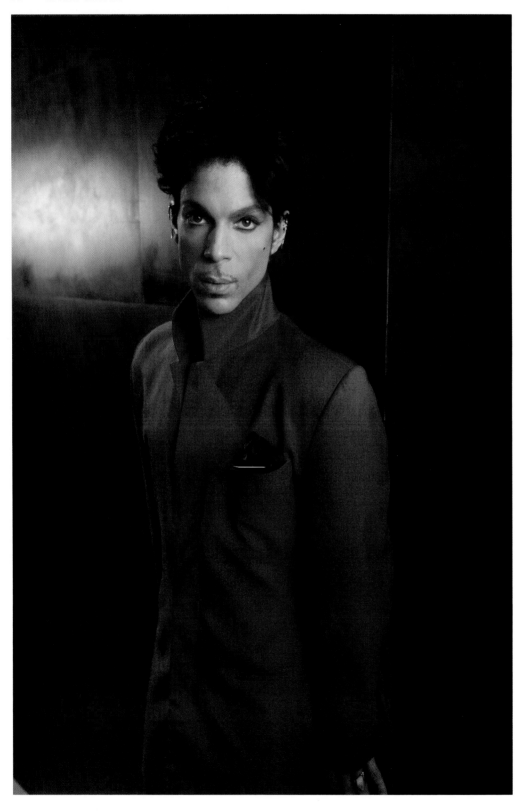

Dream no. 3

I'm sleeping soundly when I'm woken by a hand gently tapping me on my shoulder. I wake up in the upper bunk of the tour bus; it's hot, the bus is not moving, and daylight cuts into the bunk through a sliver between the curtains. The hand taps me again and asks, "Are you ready? We got to get going." I pull the curtain aside, annoyed, and find Prince standing there in his show wardrobe, which doesn't really look too different from what he normally wears. Why is he dressed for a show during the day and why is he in the band bus? He's never stepped foot in there before. He seems like he's trying to stay quiet so I can slowly wake up, but he also seems like he's in a little bit of a rush. Somehow I'm already dressed, too, in my typical show clothes, a black suit. He leads me, holding me loosely by the arm, and as we exit the bus he hands me my cameras. We walk through the tunnel and onto the dark stage. Dry-ice smoke starts covering the ground as the lights go up and I find myself standing on the stage with Prince as his show is about to start. I wake up at that moment. I'm in my bunk, the bus languidly swaying from side to side as we make our way through the Alps at night.

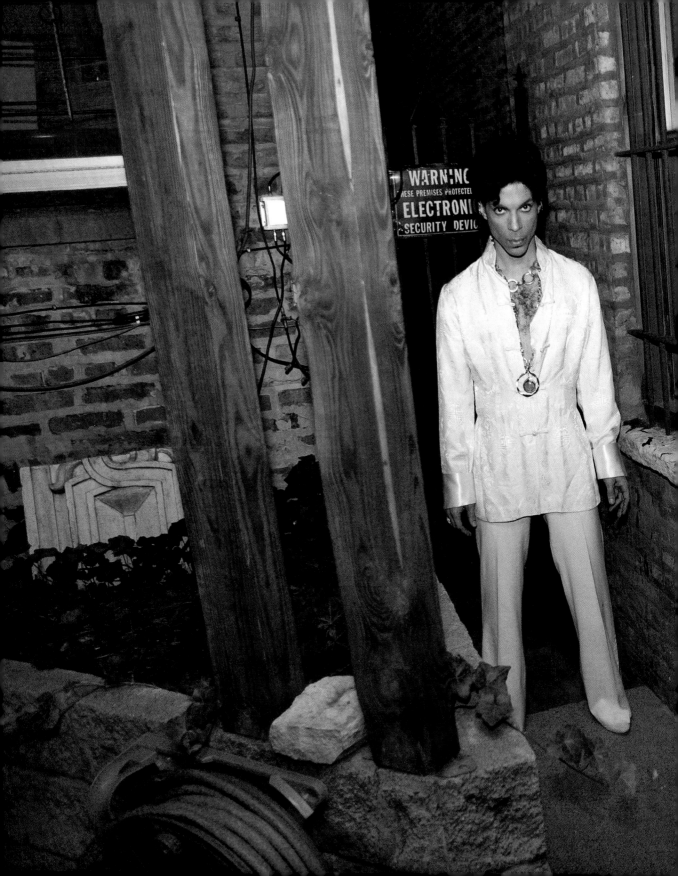

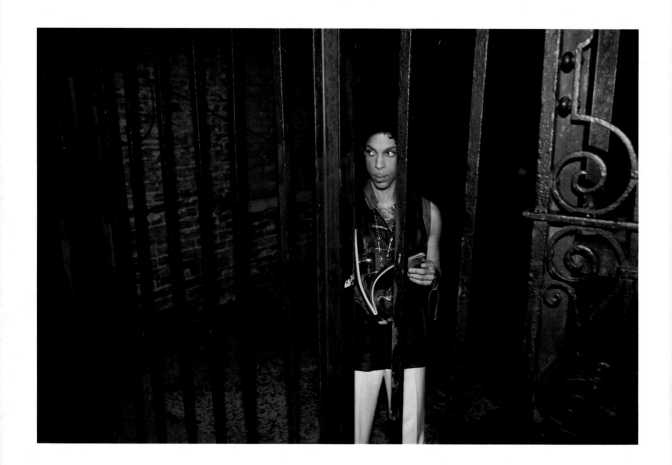

I always liked photographing Prince in unexpected places. Of course you
would see Prince on a stage or riding in the back of a limo, but I found it
intriguing to see him outside his environment. We drove down a back ally to
enter a nightclub in Chicago. I don't remember what caught our eye behind
the building, but I snapped these. When we went back to the club the next
night, we took a few more pictures.

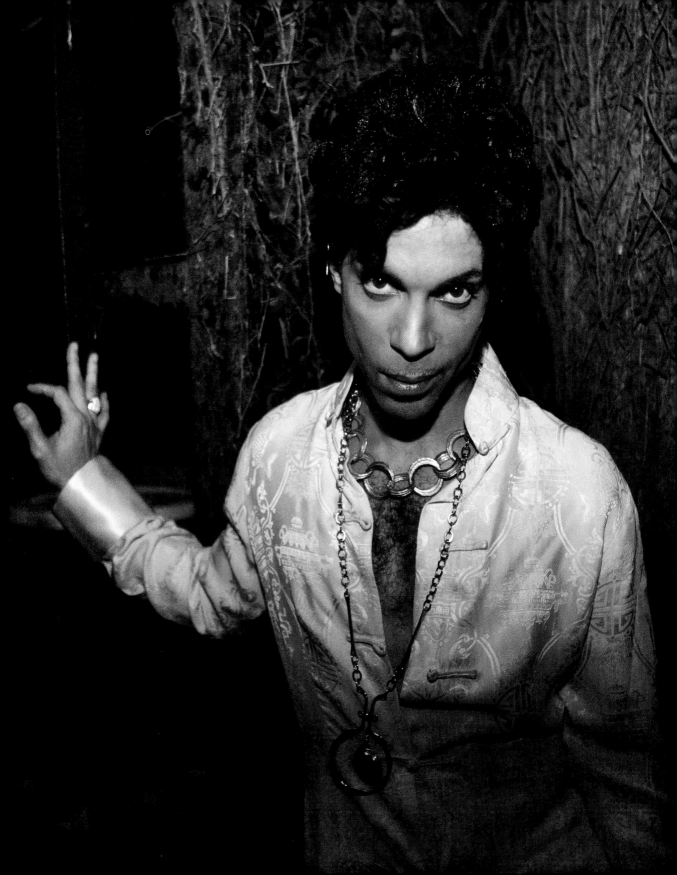

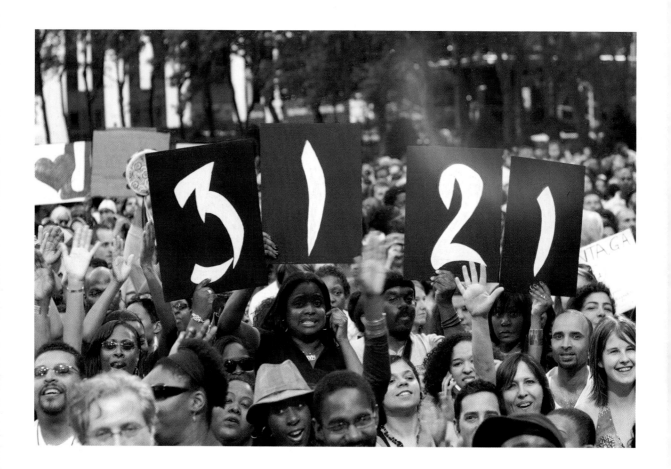

I really can't say enough about Prince's fans. The kindest, nicest, most passionate people I have had the privilege to meet and get to know over the course of the years working with Prince. It felt so heartwarming to see familiar faces wherever we went. You guys made this really fun for me. Thank you.

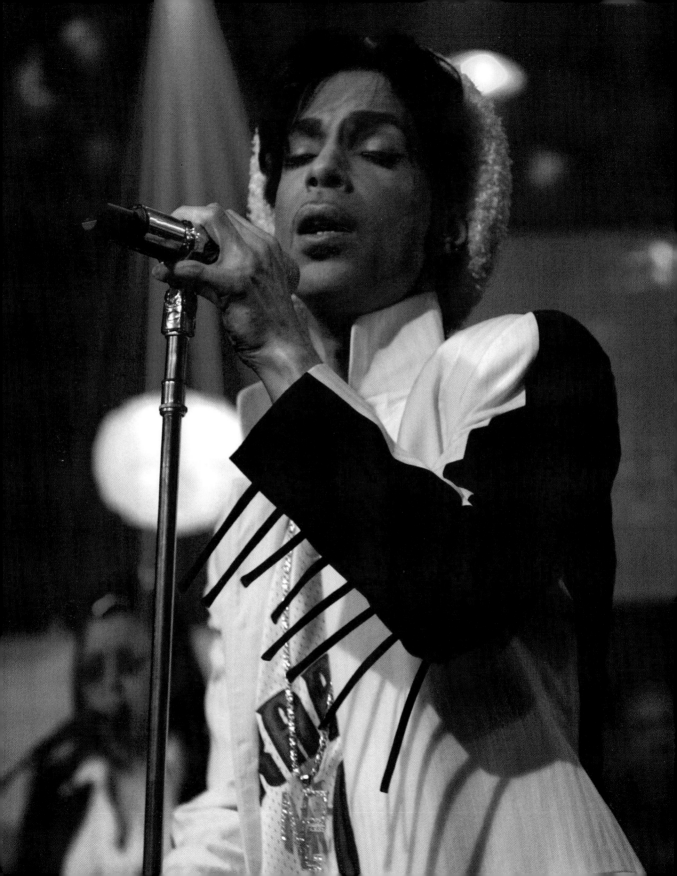

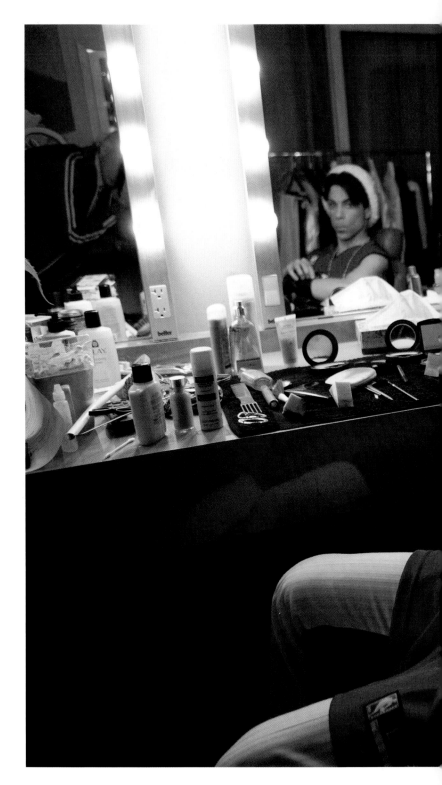

Either I had red
on because of
Prince or he had red
on because of me.

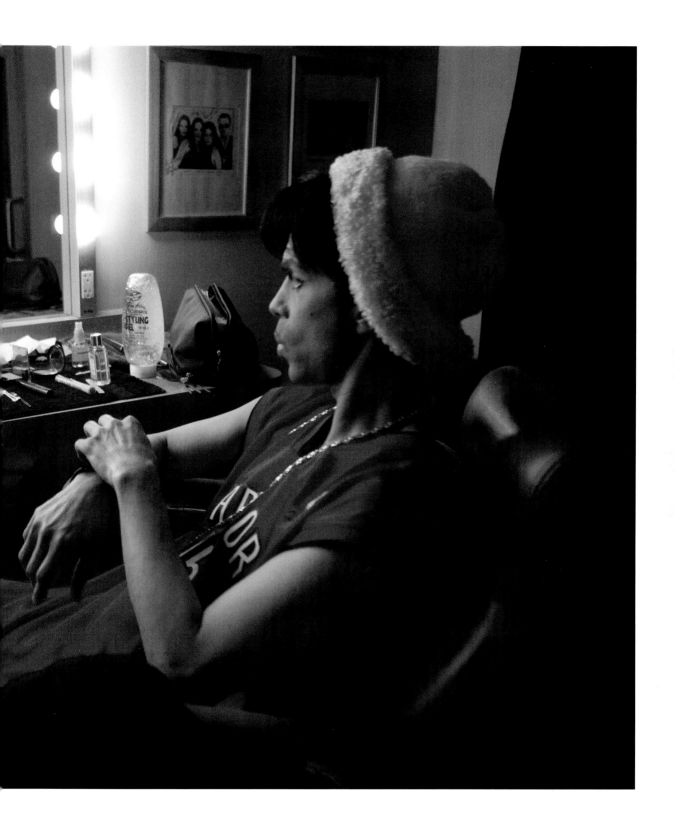

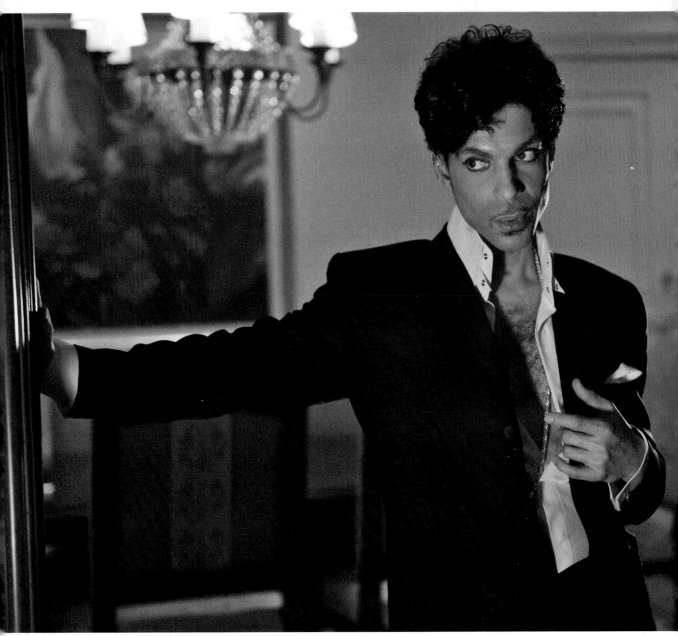

After a night on the town in Vegas.

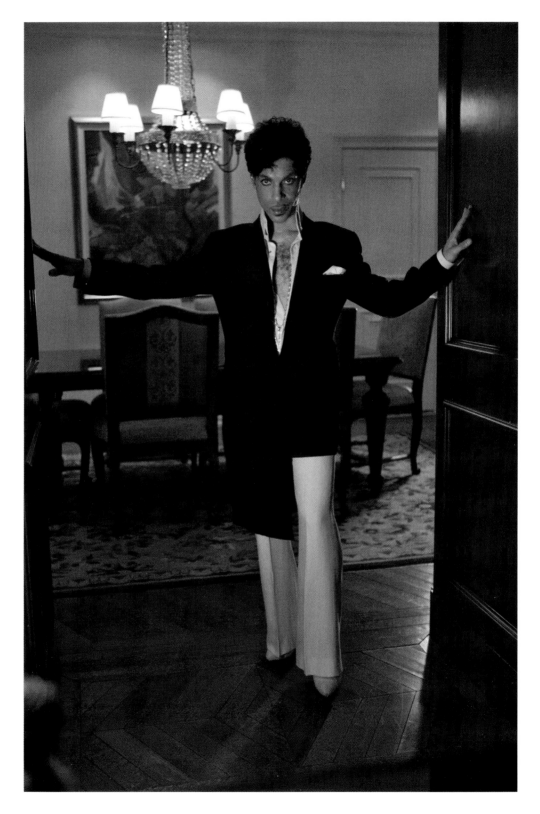

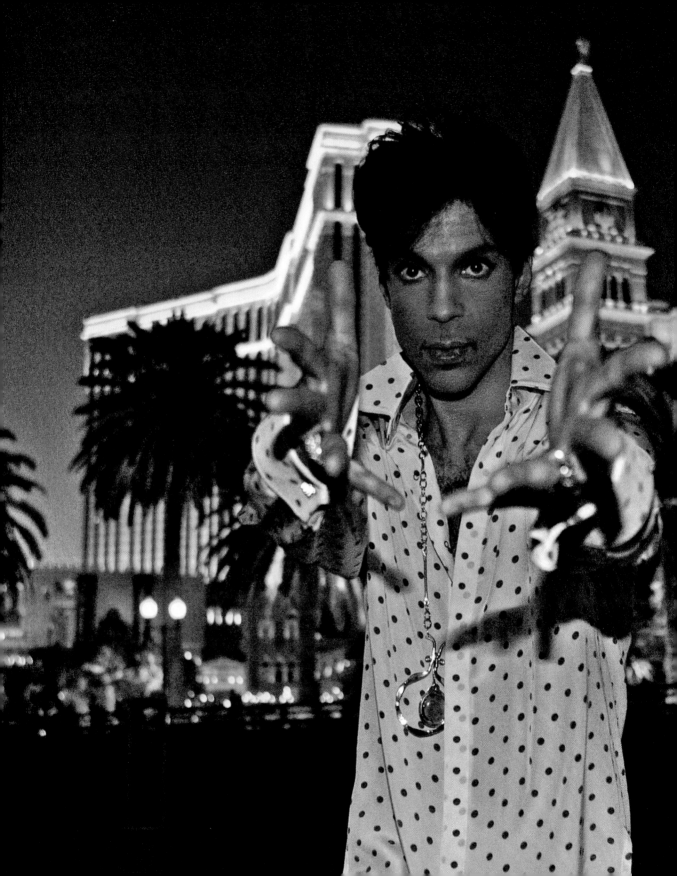

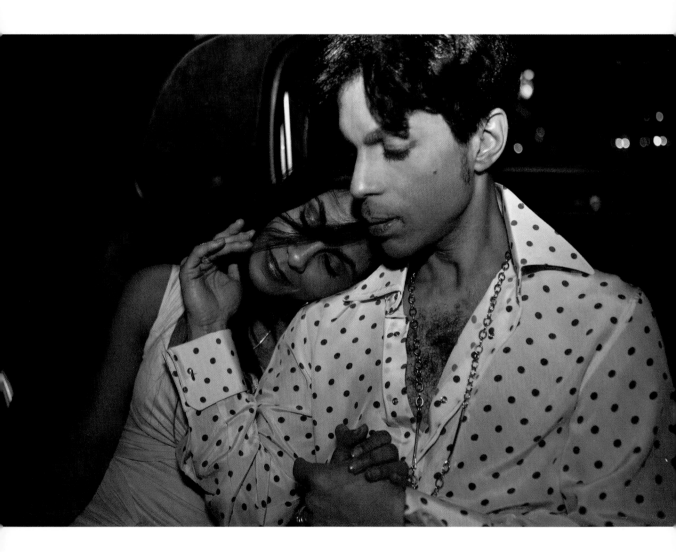

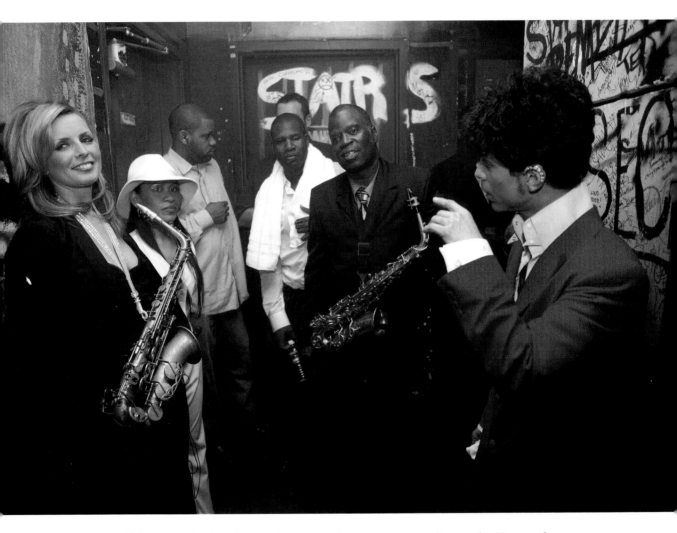

Prince and the band chopping it up after an exceptional set at the House of Blues, and right before they hit the stage again. "It ain't over!"

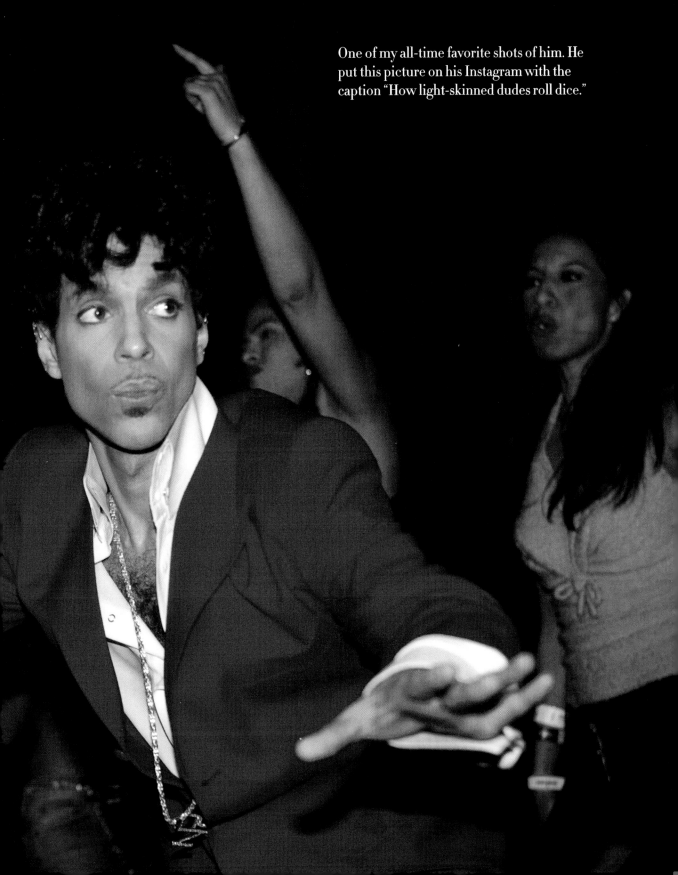

One of my all-time favorite shots of him. He put this picture on his Instagram with the caption "How light-skinned dudes roll dice."

There were always requests for images but never enough time. This was for Rhonda's Bass Player cover. Shot backstage in Philly before they hit the stage for a show.

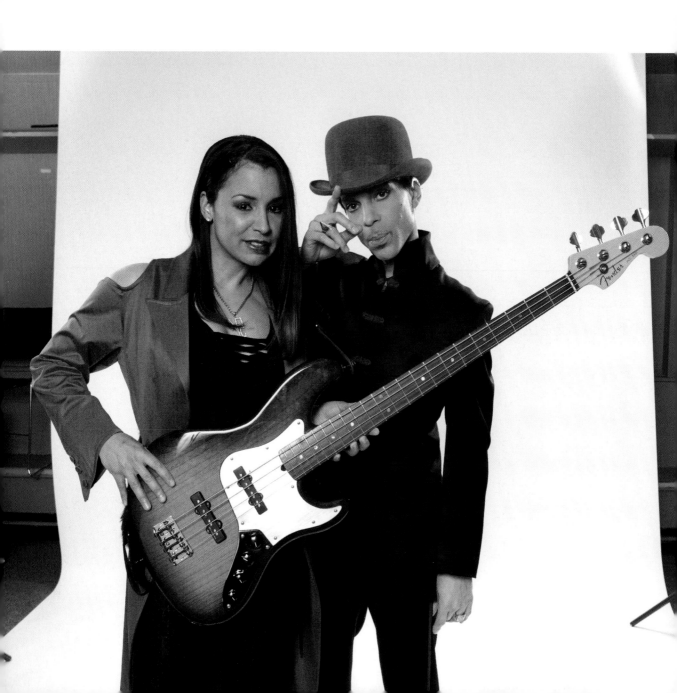

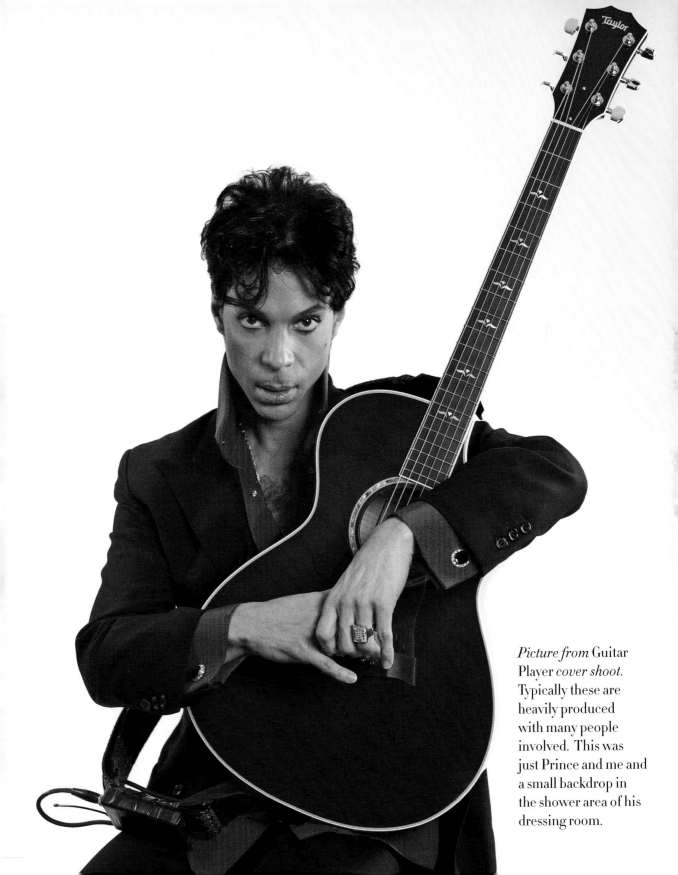

Picture from Guitar Player *cover shoot.* Typically these are heavily produced with many people involved. This was just Prince and me and a small backdrop in the shower area of his dressing room.

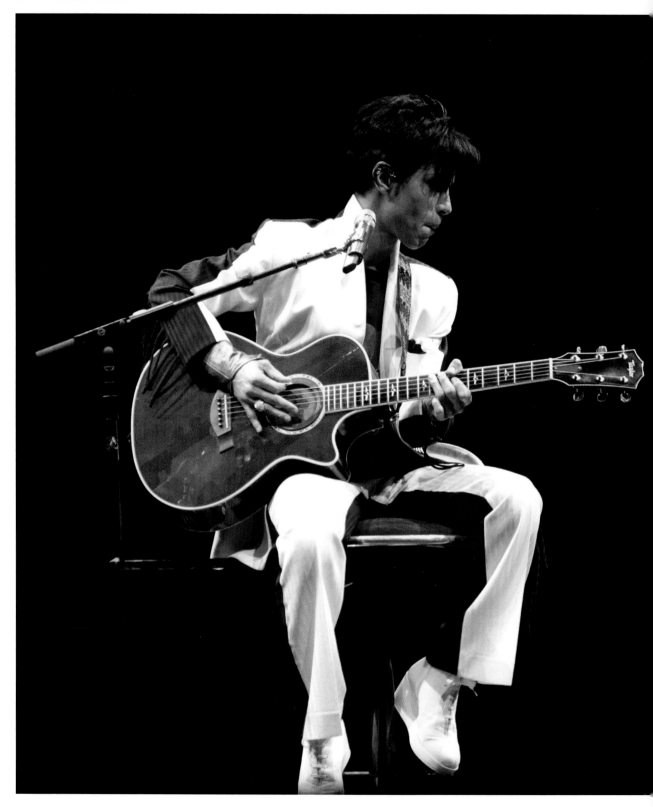

My favorite moments from the Musicology Tour were when it was just Prince and his acoustic guitar. He would do a medley of hits, joke and tease with the audience, and he seemed to be having a genuinely fantastic time.

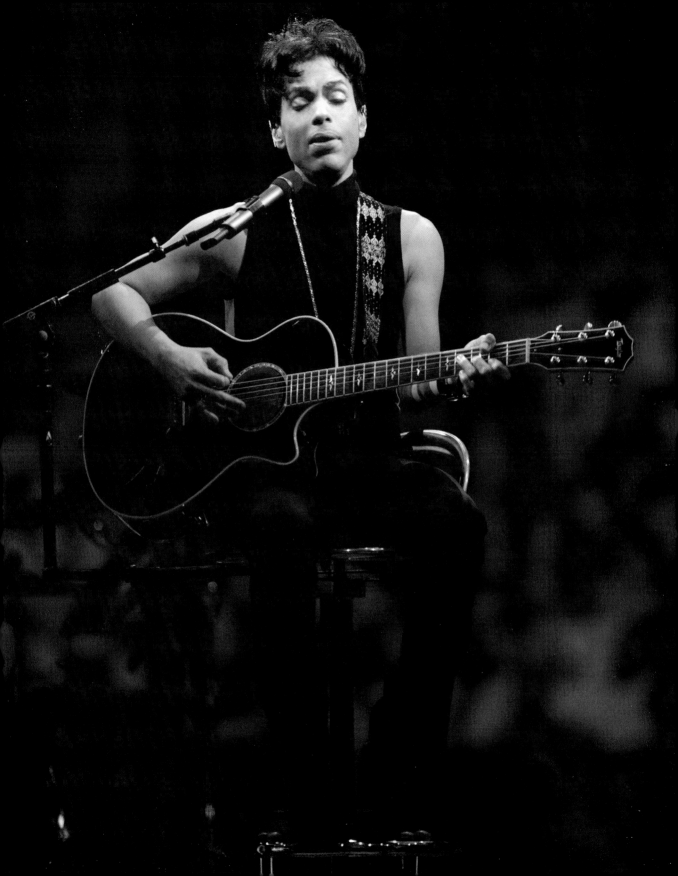

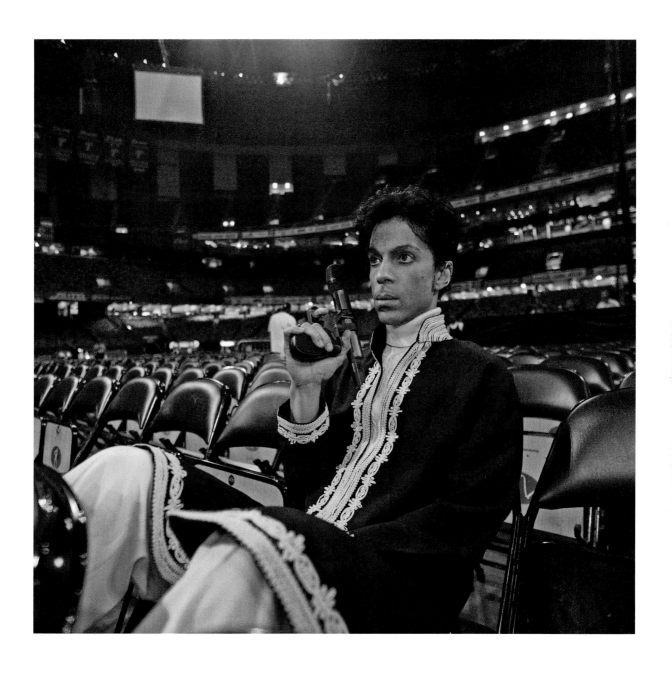

Sound check in New Orleans before Essence Fest. Everything
was about the music and the sound being just right.

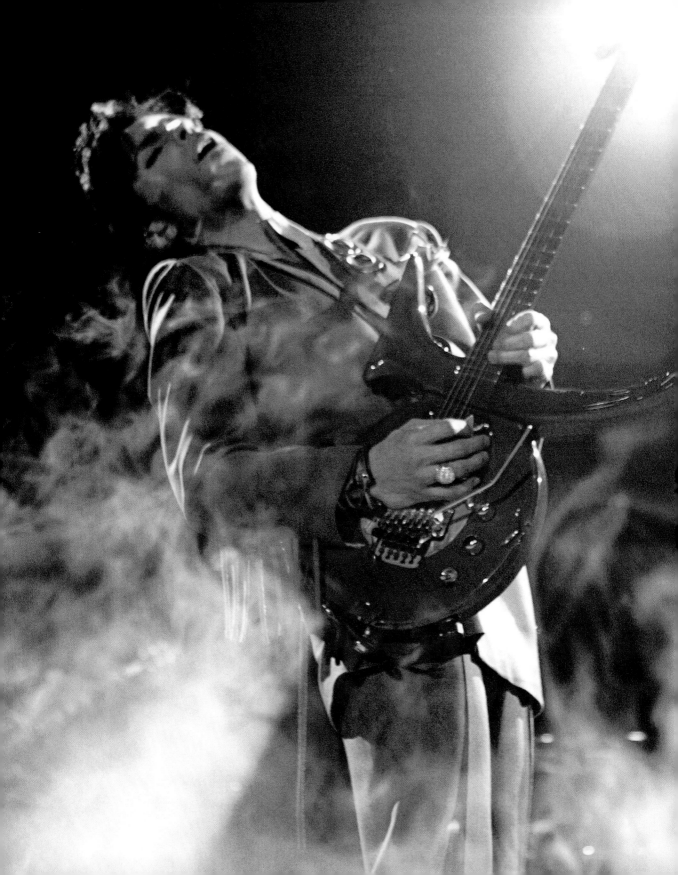

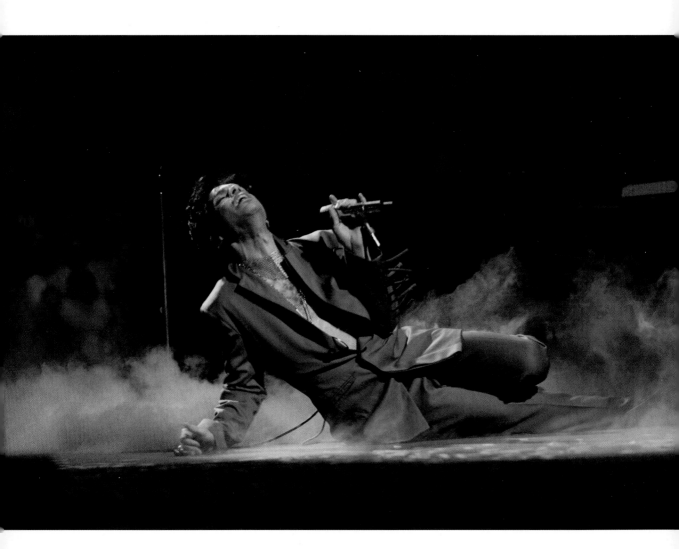

Prince gave every bit of himself when he played live. I would often catch myself just standing there mesmerized by his performance and I would have to remember to start photographing him.

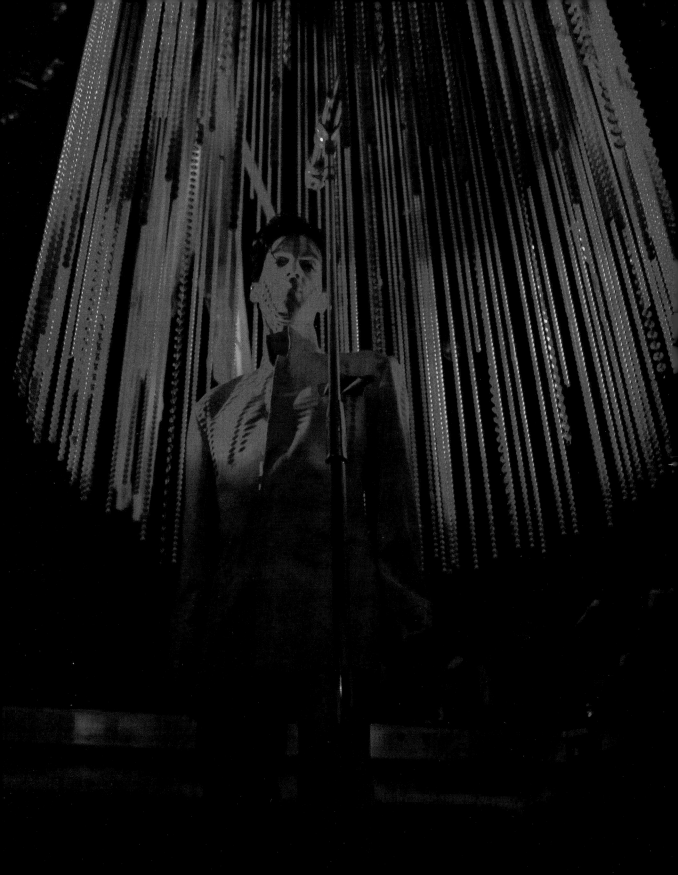

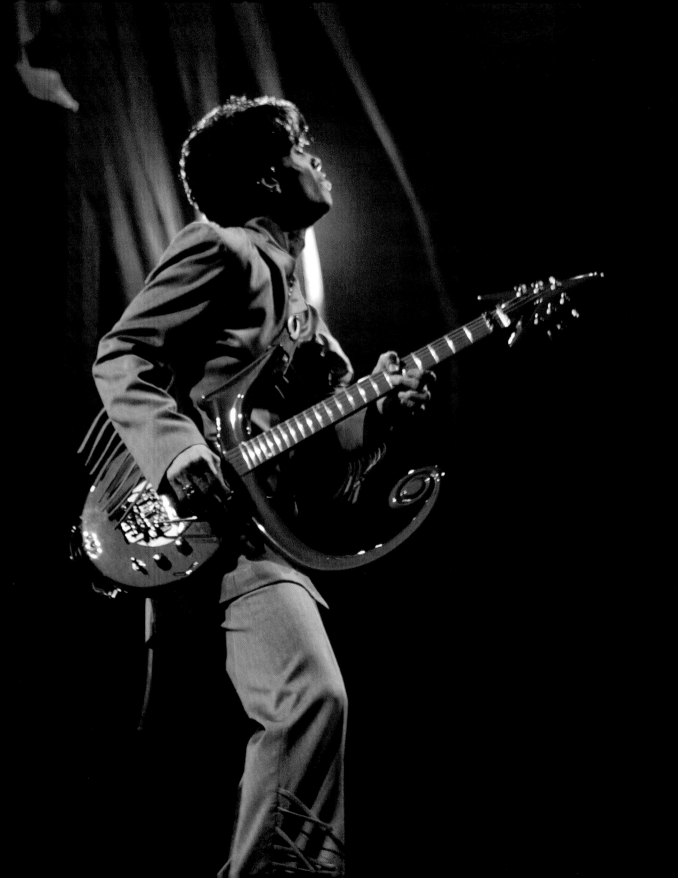

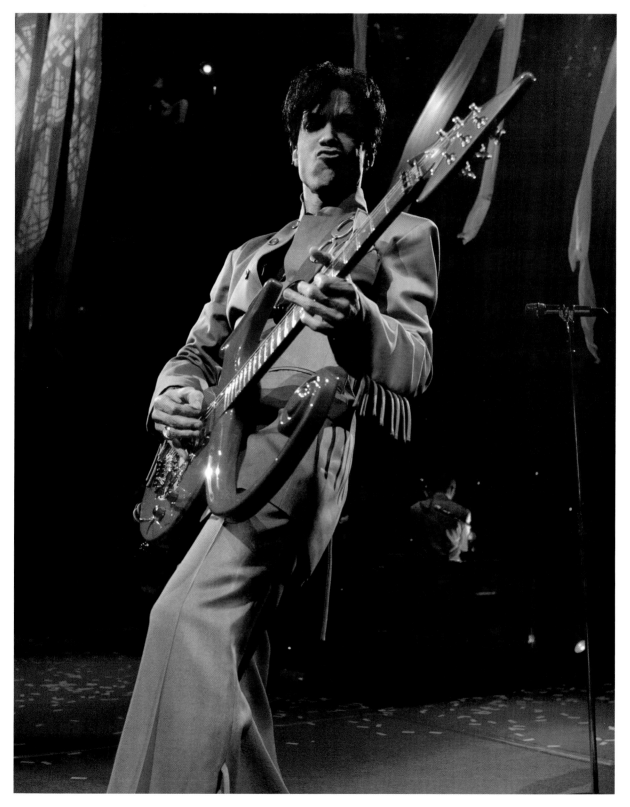

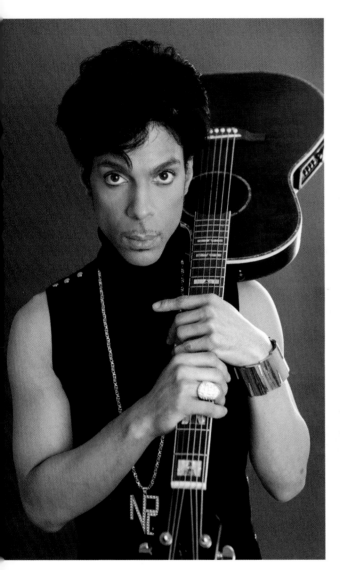 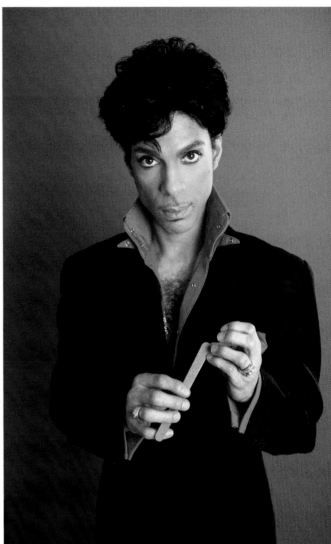

Summer 2004. Some lessons I learned the hard way. We were on a tight deadline for a magazine cover that I had been asked to shoot. I shot these images backstage at one of the venues in a room the size of a closet. I sent them directly to the magazine with instructions on color settings, etc., which I typically would have done when not rushed.

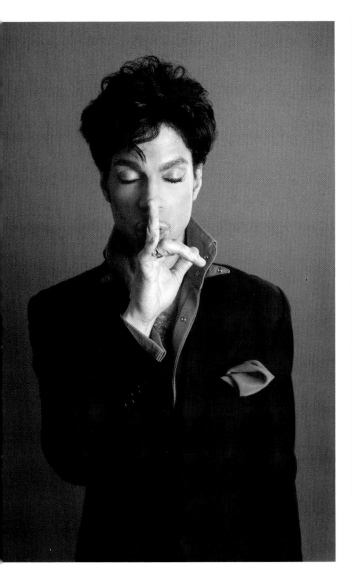
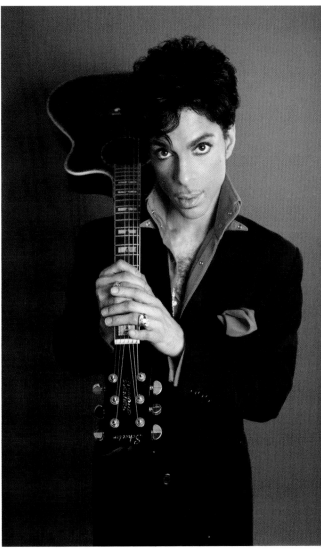

The cover came out a month later and I was sure I was going to lose my job. The picture was so blown out that the images didn't look like Prince. It was horrible and I was livid. Luckily Prince had seen the pictures before the magazine had gotten a hold of them and knew what they were supposed to look like. He asked if I had learned anything from it and smiled.

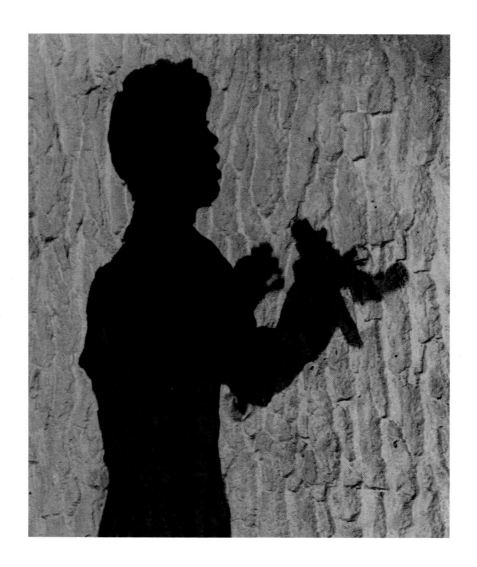

The most recognizable
shadow in the game.

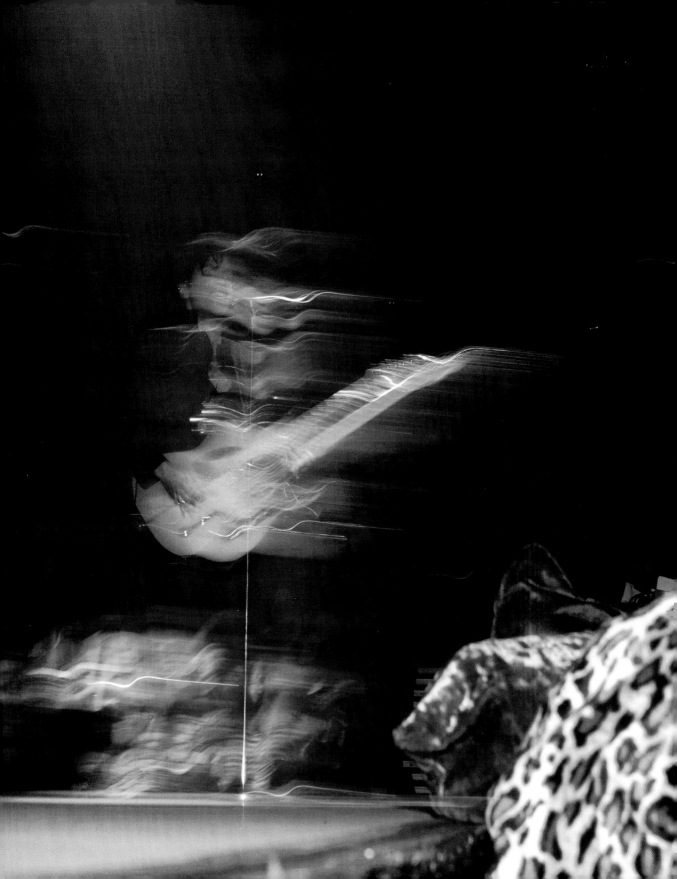

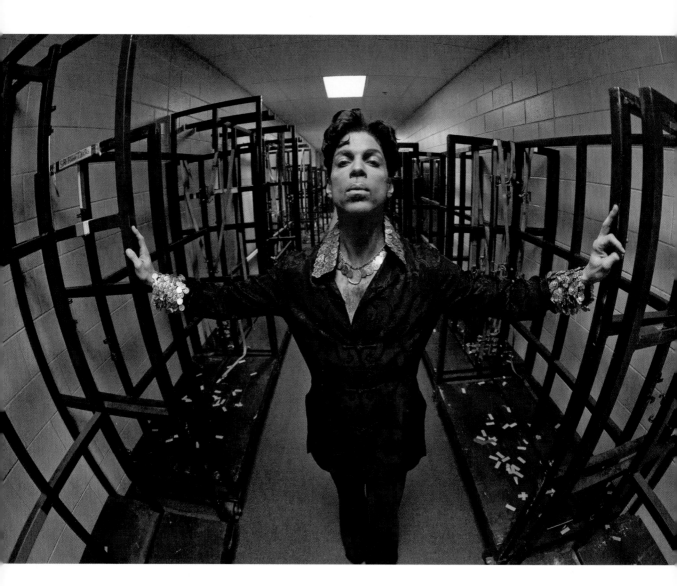

Backstage in Philadelphia. This shot was used to create the mural and cover for the album *Lotus Flower*. Sam Jennings did his magic.

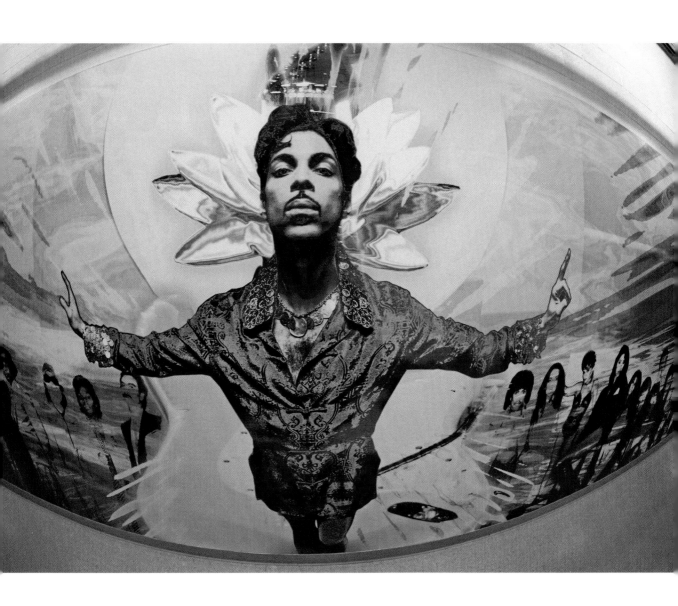

The Musicology tour was in the round, so Prince was pushed to the stage in this box so he would not be seen before the show started. It always threw me off a little seeing him get into a box, but he was always very good-natured about it.

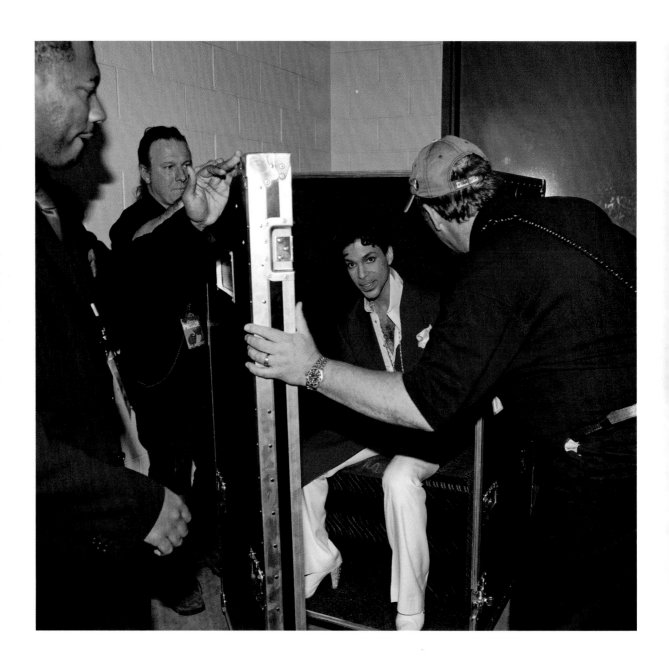

Prince checking out the sound at this open-air venue. He sat in every section to make sure the music sounded right everywhere. It was exhausting for him and the sound engineers but it made all the difference in the world for the fans.

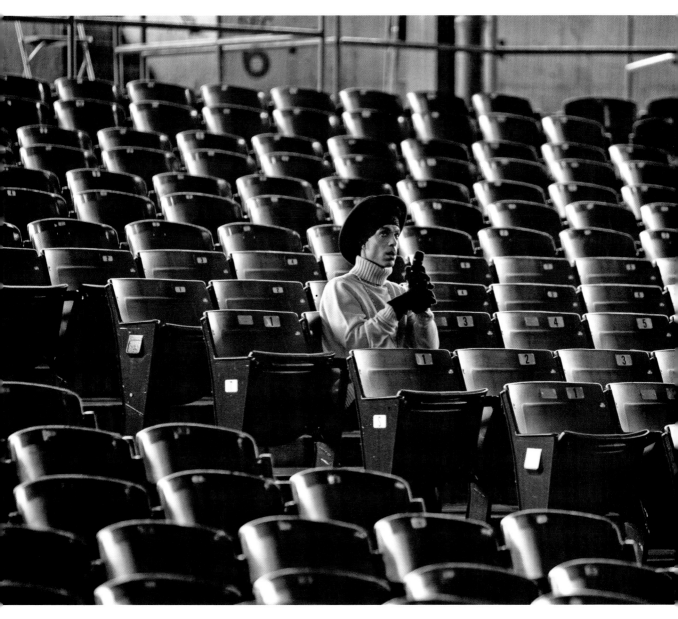

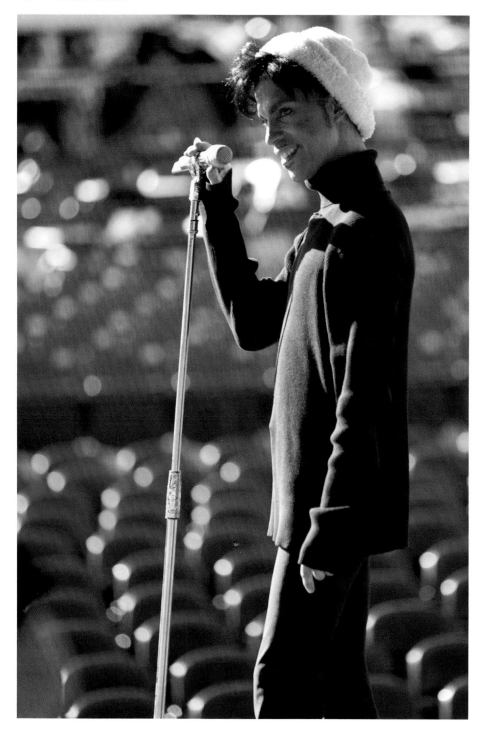

A happy moment in the sun during sound check in Salt Lake City.

Dream no. 4

I'm cooking; it must be a holiday as I have a lot of things going on in the kitchen. There is a roast, a chicken in the oven, some crab legs steaming. I'm sipping on wine and having a great time. My phone rings and the voice on the other end says, "Prince accepted your invitation and should be there in fifteen minutes." My invitation? I'm only having some relatives over. I start feeling guilty about not inviting him for dinner and panic as I haven't made any vegetarian dishes—just some sides, but I can't just offer him corn and salad. Not a minute after the phone call, my doorbell rings and it's Prince at the door. I'm in shorts and a T-shirt, the furthest from being ready for guests yet. I answer the door and let Prince in. He is happy and full of energy and follows me around wherever I go, offering to help. I ask him to chop some onions, which he does, tears streaming down his face. Then the house is all of a sudden full with my family and I'm nervous about how they may treat Prince, but everyone is getting along and Prince is even playing hide-and-seek with the younger kids. We all sit at the table and I look to him and apologize for not having any vegetarian options, and he just smiles. The doorbell rings again, and when I answer there is a waiter outside with a plate full of food and past him I see a semi truck with a garden on the flatbed and a catering truck next to it with people working feverishly. I sit back and relax, knowing he's taken care of what he needs.

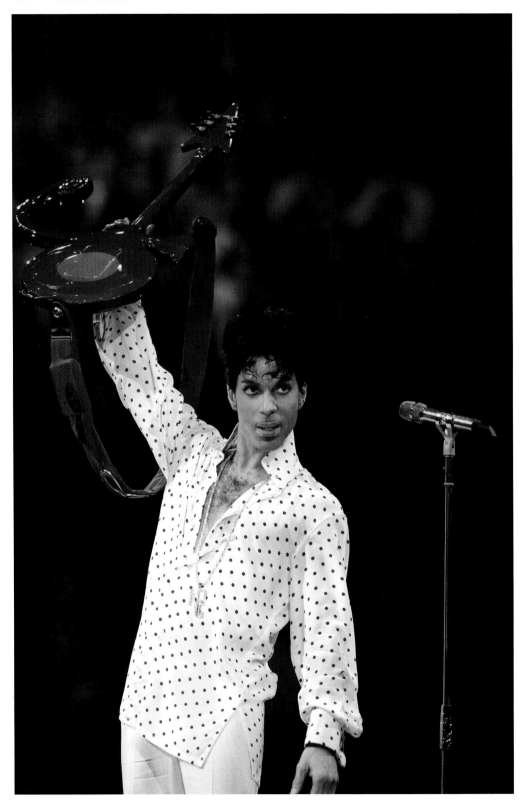

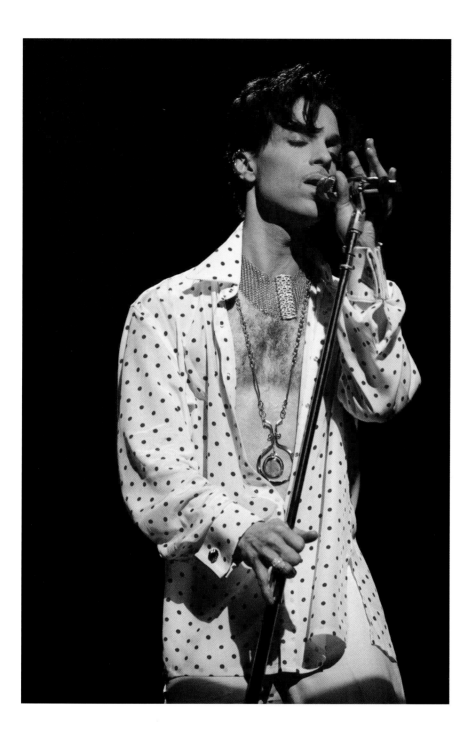

We were backstage at Madison Square Garden where the hallways are lined with photos of past performers. They had an old photo of Prince and when he saw it he wasn't too happy. He had them print this shot (above) and replace the old one with it while we were there.

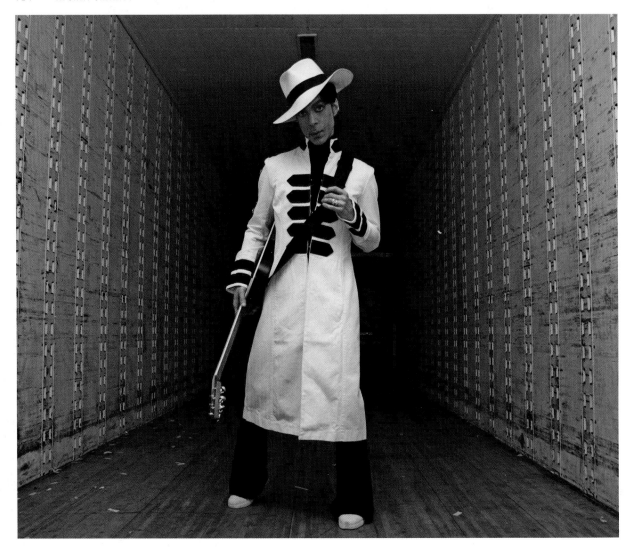

Somewhere, 2004. Whenever we would get to a new venue, I would look around for a cool backdrop to photograph Prince in front of. This place stumped me: For the life of me, I couldn't find anything. As I was standing by the loading dock contemplating my next move, Prince stepped out and said "What do you got?" In a moment somewhere between desperation and inspiration, I pointed to the empty trailer that earlier had contained some of the sound equipment for the Musicology tour. I showed him one quick test shot that he loved and we shot a handful of pictures before he had to run off to the sound check.

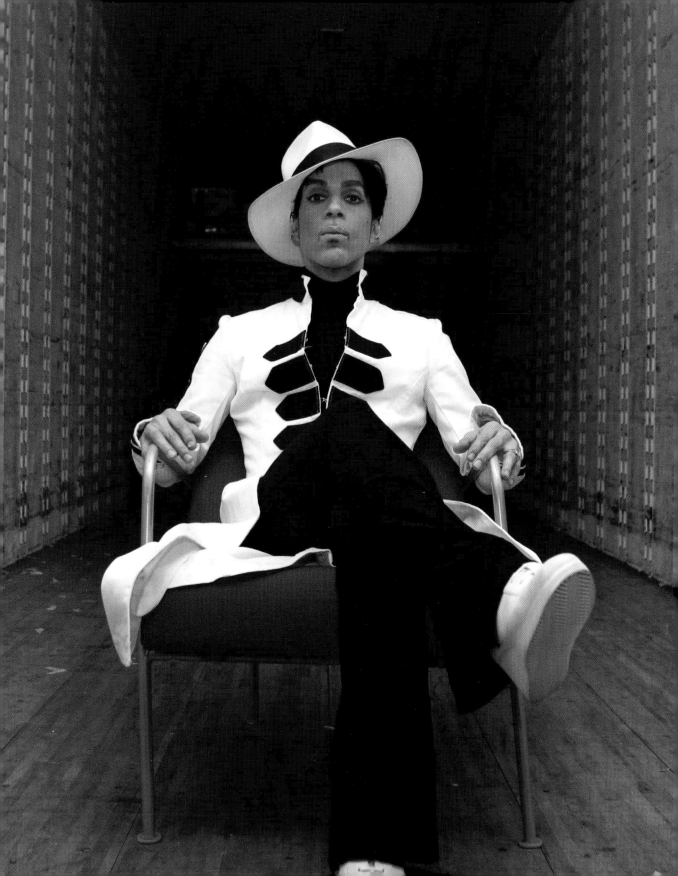

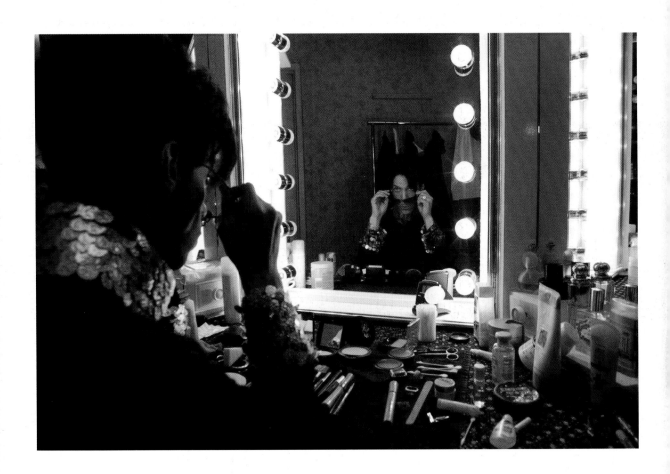

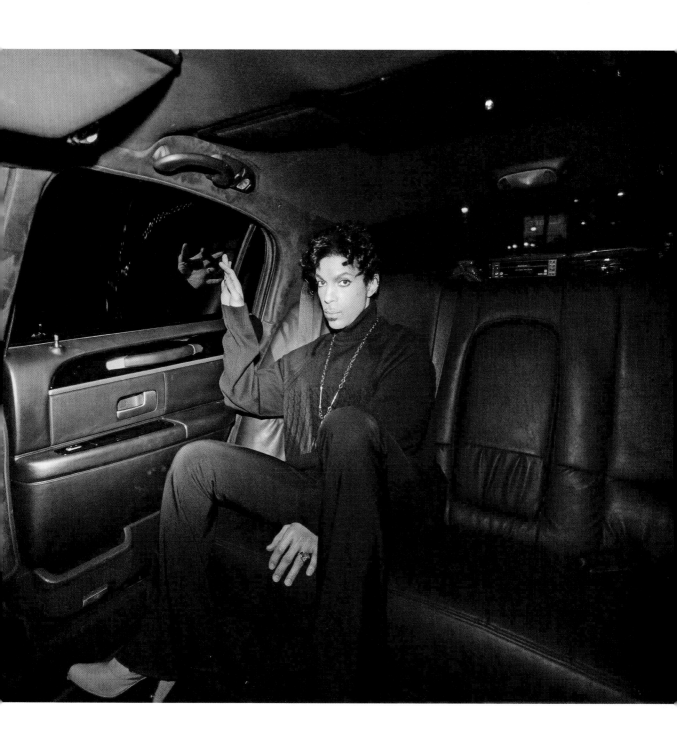

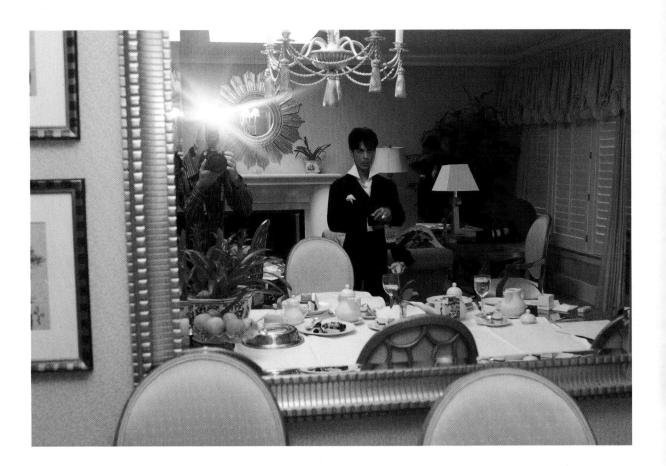

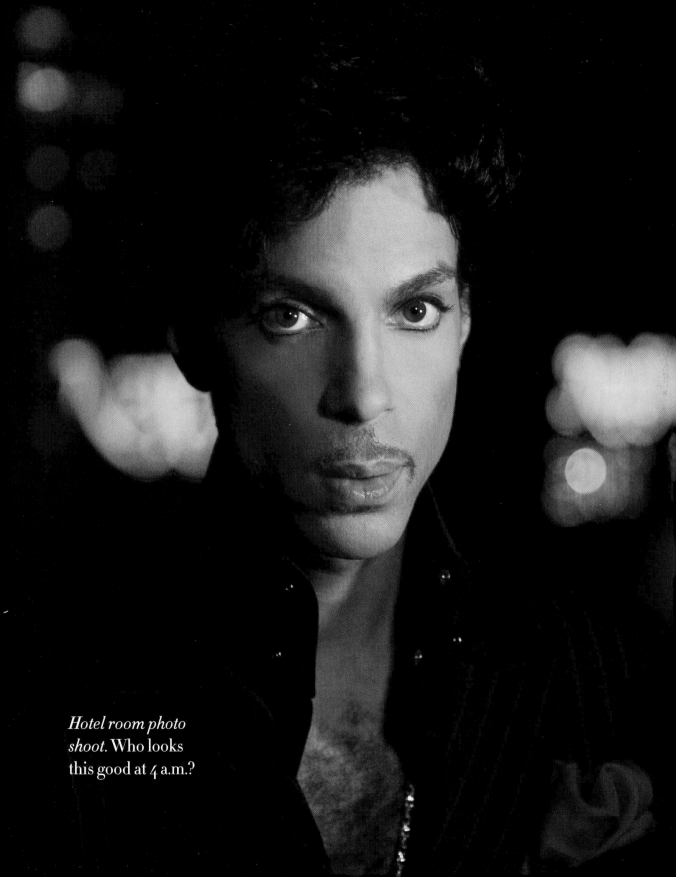

Hotel room photo shoot. Who looks this good at 4 a.m.?

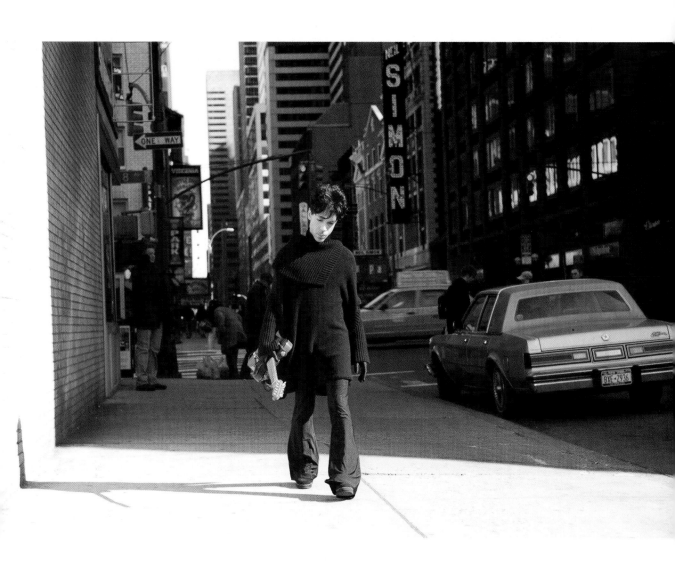

Rock and Roll Hall of Fame rehearsals.

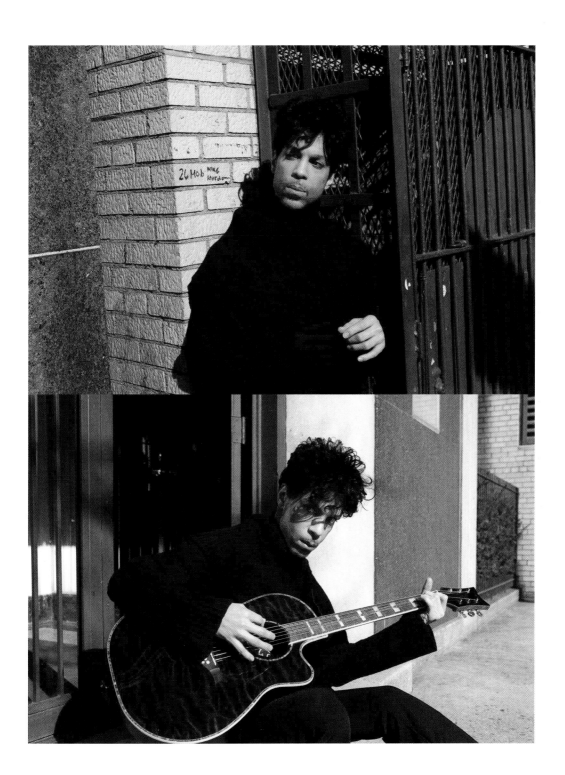

This picture reminds me of April 2005.
Prince contacted me to see if I could
come to Paisley Park in a couple of days
to discuss something. I gladly obliged; it
was a good chance to see my family and
Minnesota in the spring. Unless there were
major events happening at Paisley Park,
the main entrance was hardly ever used. I
never used it as I was usually showing up
with equipment for a shoot. I arrived at
10 a.m on the agreed-upon day and went
to the small side door at the end of the
hall where Studio A was. I rang the bell
and waited for one of the sound engineers
or studio managers to open the door. No
one came, so I rang the bell again. This
time the door opened right after and it
was Prince standing there in a do-rag,
slippers, and a robe. He asked why I was
so impatient. All I could do was smile. The
thought of Prince ever answering the back
door to Paisley Park had never crossed my
mind, and yet here we were. It was clear
he had just woken up as the light of the
day seemed to be bothering his eyes, but
he still picked up on the fact that I was
amused. "What's so funny?" he wanted to
know. I told him that I never imagined that
he would be the one opening the door to
let me in, that I thought it was cool and I
appreciated it. He laughed and said, "Don't
get used to it, there's no one else here."
However, after that he always seemed to
be the one opening the door for me, even
when his staff was around. I would smile
every time and he would remind me not
to get used to it every time. Somehow he is
still opening doors for us.

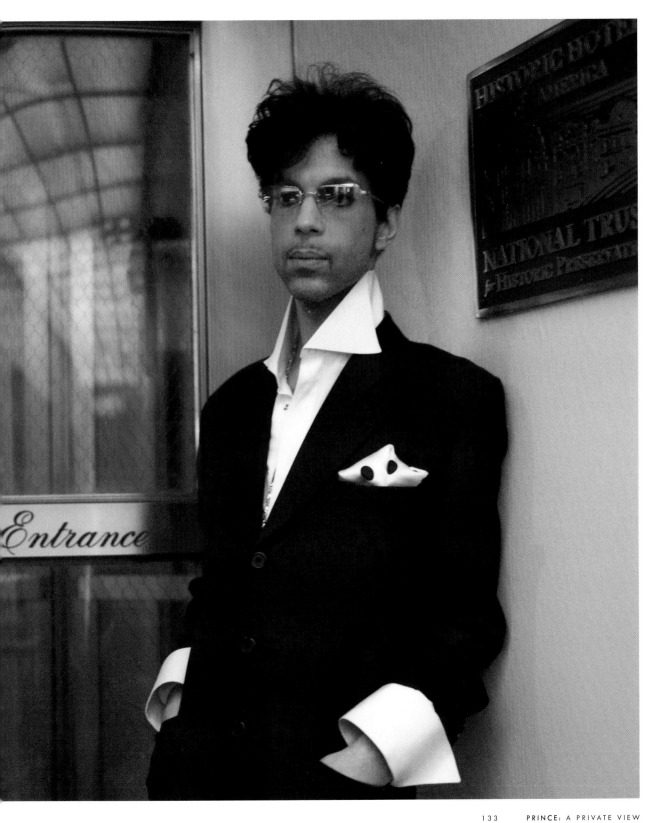

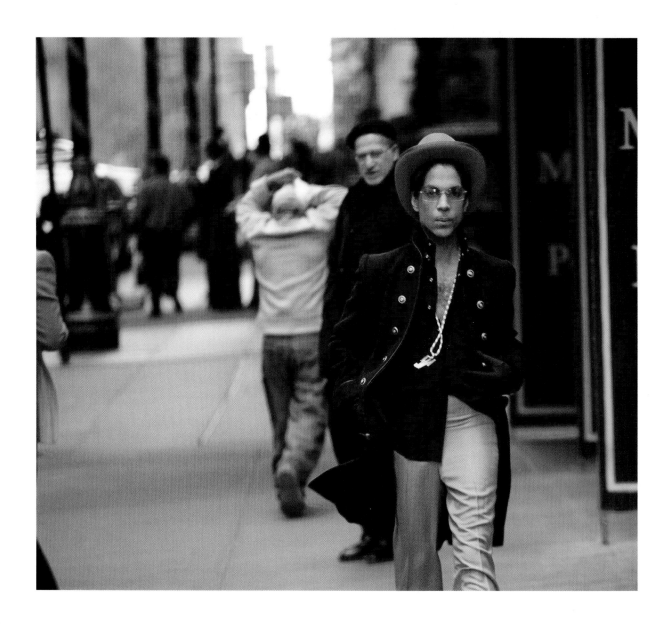

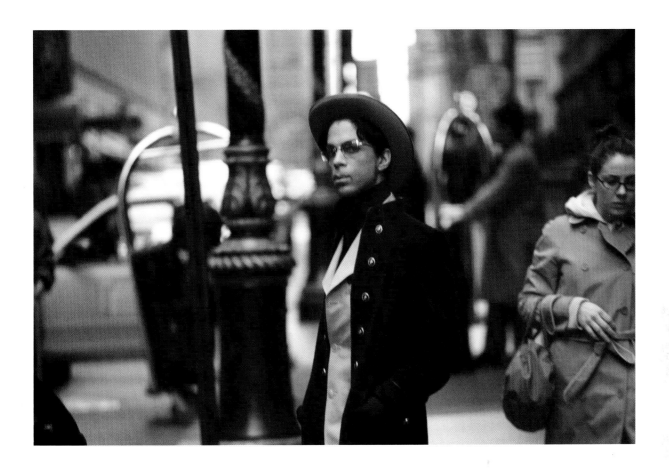

We were going to the Rock and Roll Hall of Fame induction ceremony
rehearsal at the Waldorf Hotel, just two blocks away from the Palace
Hotel where he was staying. It was a beautiful New York fall day and
I saw that Prince was getting in his limo. I ran over and asked if he
was willing to walk the two blocks to the Waldorf. To my surprise, he
agreed and off we went, no bodyguard in tow. I don't think people
were able to compute the fact that it was Prince walking by them; they
just felt someone special was nearby.

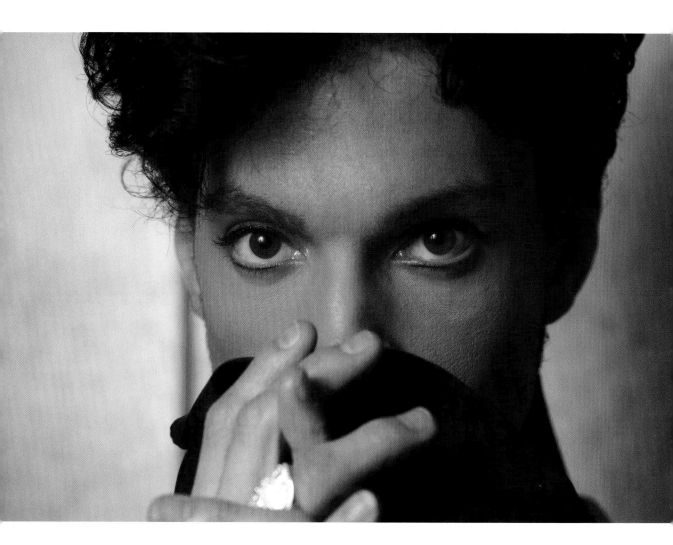

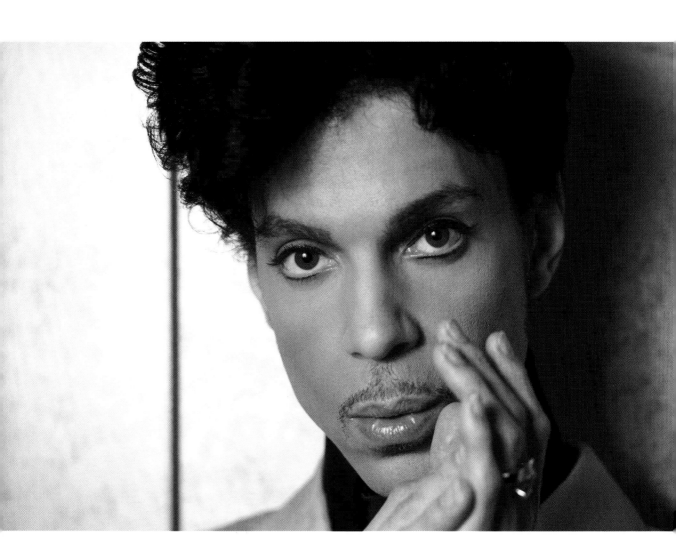

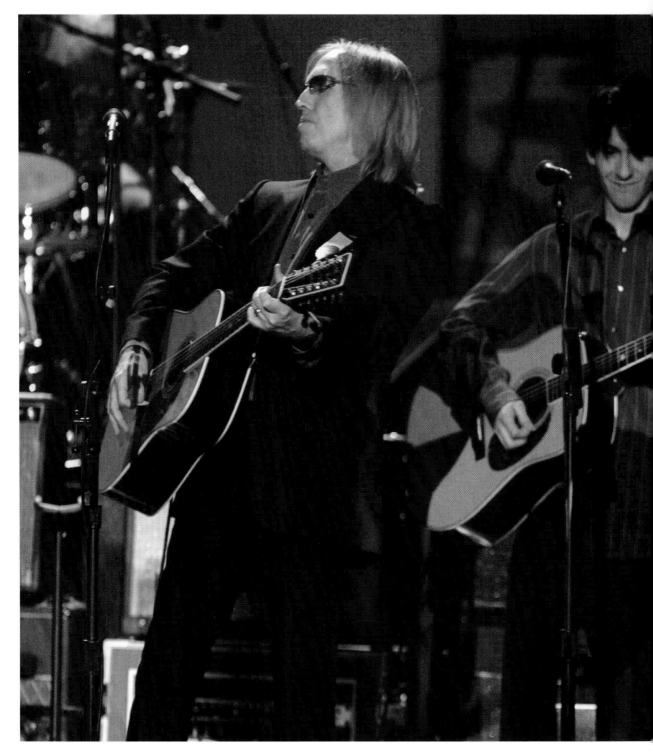

Rock and Roll induction ceremony. If you haven't seen his solo during
George Harrison's "While My Guitar Gently Weeps," please watch it.

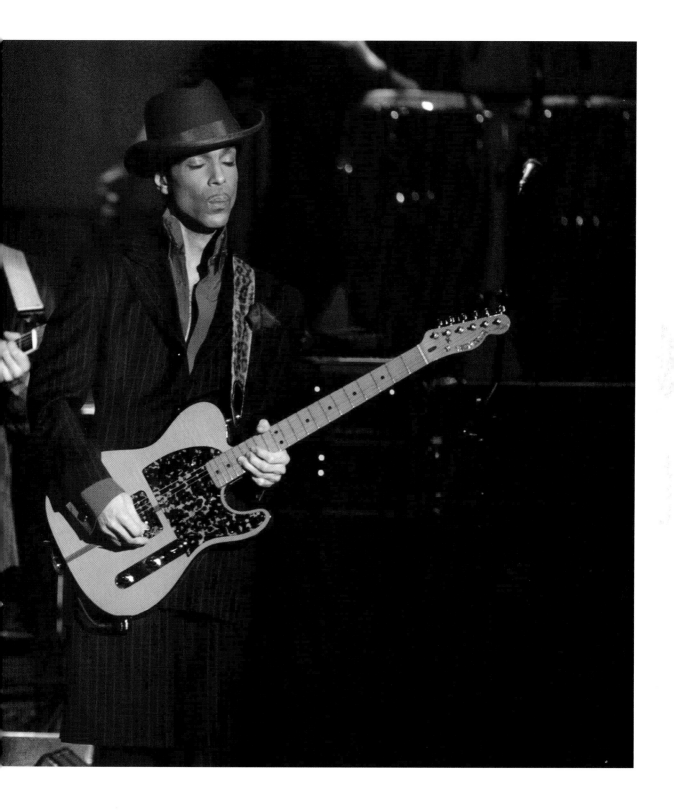

A quiet moment of reflection as Prince writes his speech for his induction into the Rock and Roll Hall of Fame.

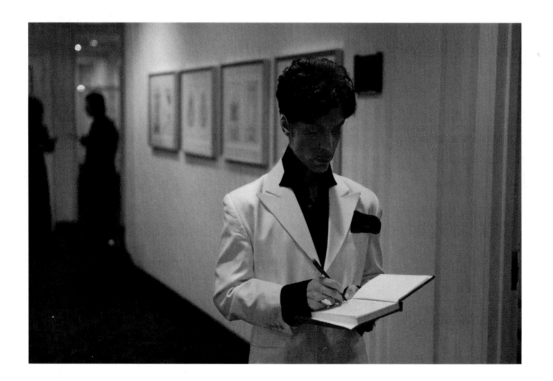

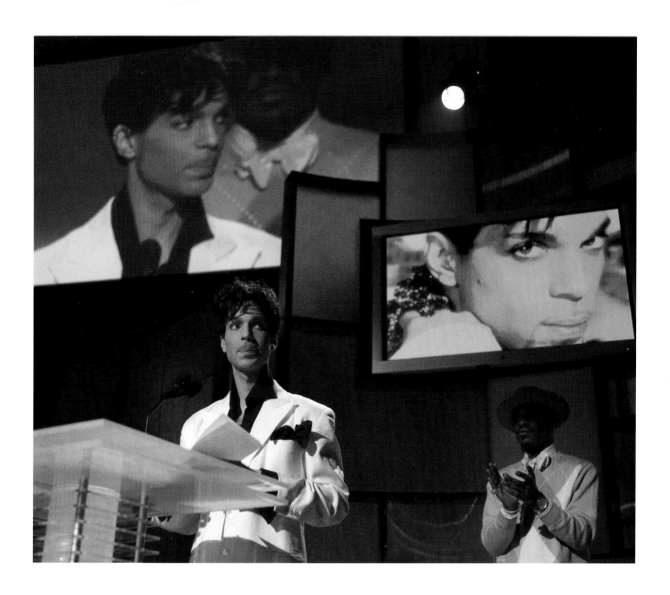

<p style="text-align:center">The fans were everything for him
and he was everything for them.</p>

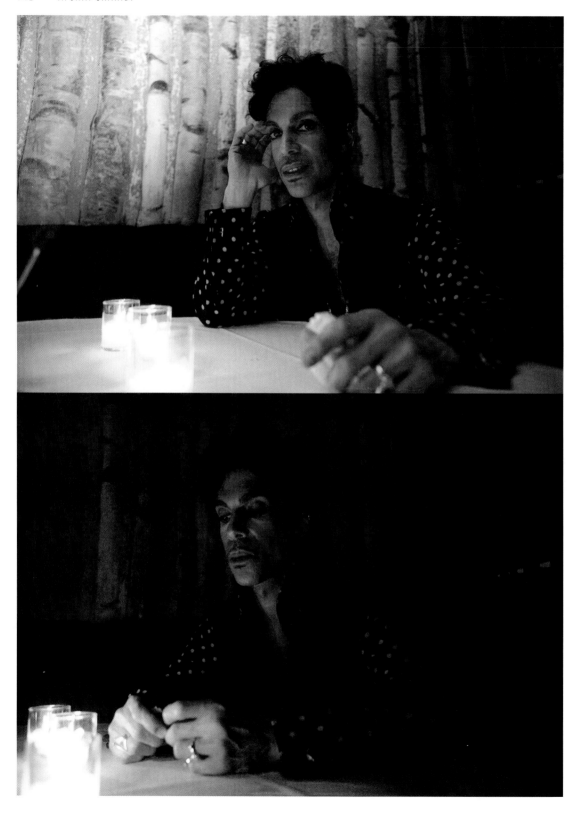

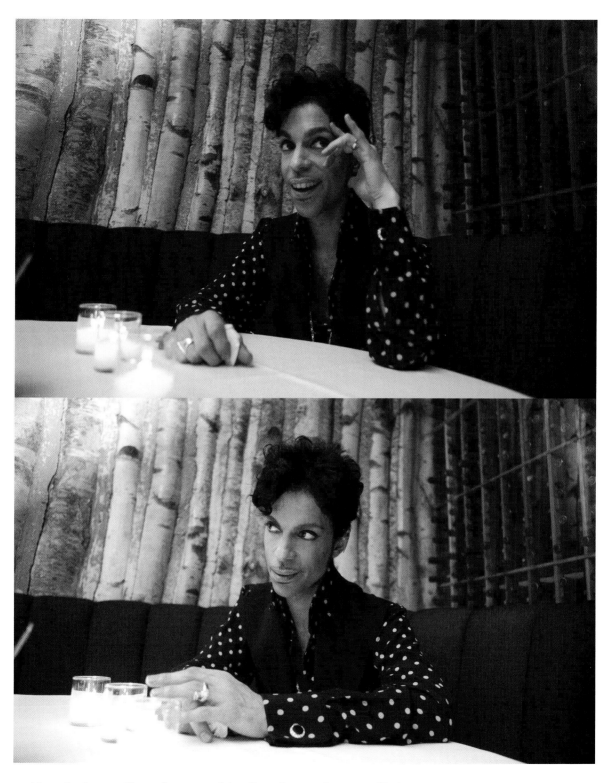

After afterhours, discussing everything from love to the constellations.

Dream no. 5

I'm driving down a long desert highway in my '65 Mustang Fastback that I had bought back in high school. There is nothing around except cacti and more desert. The wind blows through my hair; somehow I have hair again. My arm is stretched out of the window and my hand is a wing making waves as I cruise down the highway. The radio doesn't work so this is my only entertainment. I don't know where I'm going or how long it will take me to get there. There are no other cars on the road. In the distance I see heat waves like a shimmering sea, floating above the road and a dark object hovering above that. As I get closer, there is a person walking down the middle of the road, arm stretched out and thumb sticking out. I pull over, hoping a companion will break the monotony of the radioless drive. The person gets in the car dressed in what looks like a costume from the Road Warrior films. It's Prince. For some reason I'm not surprised to see him and he's not surprised to see me. Almost like we had planned it except we hadn't. He explains he was at a party that got dangerous so he decided to hitch it home. I'm good with that explanation and we drive on. It's quiet again for a while, my arm back out of the window. He asks me if he can sing, to which I nod yes, and he proceeds to sing "Controversy," one of my favorite songs. After he's done he says it's my turn, and I reluctantly sing "1999." He seems impressed but when I'm done he tells me to stick to driving and he'll take care of the singing, which I'm totally cool with.

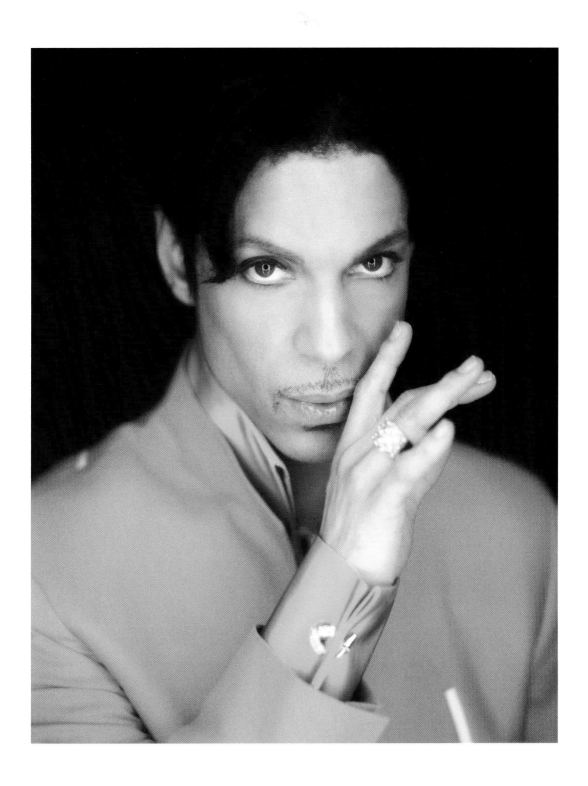

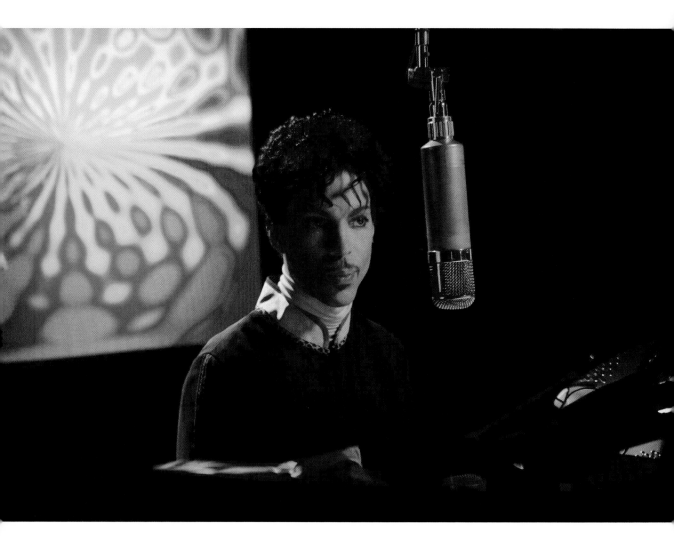

Set pictures from film shoots, most of which I was also the cinematographer on. It always astonished me how much he knew about lighting and film until I would remember that he had starred in a groundbreaking movie when I was only just in high school.

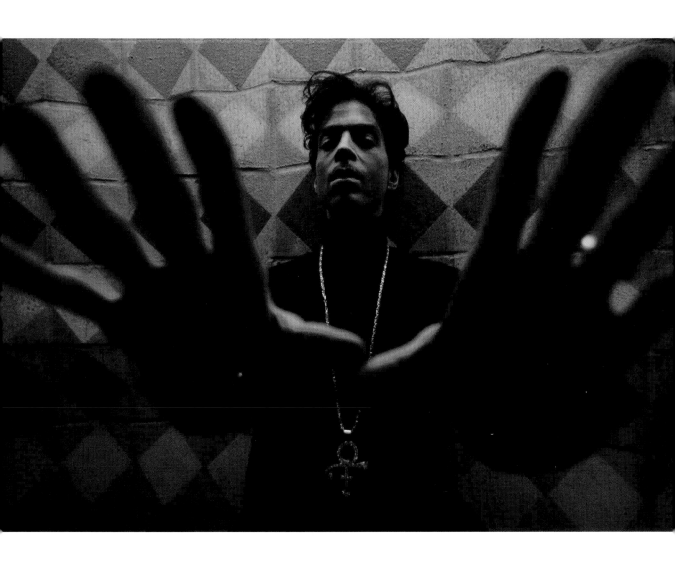

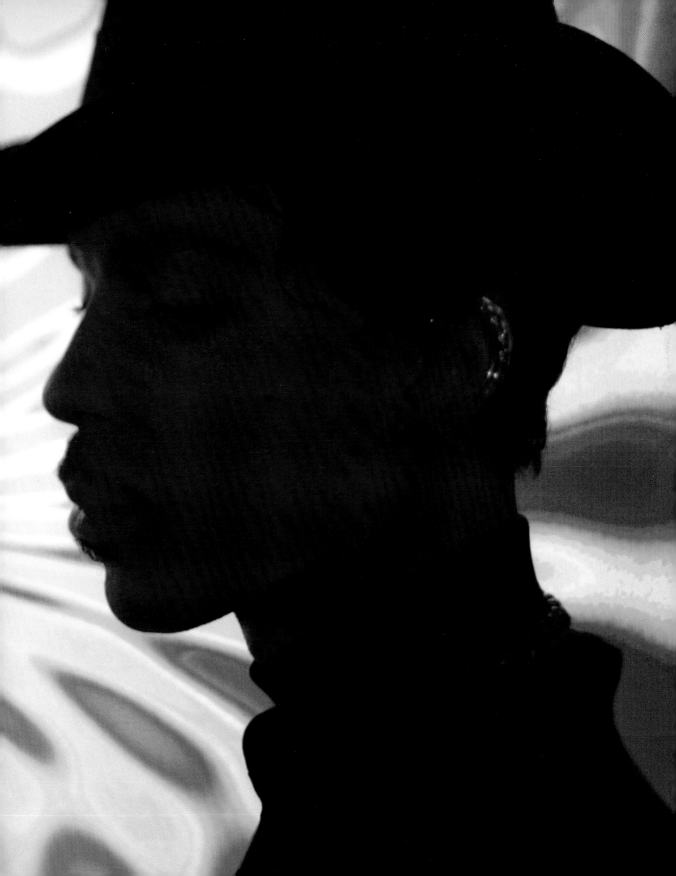

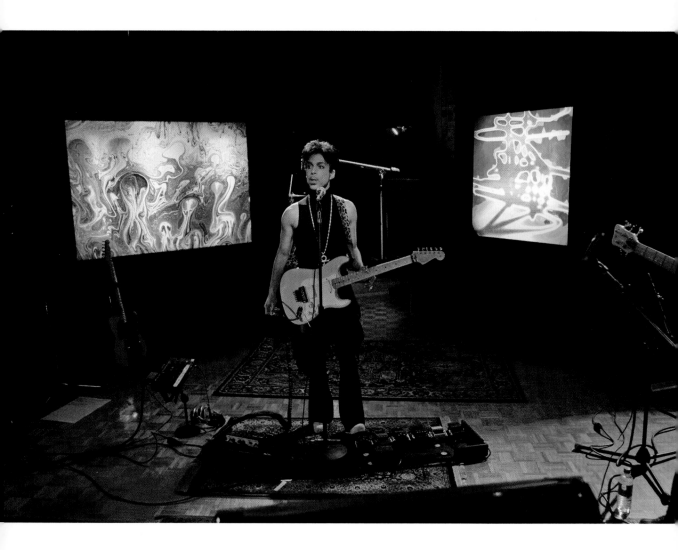

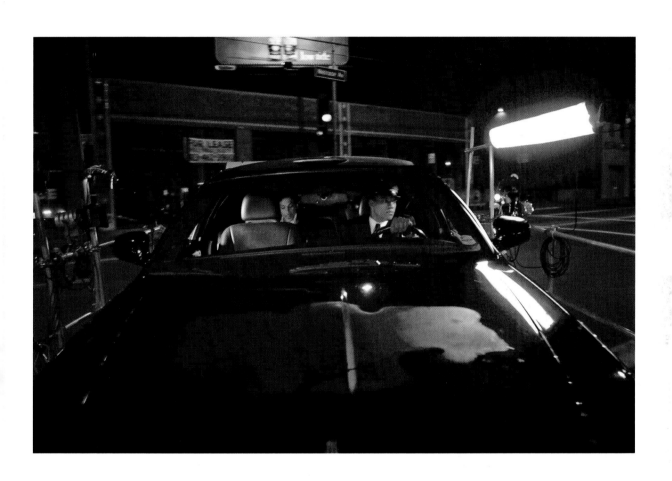

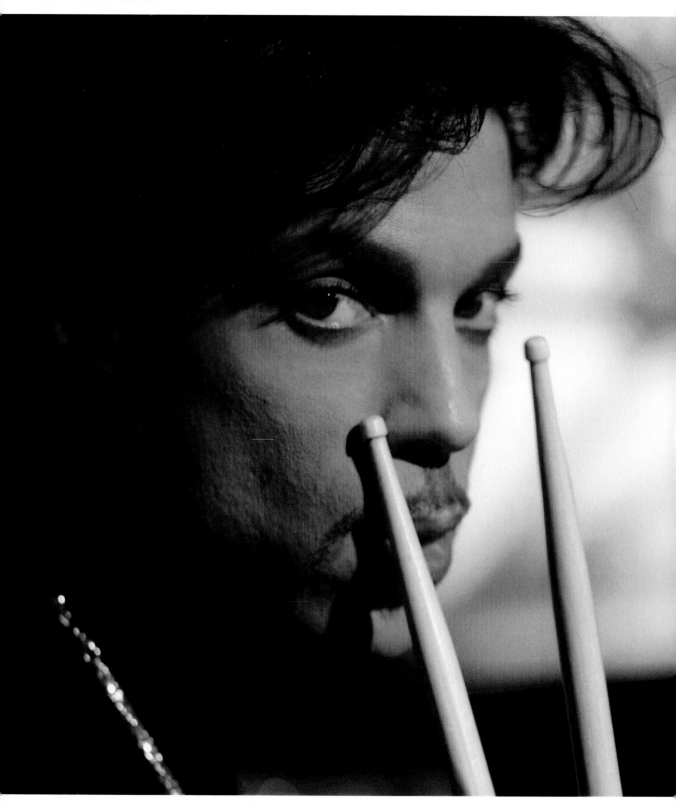

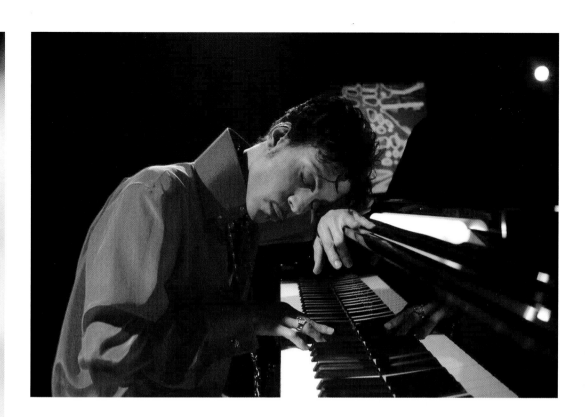

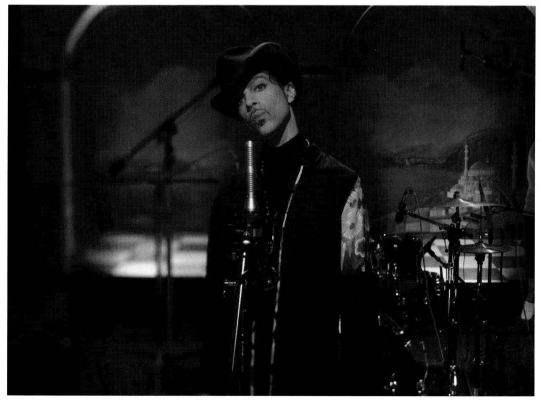

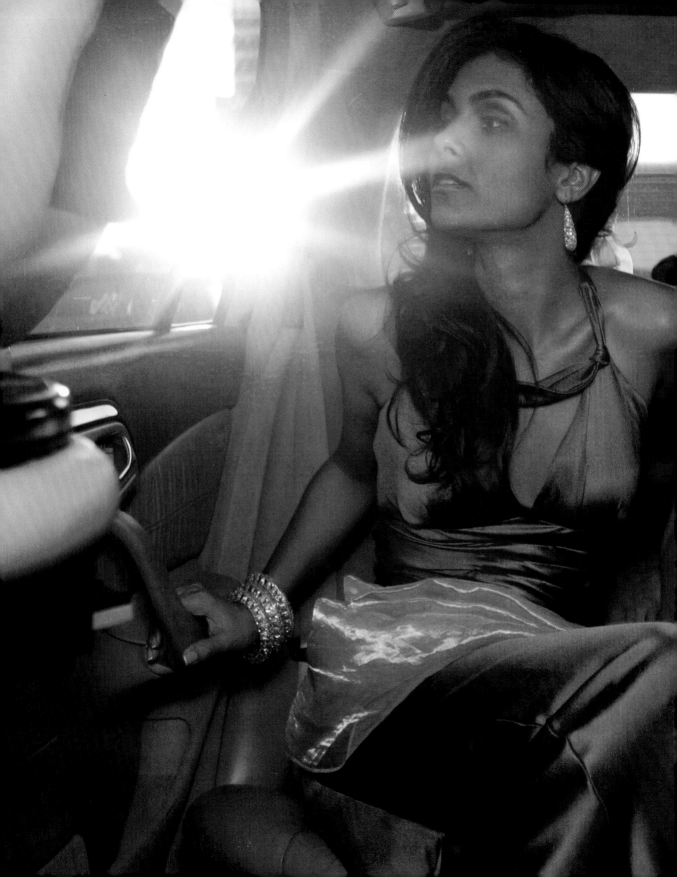

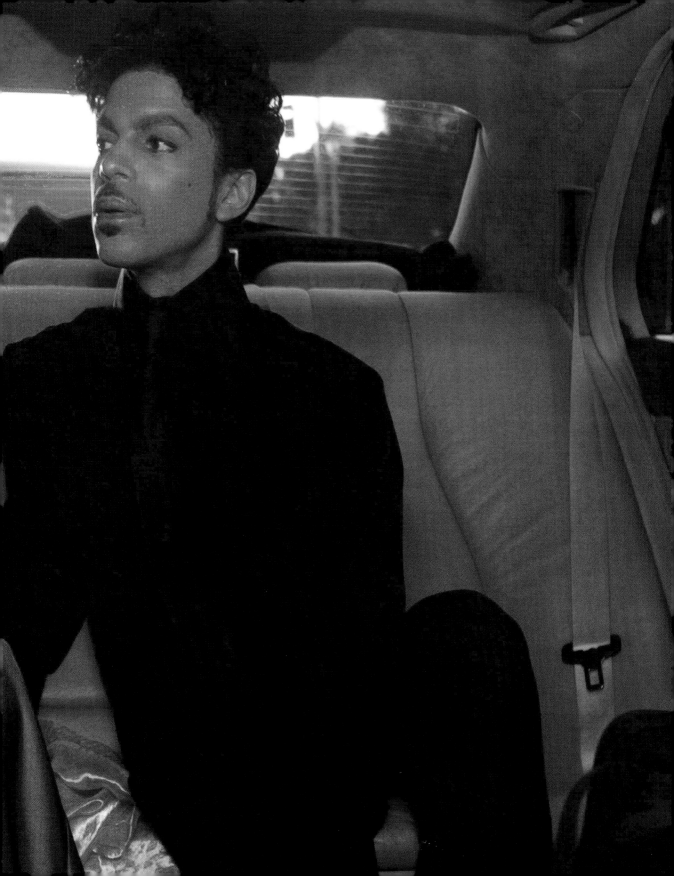

Dream no. 6

I'm sitting at a library table, books and papers spread in front of me as I frantically work to finish a report that I believe is already late. I'm taking collage classes, maybe going for my Master's degree. I don't know what the report is about but it's of the utmost importance that I finish it. As I sit there working away, Prince comes and sits across from me at the table and proceeds to talk to me loudly. I'm confused by his presence there and annoyed by his volume. I thought you were in Europe on a yacht, I ask him, and he confirms that he was but he got bored so he flew home with the band. I try to continue with my work but he pushes the books aside and tells me we're going to go shoot pool at Smokey's. I tell him Smokey's was shut down a long time ago in a police raid and he tells me he opened it back up and he wants to go there now because he has people waiting. I reluctantly go along knowing I won't get any work done with him at the library. We are inside Smokey's pool hall and it hasn't changed one iota since it got raided over a decade ago, except that Prince's symbol is embroidered into the felt of the pool tables. As the name suggests, there is a cloud of smoke hovering over every table. Prince wants to play for something. I suggest five dollars, to which he laughs and says the stakes need to be higher. He offers that if I win, he will write the report that I was working on and if he wins, I have to go in his place back to the private yacht in the Mediterranean. I try to explain that both are winning propositions for me, to which he laughs again. I tell him that I'm not sure if I should try to win or lose, to which he replies "You got to always play your best game."

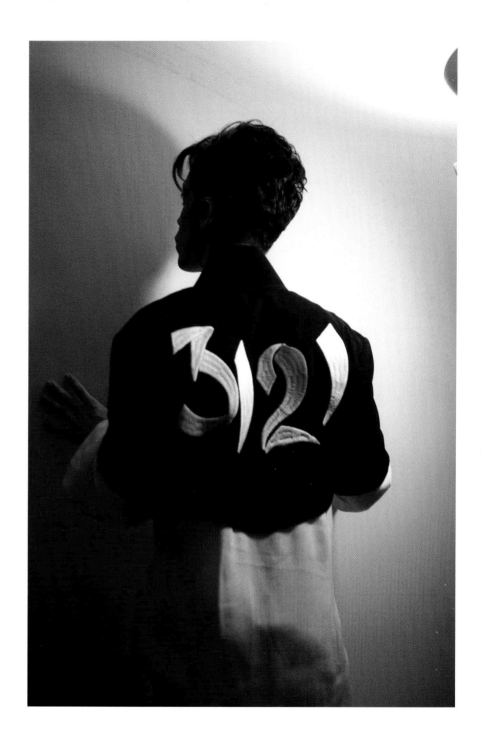

Backstage before an awards show. Hmm, why don't we shoot an album cover using the wall and the lamp in the corner.

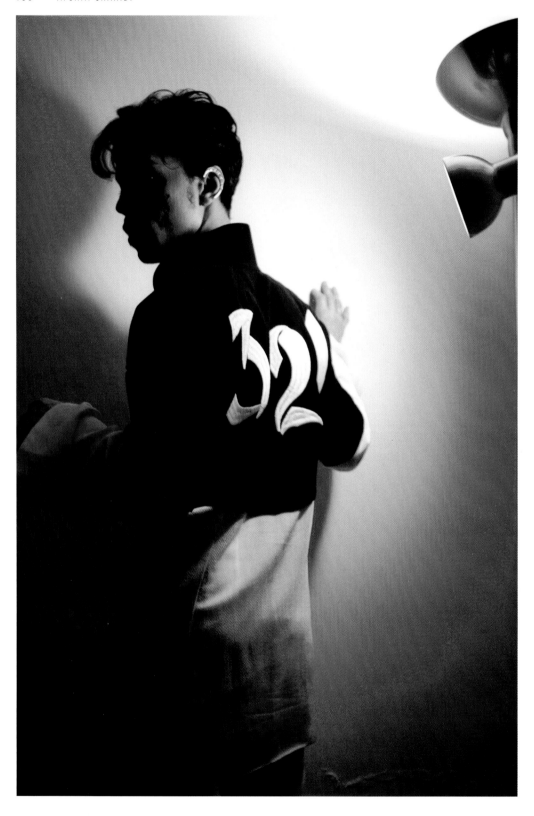

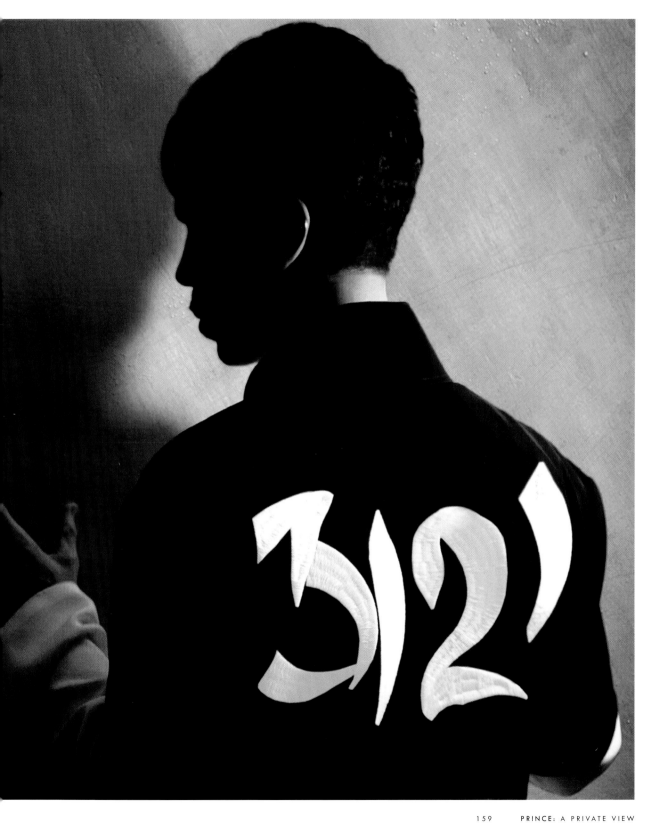

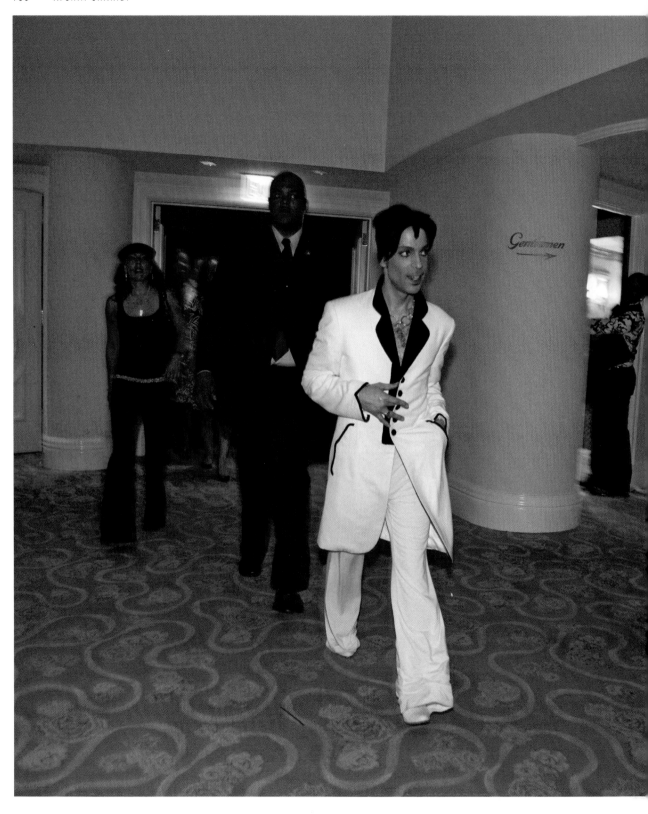

Prince walks into a room. This is not the lead line of a joke. Prince walks into many rooms and to say it's a grand entrance would be like calling the "Mona Lisa" a sketch. It's not that he enters with fanfare, fireworks, or an entourage. He's not riding in on an ostrich or an elephant with dancers and lasers. He just enters a room and the energy shifts, worries and concerns evaporate, and a Gabriel García Márquez–esque trance folds over the room and all the possibilities of the world seem to present themselves, falling at your feet. After all, you are occupying the same space as Prince, the molecules and atoms bouncing between your bodies. I've watched Prince enter many a room and it's always the same. You could be the guy working the bar or the CEO of a Fortune 500 company, an actor with billions in box office sales, a fashion icon guiding next seasons trends, or a fan who is lucky enough to be there: The moment Prince enters the room you are all the same, mouths slightly agape, eyes tracking the movements of the dynamo who just appeared, trying not to be caught staring but eyes drawn like magnets to his every movement. It's not his intention to hypnotize those present when he enters, it's just that he enters with such confidence, swag, and freedom that it can't be helped. He walks in and his entourage is his music, his hits, his movies, his dancing, his girlfriends, his controversies, and eccentricities. And then he walks up to you and say's "Hi, I'm Prince," and the tension is broken.

*A*nother call, another adventure. Not sure why Prince was averse to giving me more than a moment's notice but I didn't mind. I was about to step into a movie with my wife when my phone rang. Trevor, Prince's bodyguard, was on the other end. "Hey, Prince has a quick question." Prince gets on the phone, "Afshin?" "Hi, Prince." "Can you meet me in Morocco tomorrow?" I loved how ordinary that sounded to him, like he was calling to see if I wanted to meet for coffee. I also loved that my wife and family were used to these calls and everything was very matter of fact. I said sure and he said "Cool. Trevor will send you a ticket." And just like that I was headed to Marrakech the next morning to photograph Prince in Morocco during the filming of his video for "Te Amo Corazon" that Salma Hayek directed.

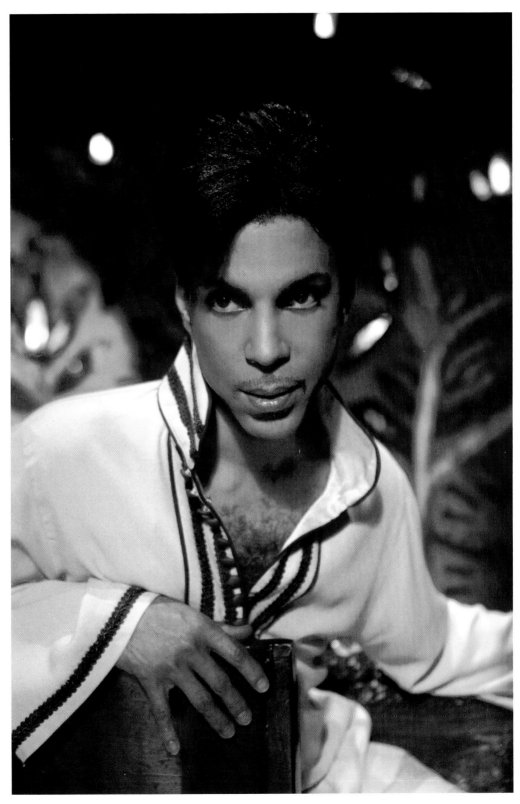

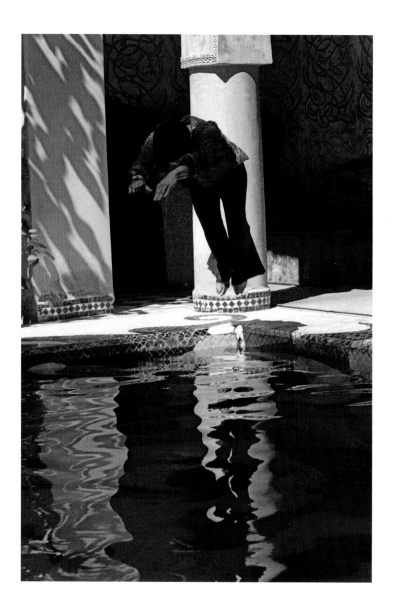

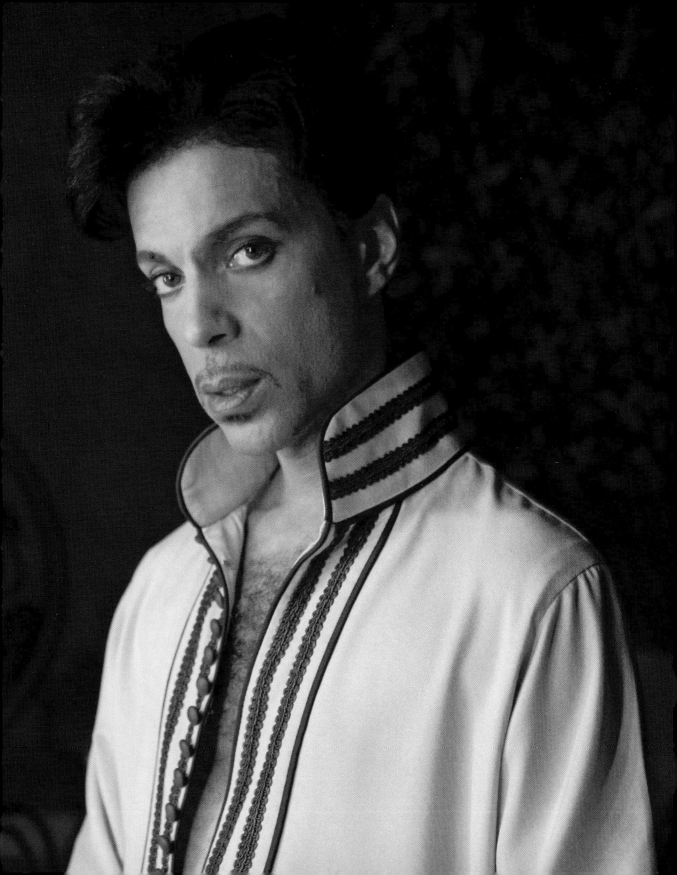

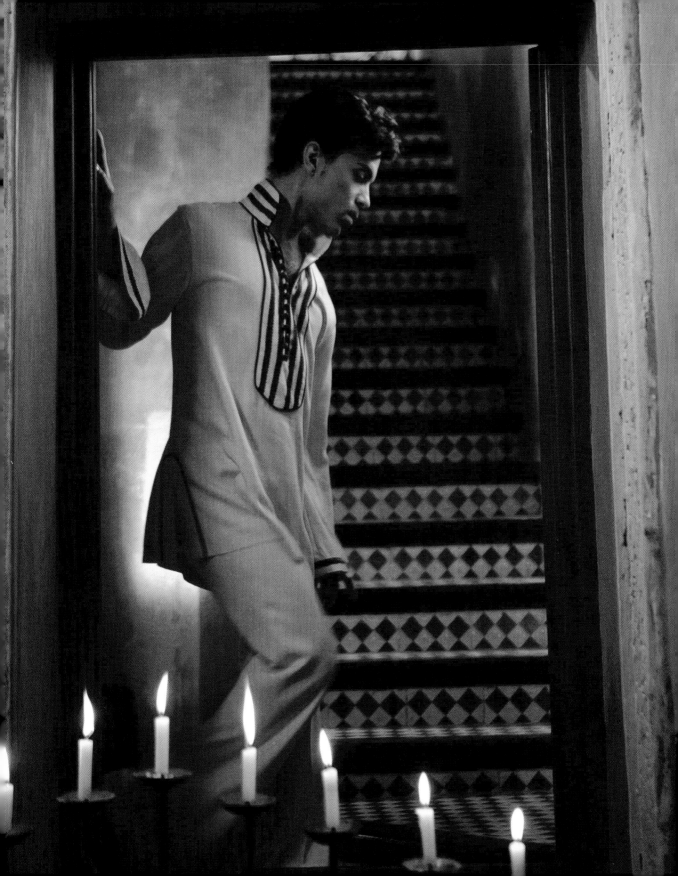

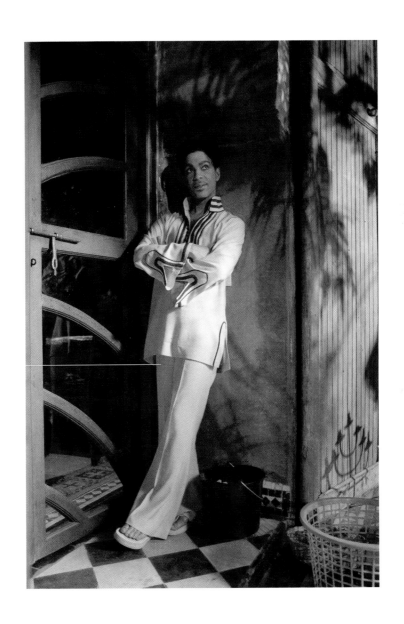

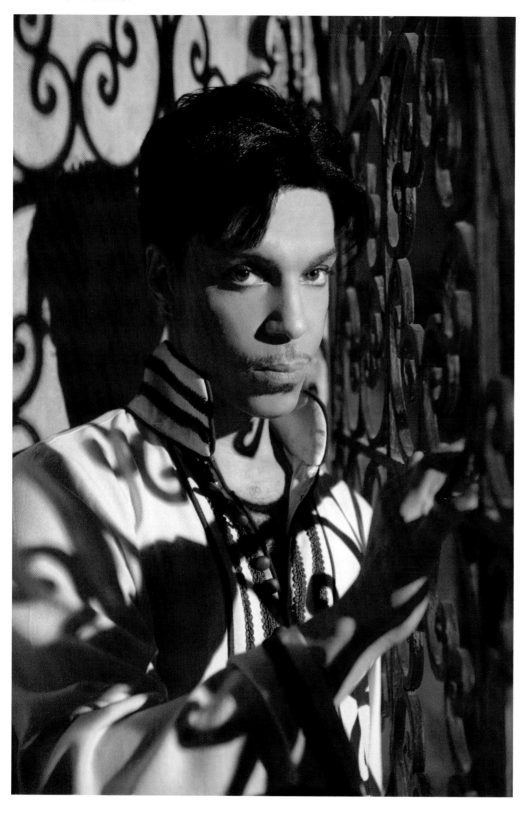

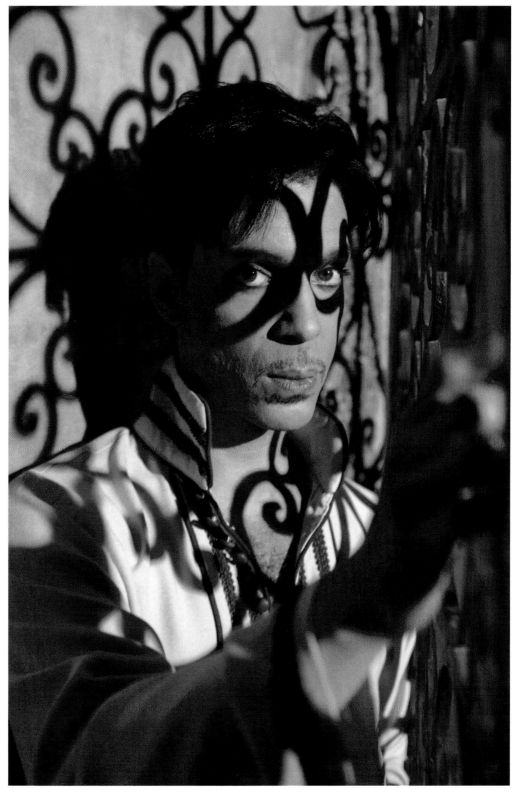

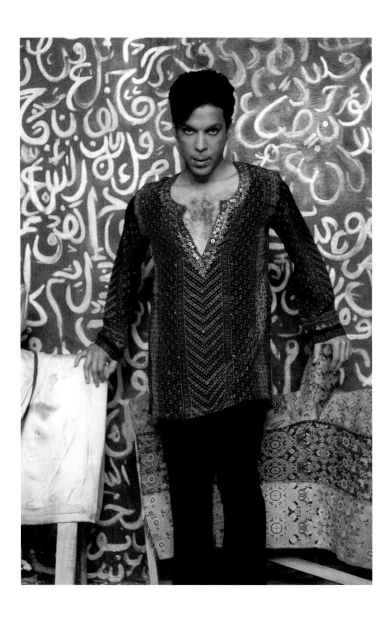

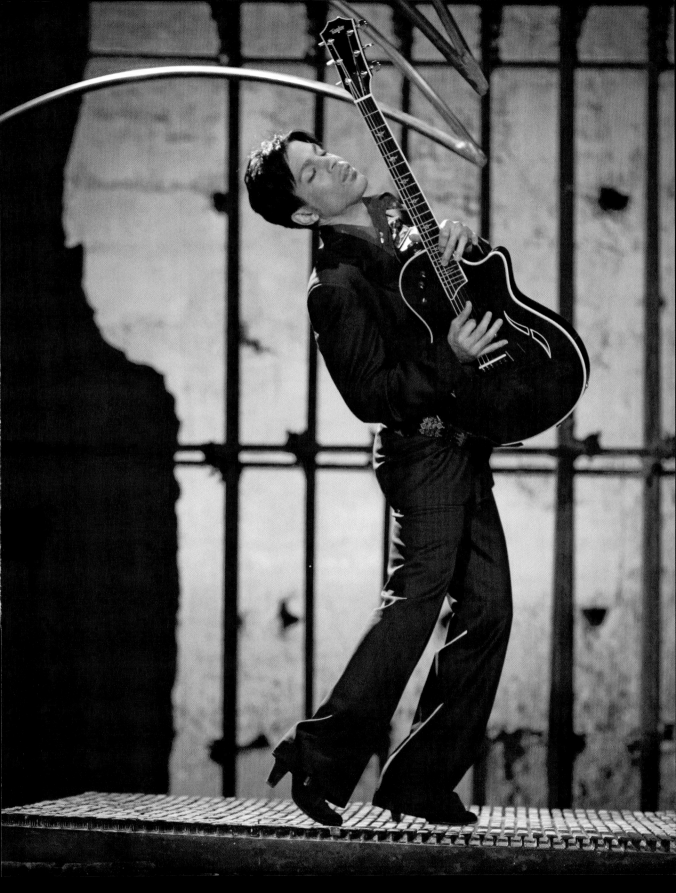

Prince didn't want to shoot with the
SNL photographer for some reason so
he asked me to give them this picture
to use for their on-air promos.

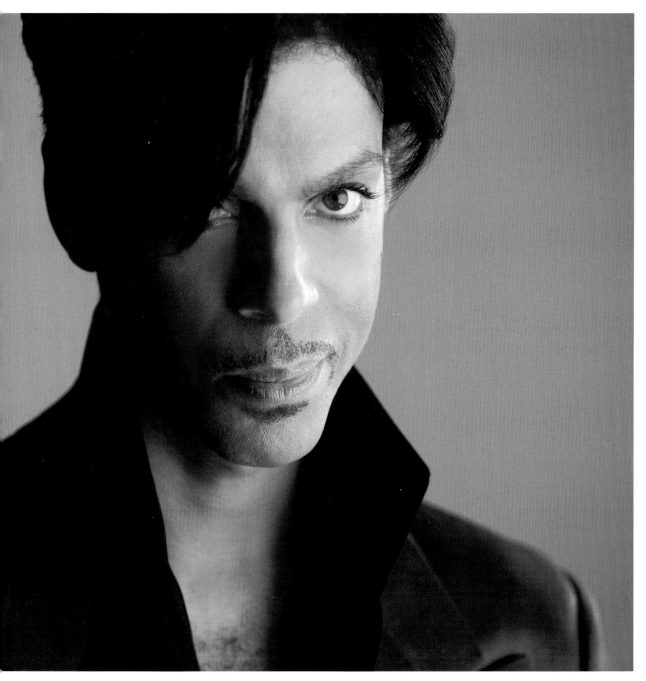

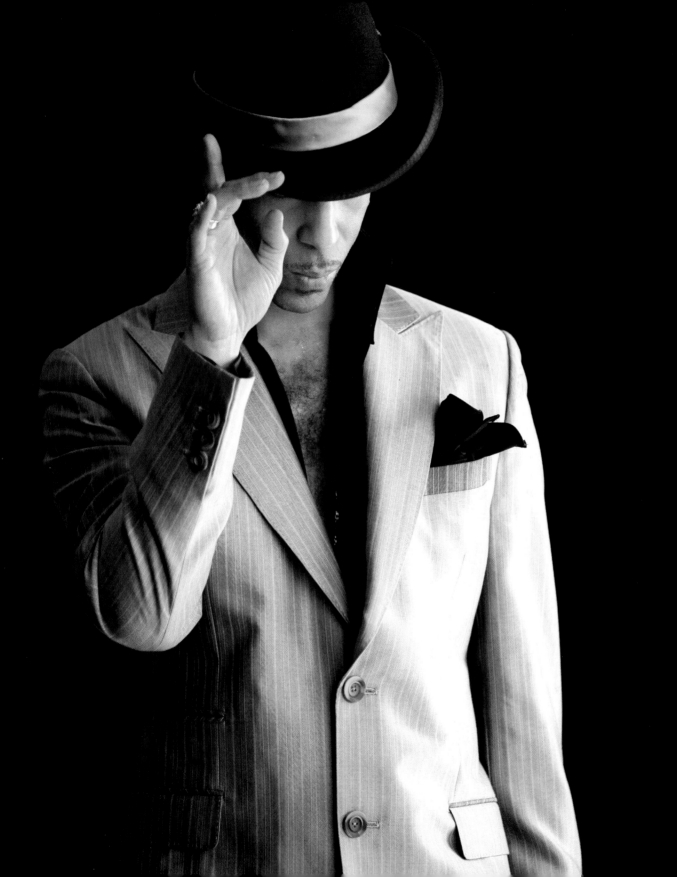

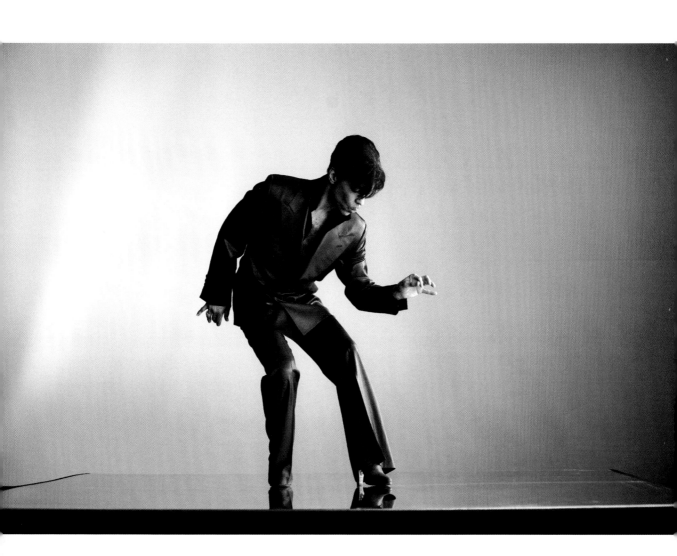

Set shots from the "Black Sweat" music video shoot, which was shot in his home in Beverly Hills.

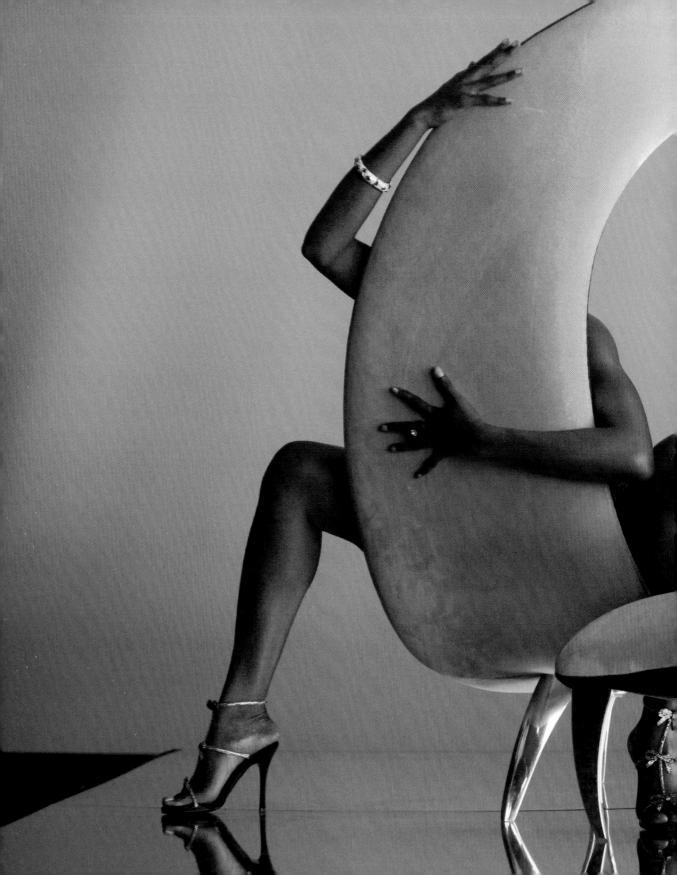

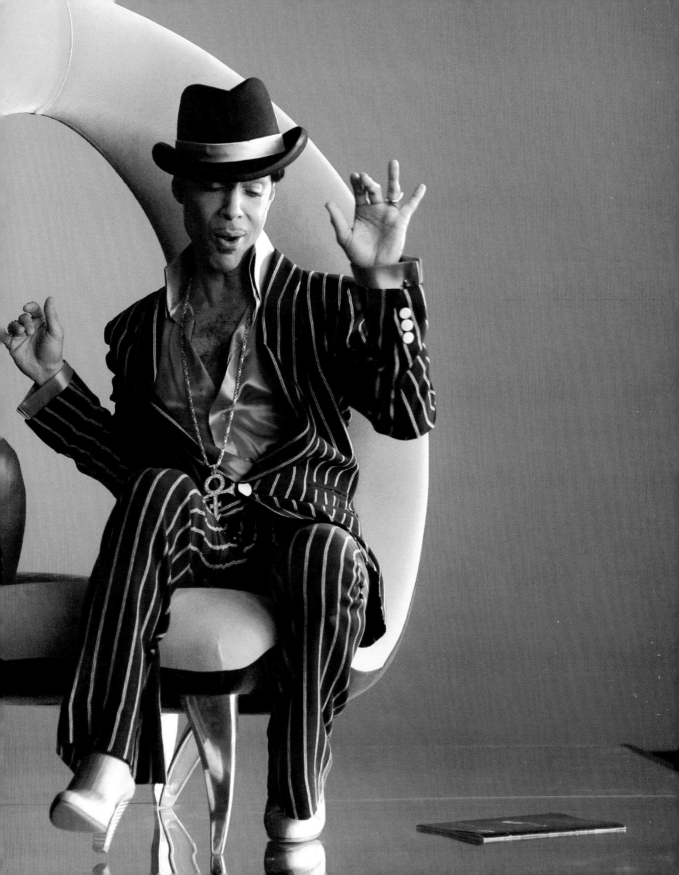

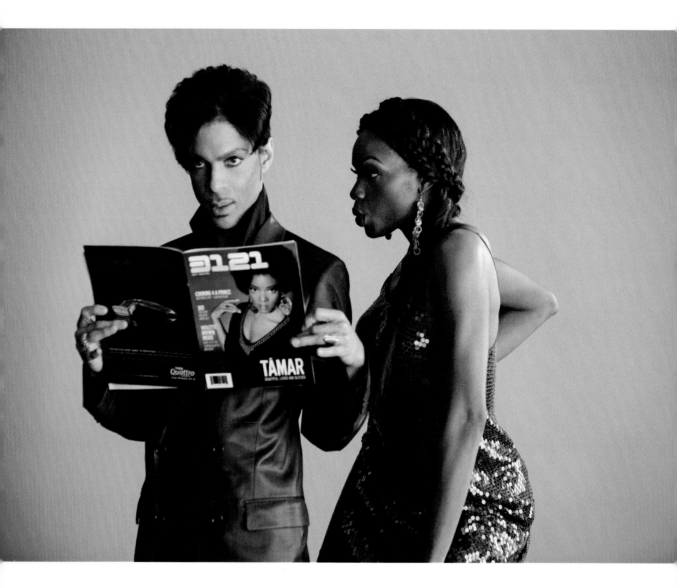

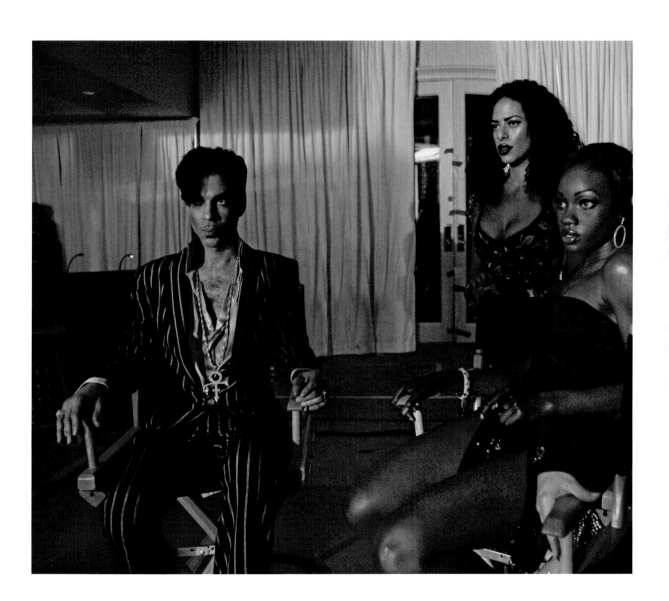

The eyes of a man who has seen and gone through so much, but still has so much to give. This image resonated with Prince; he seemed to really like it. I believe this is how he saw himself, and how others saw him later in his career—as a mature artist.

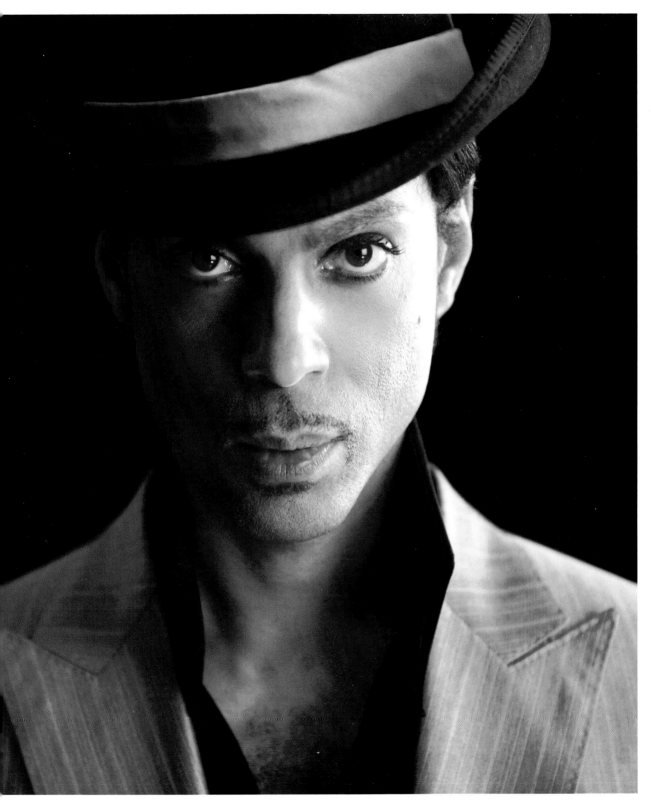

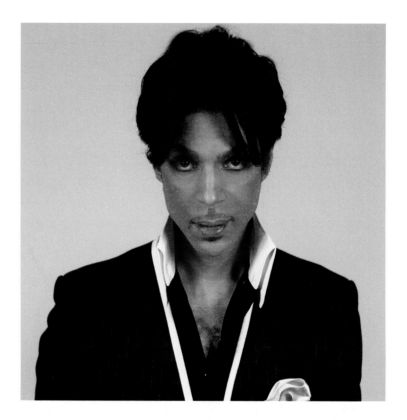

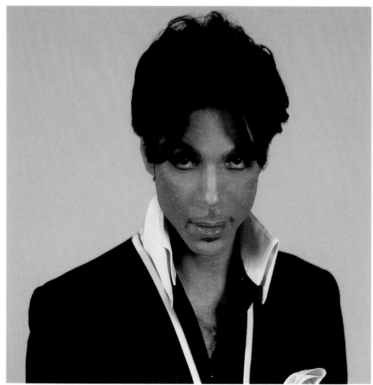

April 6, Los Angeles, California. Prince calls and asks if I can come over to the studio where he is recording. I'm free and I head over there, bringing a camera, knowing from past experience that this could be just for a conversation or we're going to fill the pages of a magazine. I get there and he is finishing up a track; I sit in the studio taking it all in. It never gets old and the opportunity to be in that room is never lost on me. He's just laid down a blistering guitar solo; he motions to me through the glass to come into the large booth. He's a bit sweaty and pretty fired up. I'm wondering what he wants to discuss—perhaps a music video idea or other thoughts on how I could take over the wire photo services like AP or Getty. I'm expecting something heavy. He tells me that he needs a passport photo. *A passport photo?* I guess even Prince would need a passport photo. I offer to drive him to Kinko's!— half kidding, but half serous, as I always enjoying watching people's reactions when Prince shows up somewhere unexpected. He gives me a look like I don't have time for your jokes, so I agree to shoot it but let him know I need to look up what the specifications are for passport photos. He asks me to ride back to the house with him but I tell him I'll drive, having learned from the past when I've been stranded at his house without my car. I beat him there, go inside, and start looking up the specs for passport photos. They are to be a certain size, the eyes need to be a certain distance from the top of the image, look directly into camera, no smiles, etc. I take it in and find a place to set up with a white background. Prince has come in already and gone to shower and change. I'm set up and reading *Love in the Time of Cholera* by Gabriel García Márquez when he walks in. His hair is perfect, makeup done, and clothes like he's going to be on *America's Next Top Model.* I smile and say, "Hey, I thought we were going to do the passport pic; looks like you're ready to hit the clubs. He smiles, a little self-conscious. "Did I overdo it?" he asks. I tell him he looks great—he did—but let him know they are looking for the most pedestrian, boring image and that I don't want his application to be rejected because he looks too good. He smiles and goes to change. I think to myself, did I just ask Prince to change his clothes and he agreed. Wow. These pictures are not his actual passport photos but are a couple of outtakes from the shoot.

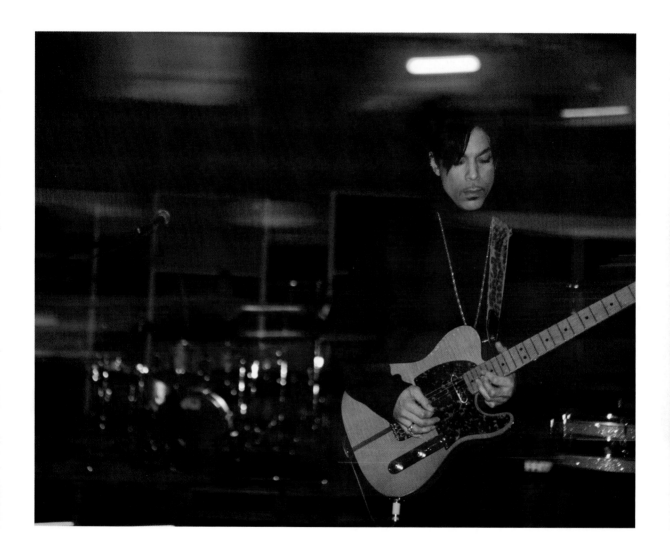

Rehearsals for the Brit Awards in London at Air Studios.

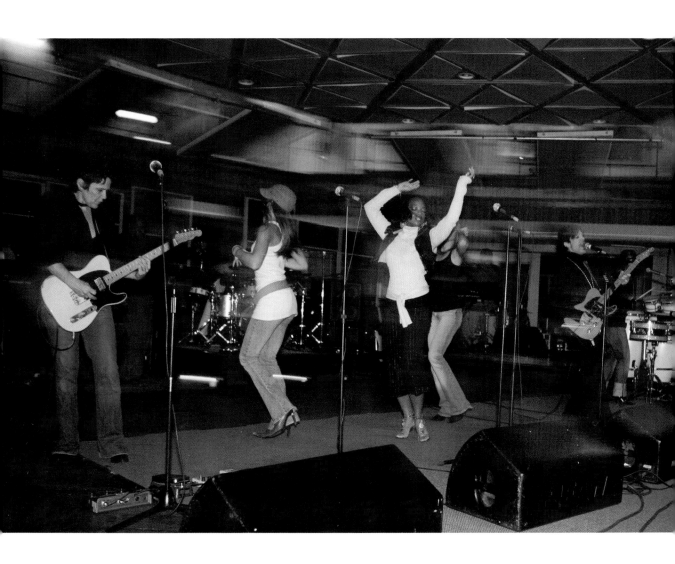

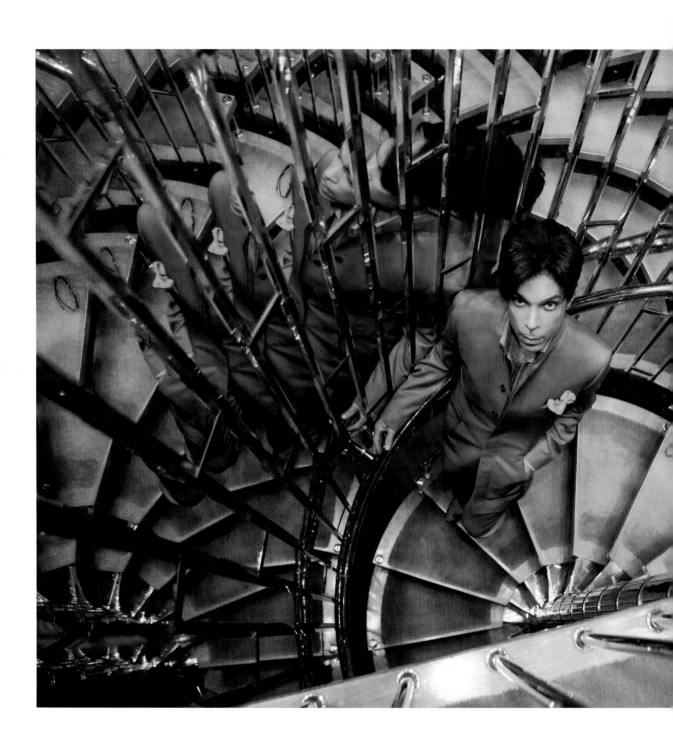

Dorchester Hotel, London. Prince had called me to come to his suite to discuss something quickly before we had to race off to the venue for his show. I think it was a British awards show, the Brit Awards maybe. As he talked and I poked around the expansive suite, I opened a door that led to this mirrored staircase. I told him we need to do a shoot in there and he said "Ok, you have one minute!" "Now? Can't we do it when we have more time?" I said. "The clock is ticking," he told me. "Now you have time to take one shot."

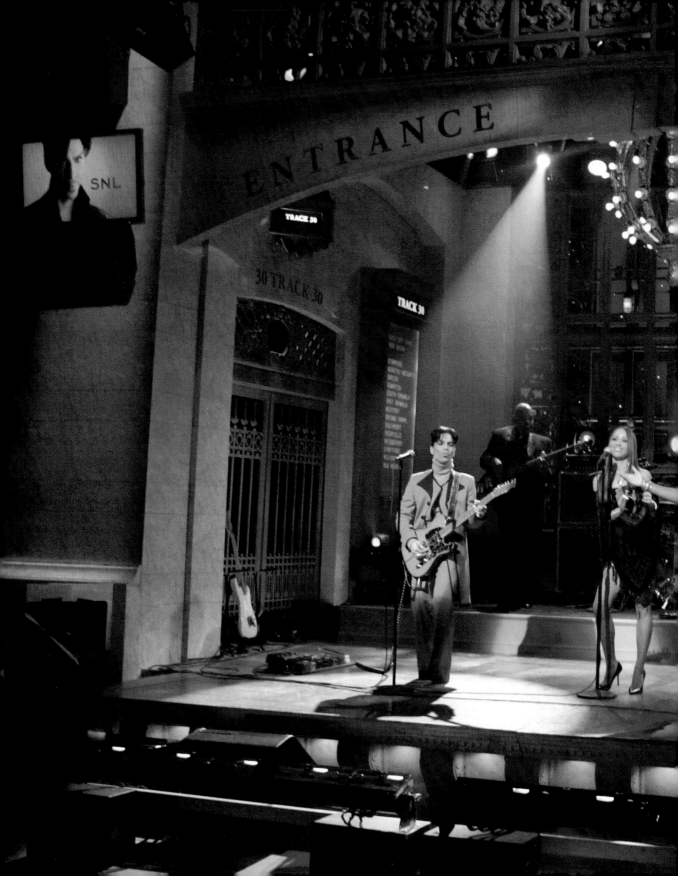

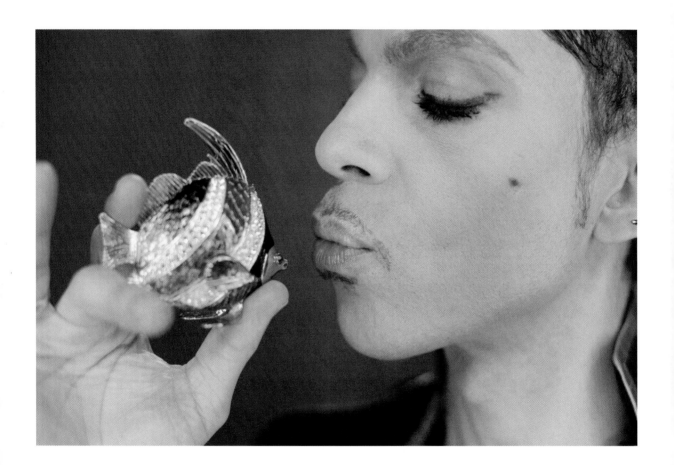

Prince's silly side on full display. I don't remember if I brought the fish or if he did.

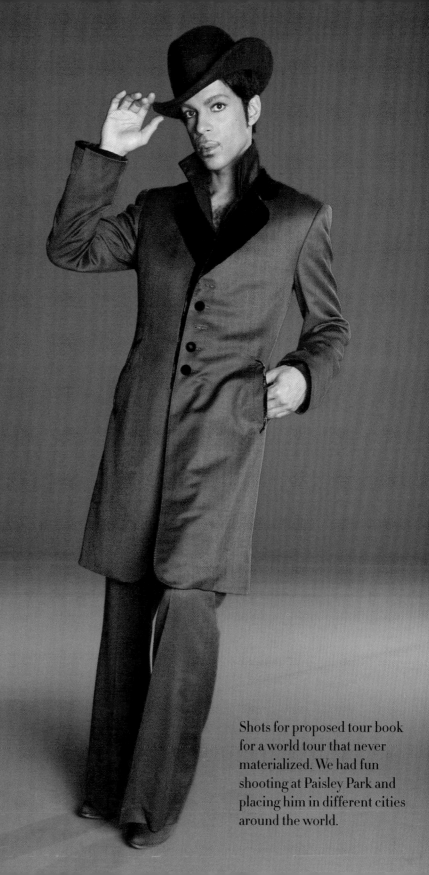

Shots for proposed tour book for a world tour that never materialized. We had fun shooting at Paisley Park and placing him in different cities around the world.

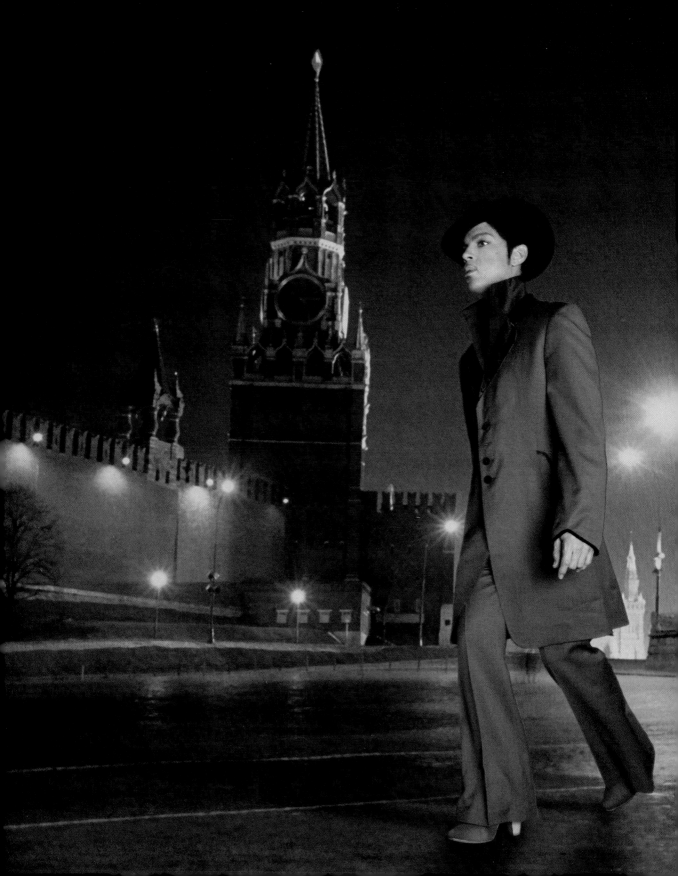

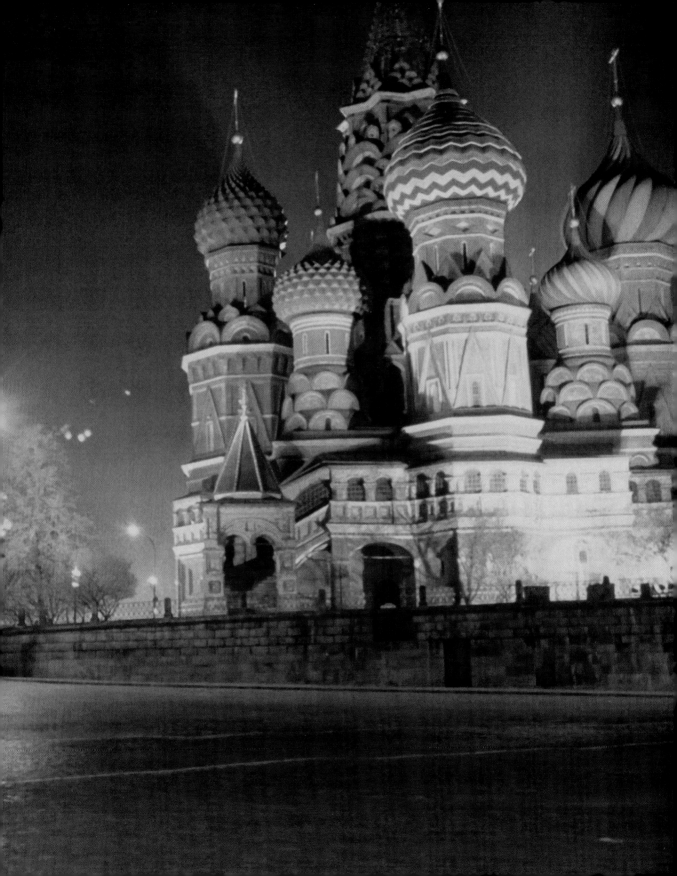

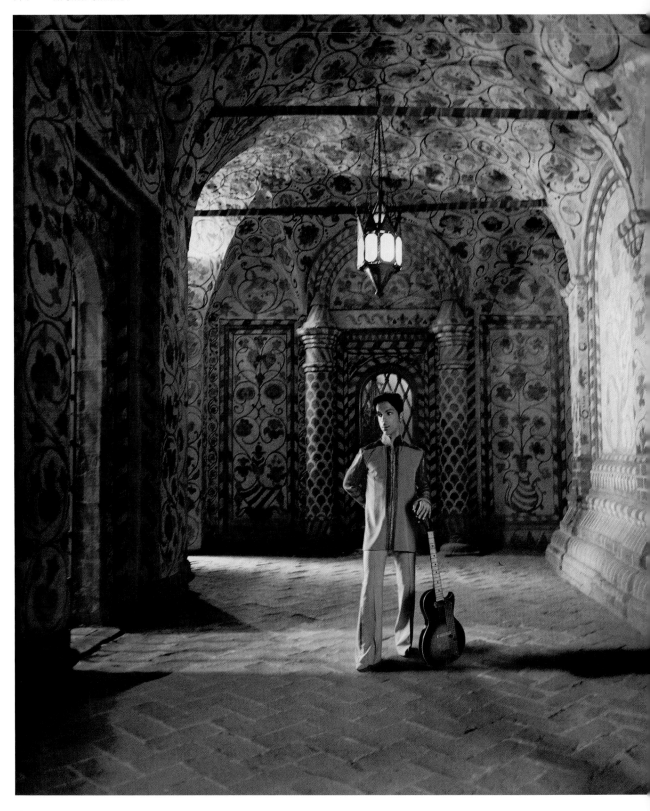

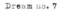

I walk into the first home I had purchased with my wife more than twenty years ago. Since then we have moved quite a few times. Prince walks in from around the corner. He's just bought the house from the current owners and has called me to look at a few things. It appears that when we moved out of this house years ago, we left a lot behind. Prince tells me he was going through things and realized a lot of it was mine. There are old kids' clothes, a backpack with some crumpled-up cash, photo albums, memories from our youth, a car, some furniture, old paintings. It all seems kind of normal, and I thank him and let him know I'll be back to pick everything up later, but he says it's okay, it can all stay here and I can come visit it anytime I want.

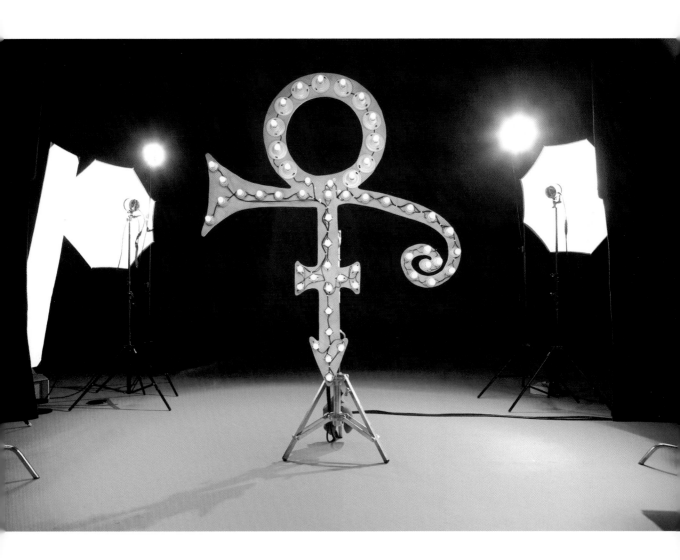

I had this symbol built to use as an eyelight. Prince thought it
was cool, but asked why I couldn't just Photoshop it in later.

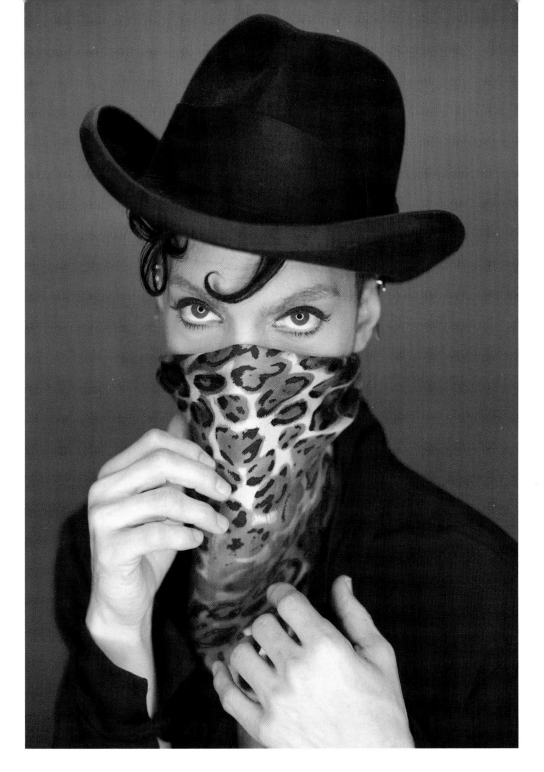

Prince was hesitant when I asked him to wear his bandana like that but when I told him it made him look like a gangster of love, he was onboard with a chuckle.

When I saw this image years later I wondered why I had kept it
on the hard drives. Then I noticed what was over his shoulder.
He had a thing for throwing guitars.

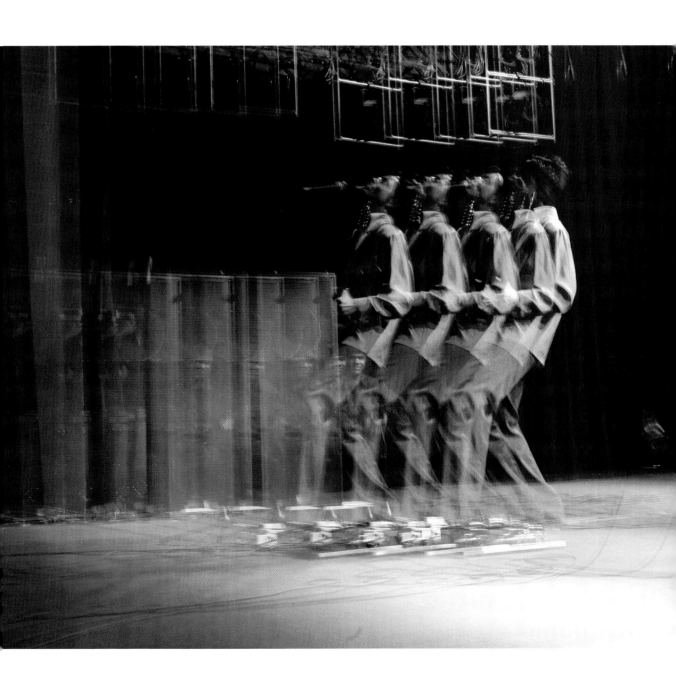

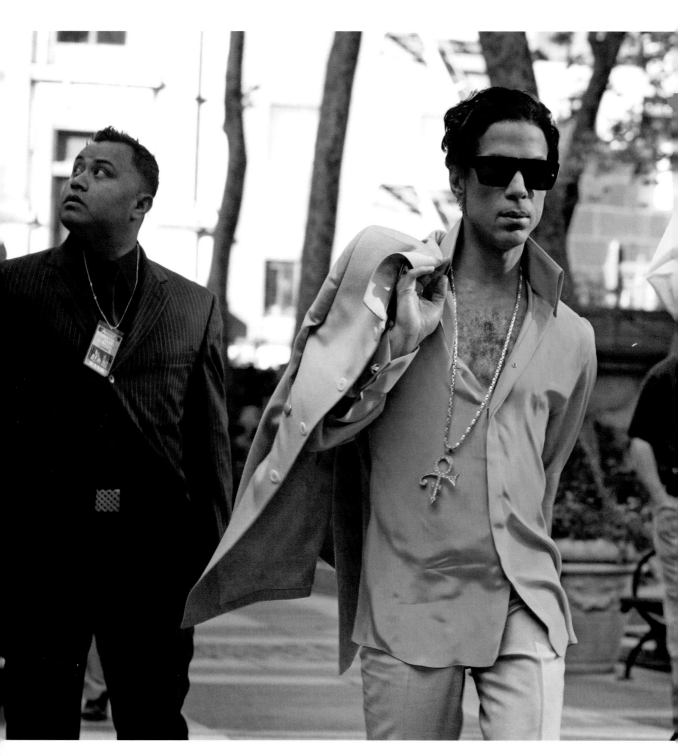

Swagger for days.

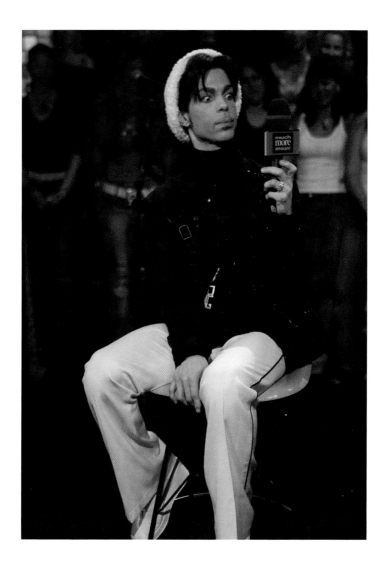

I had just dropped my son off at school and gotten back in the car when my phone rang. I put it on speakerphone and proceeded to drive; I had to get across town to a meeting. "Hi. It's Afshin," I said, my usual greeting when I answered my phone. The voice on the other end said "Afshin?" "Yep. It's Afshin." Silence . . . then: "Afshin, put your seat belt on, you have a wife and kids!" I realized then who it was; it had been a while since we had spoken. "Hey, Prince, how do you know I'm not wearing my seat belt?" I hear the beeping and figured you're either recording me or aren't wearing your seat belt, and I know you're not recording me . . ."

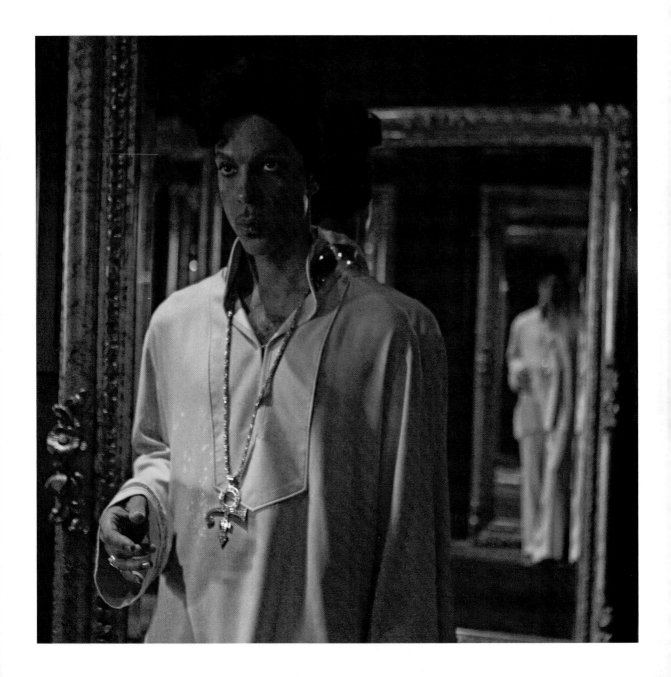

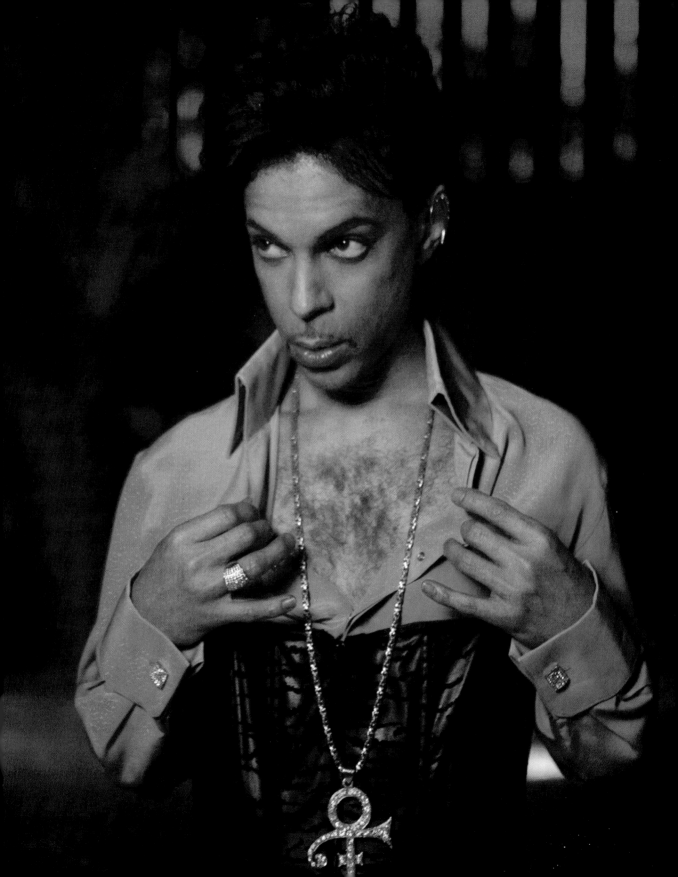

3121. I pull up to the new address, the large black gate stops me, and I have to call Ruth, Prince's assistant, to open the gate because I don't see a call button anywhere. This becomes an address I drive to frequently and leave in the early hours of the dawn. This is the address that becomes the impetus for an album, a film, and multiple legendary parties over the course of a few years. Prince would winter in L.A. and usually rent a mansion while he was here. The parties would usually take place around the award season and would end up being the hottest ticket in town, starting past midnight and going into the early hours of the morning. It was always an eclectic and electric mix of people, actors, musicians, artists, and fans, and there was always music involved. Whether Prince was going to perform or not, there was a full band's worth of instruments set up and anyone daring enough to play in front of Prince was always welcome. I think these parties were some of the happiest times for Prince: They brought together like-minded people in a very easy-going unpretentious setting and people really let their hair down, relaxed, and had an incredible time. The following years when he came back to L.A. and ended up renting other houses, he would always have the address changed to 3121 at the entrance.

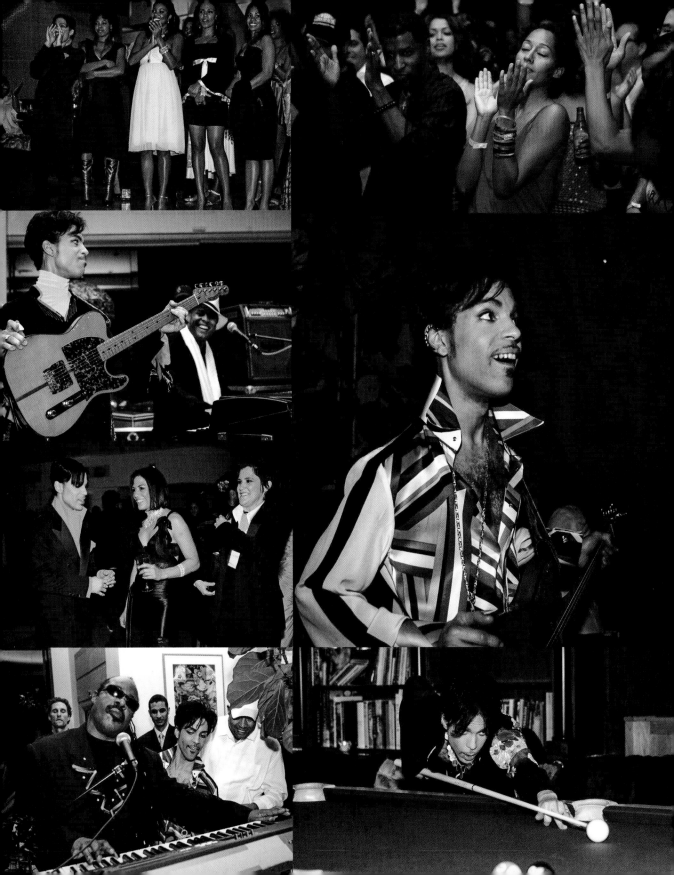

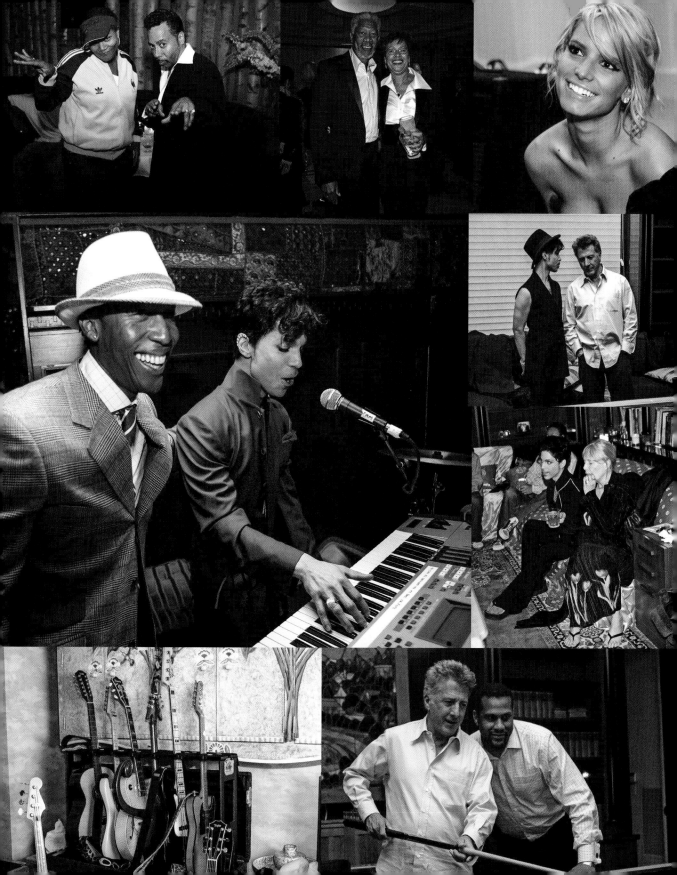

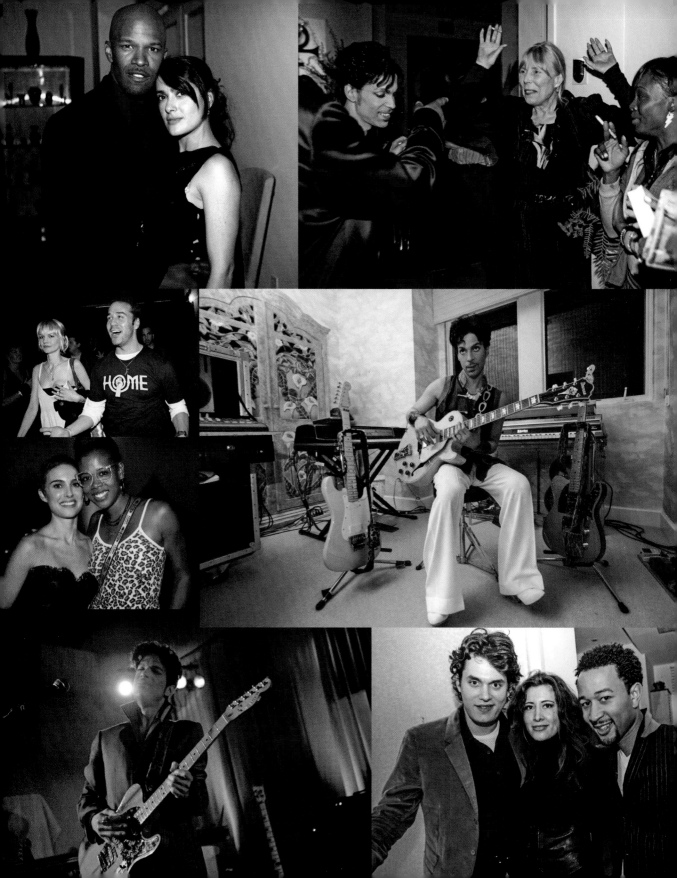

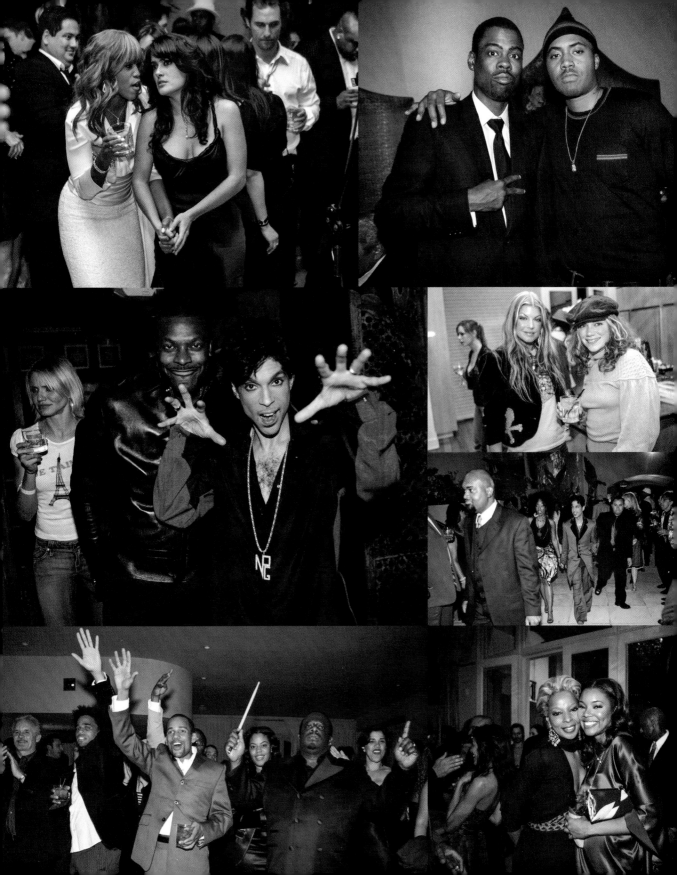

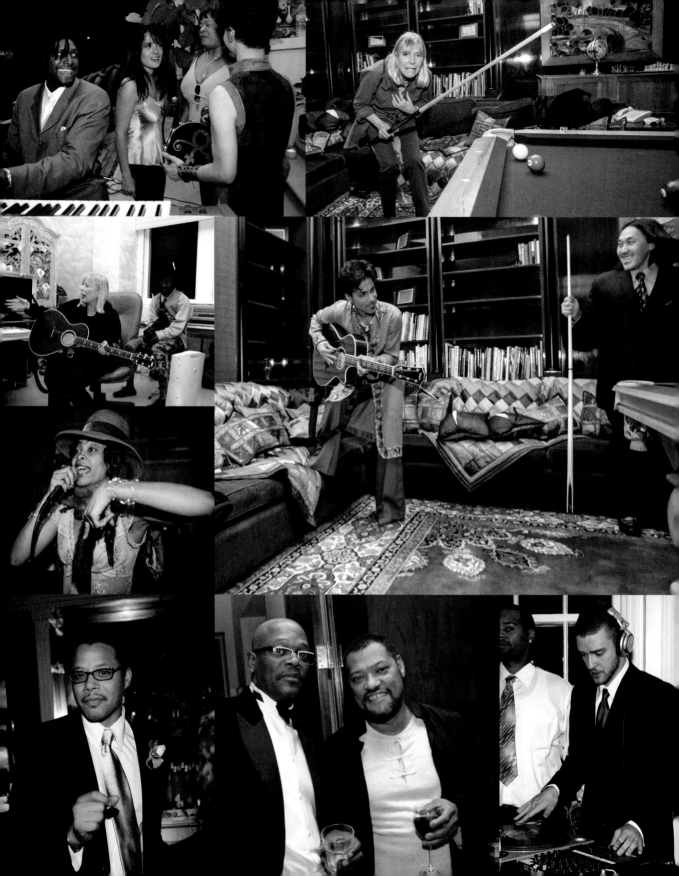

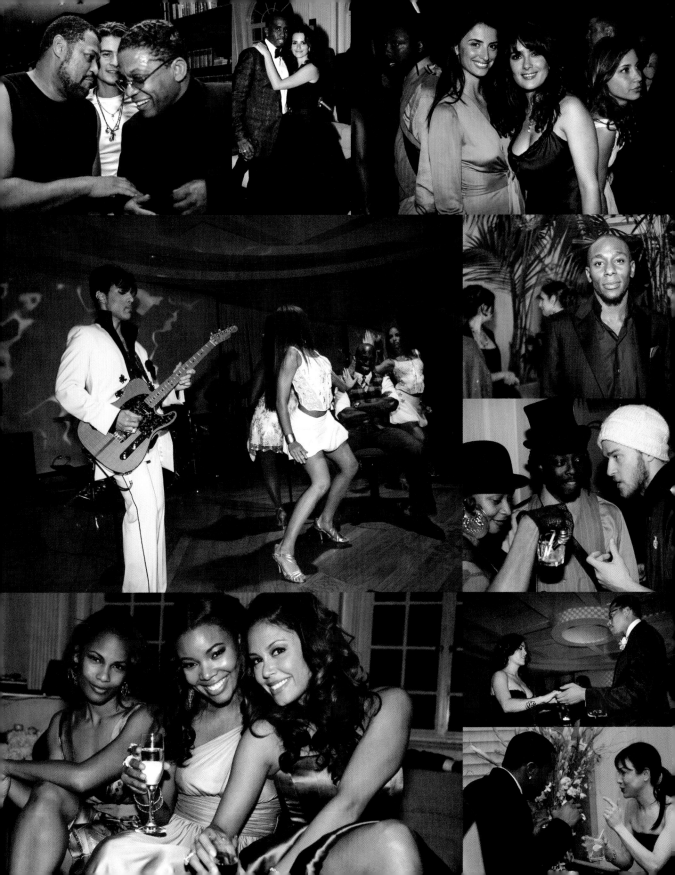

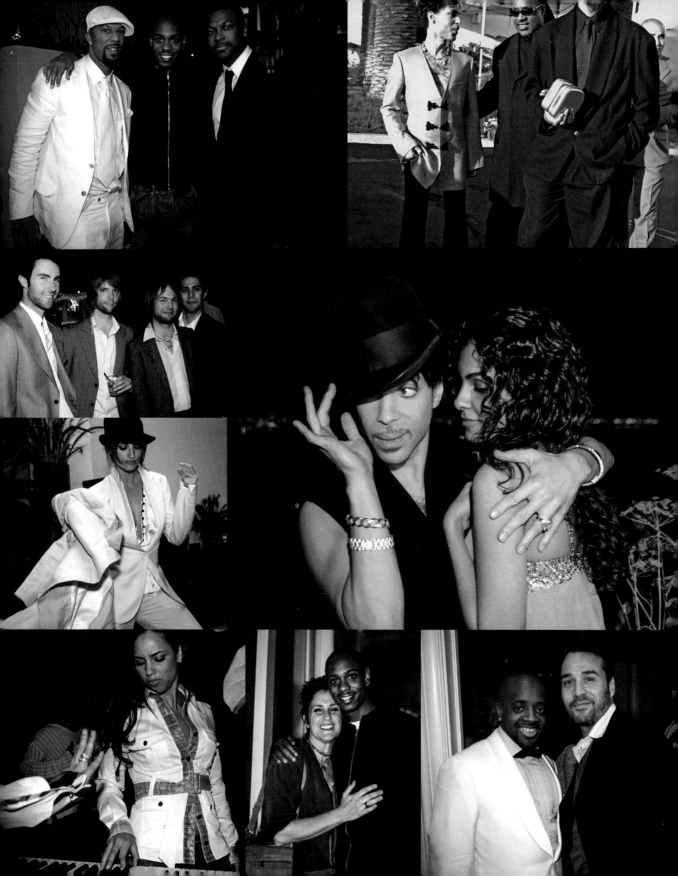

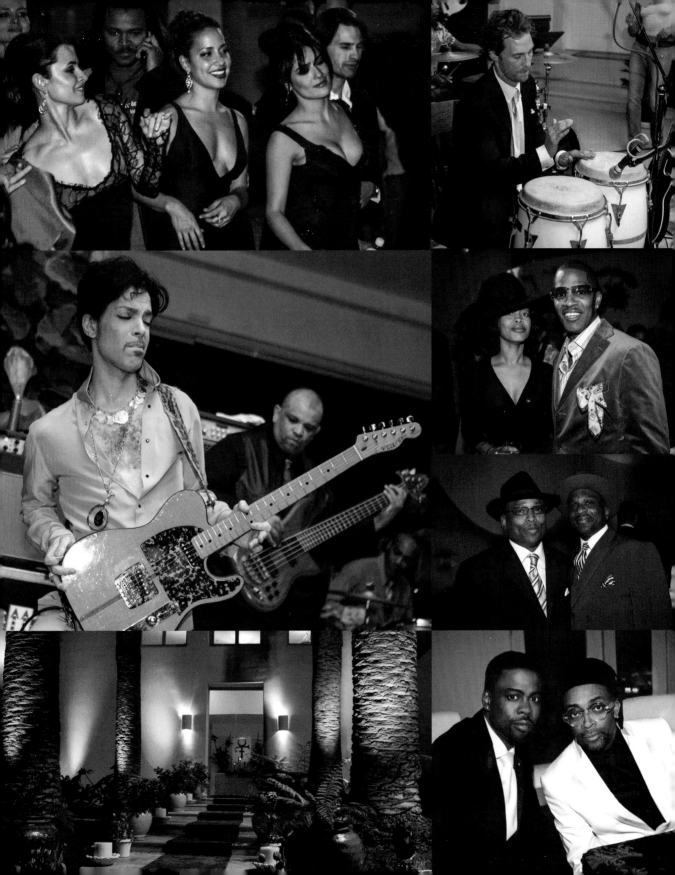

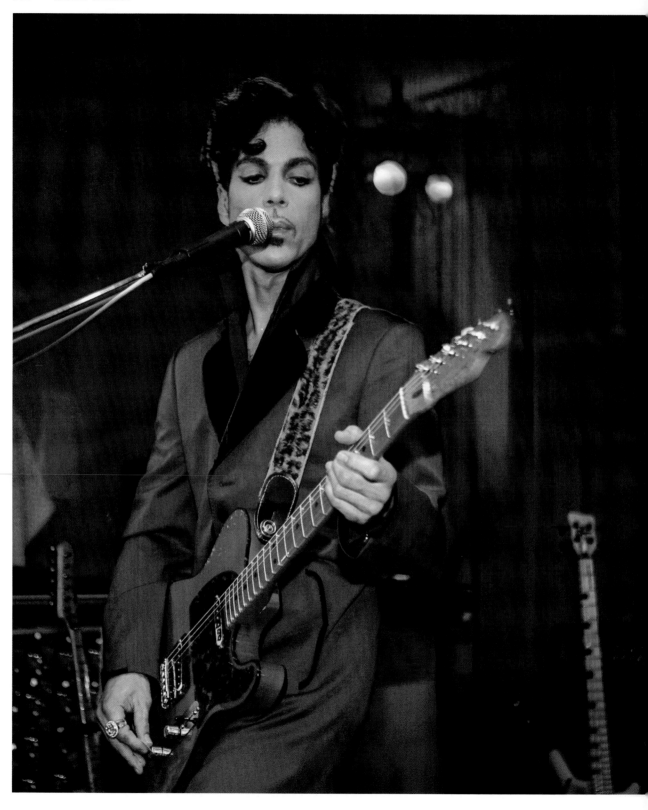

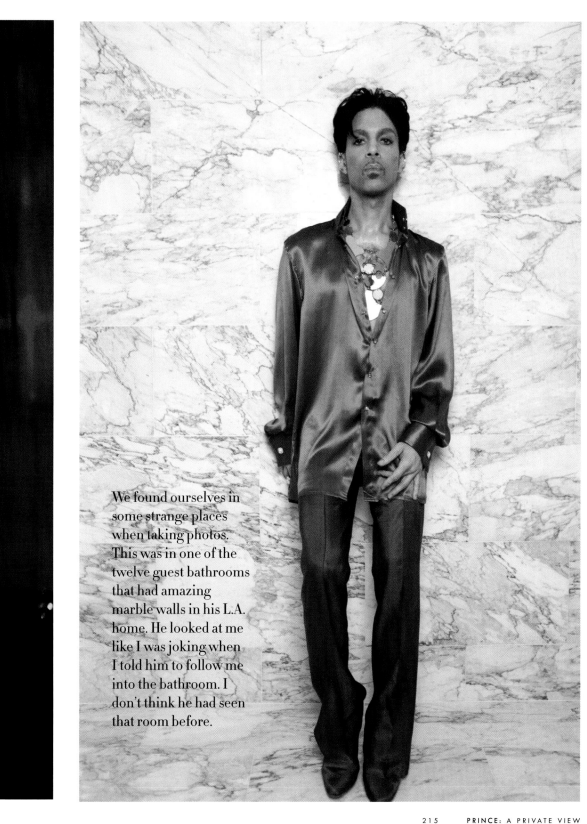

We found ourselves in some strange places when taking photos. This was in one of the twelve guest bathrooms that had amazing marble walls in his L.A. home. He looked at me like I was joking when I told him to follow me into the bathroom. I don't think he had seen that room before.

Roosevelt Hotel. Prince put on three incredible shows there and gave everything he had, which was a lot. These shows were so memorable because of how intimate they were and how much fun Prince seemed to be having.

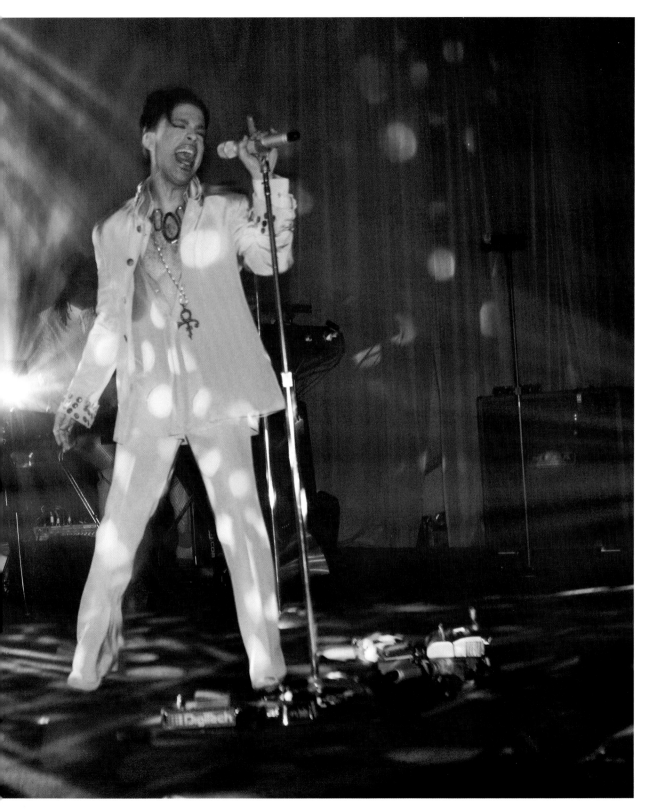

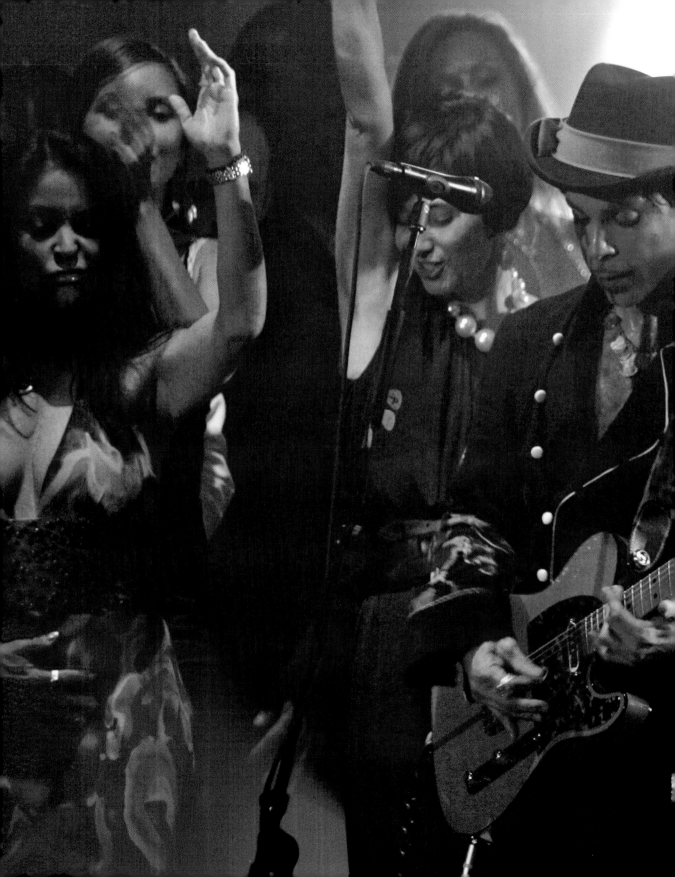

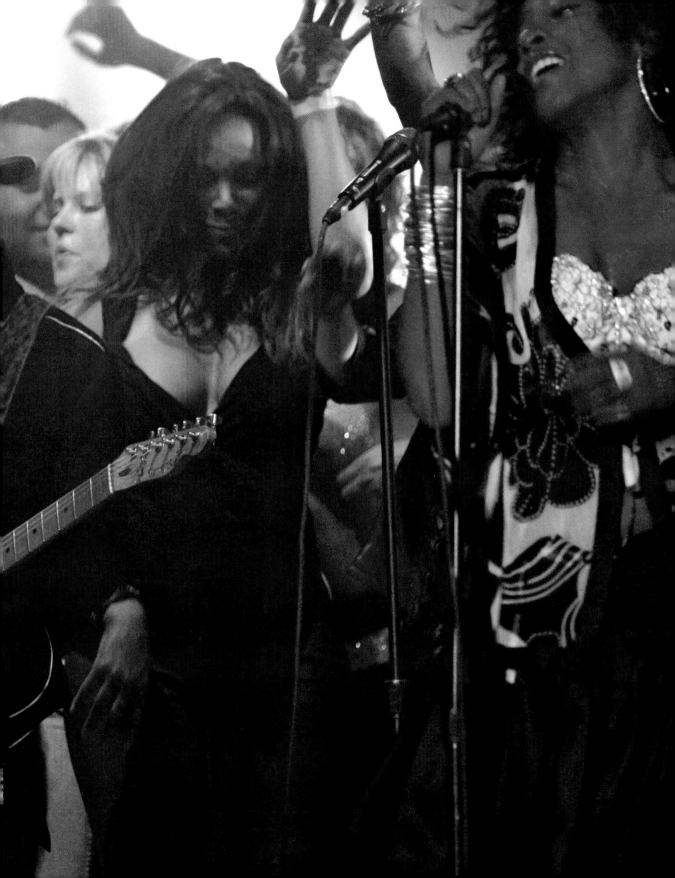

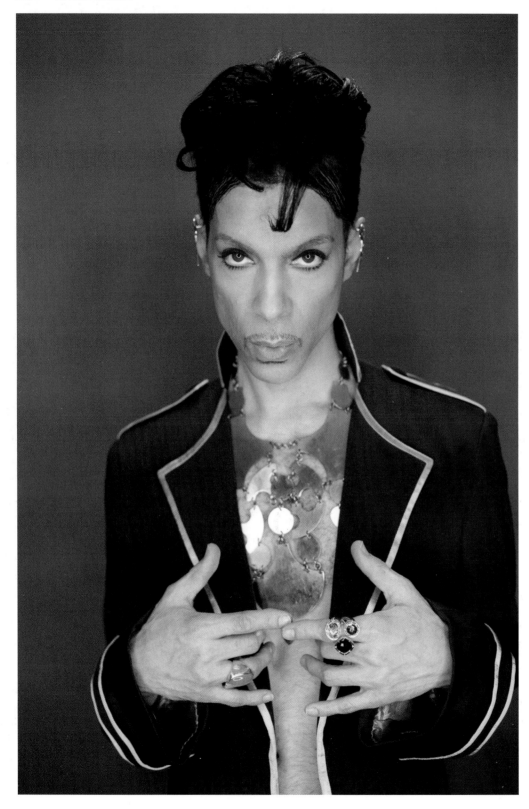

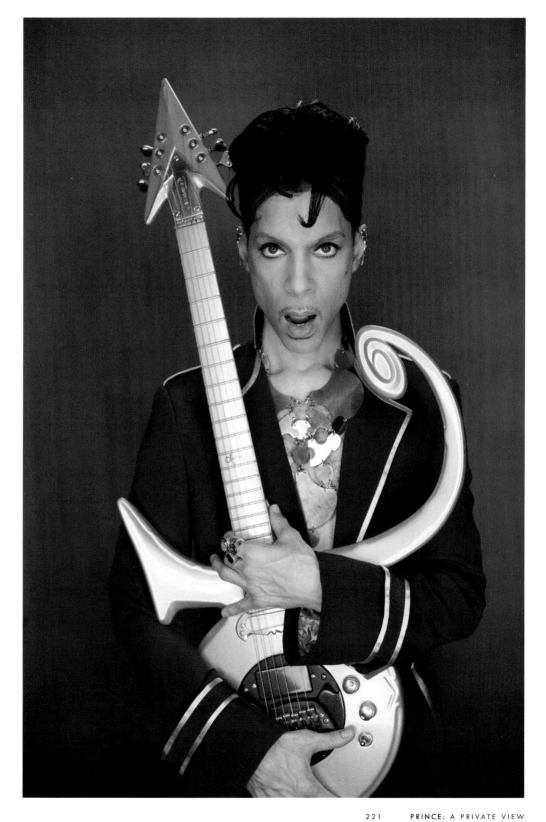

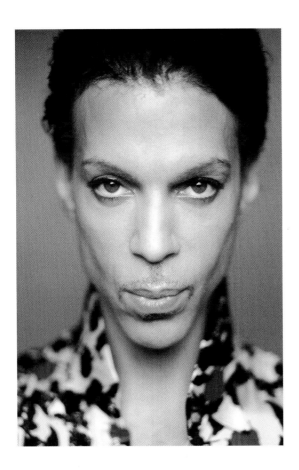

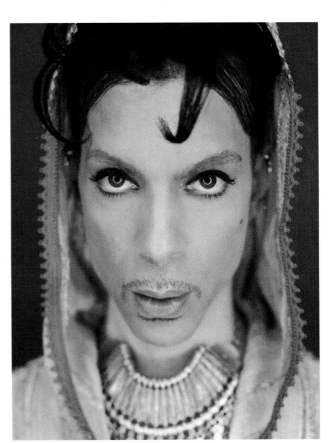

Prince had the most captivating eyes. Whether in photos I've taken or in ones by the many talented photographers that have captured his image over the years, his eyes have always stood out to me and been the focal point of his pictures. I asked him once if he practiced his piercing gaze in the mirror. He chuckled and replied, "What do you think?"

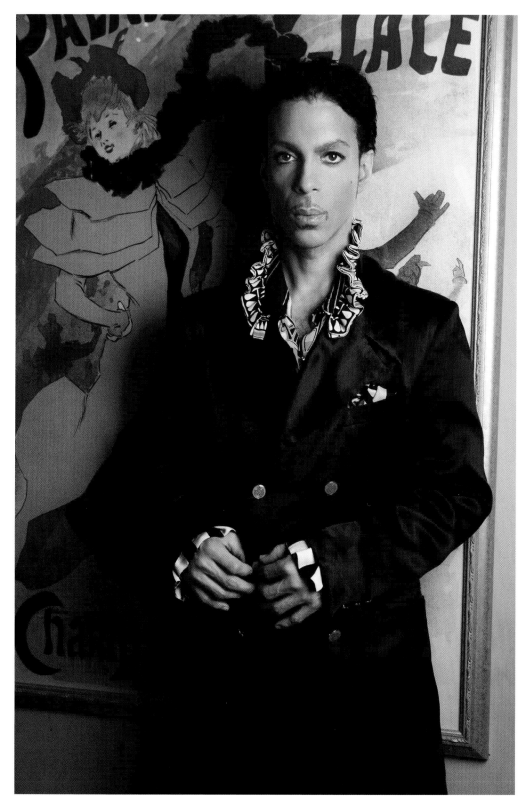

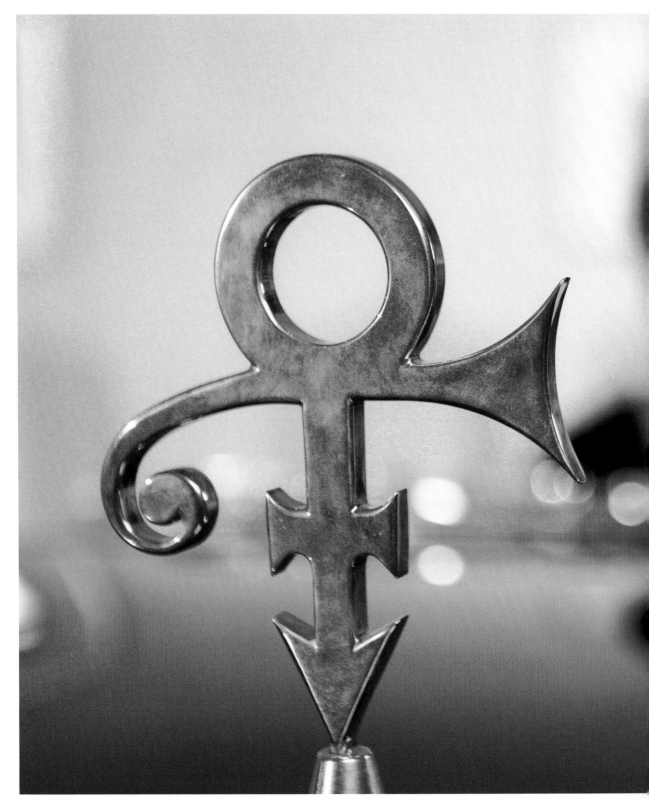

Sitting at his black grand piano.
He played while I took pictures.
He was in this thirty-five-
thousand-square-foot house
all by himself. I remember that
he made me tea afterward and
we sat and talked about the
quality of light in Rembrandt's
painting, of all things, and I
remember feeling sad for him.

The last photo I took of Prince.
December 18, 2011, in Victoria, BC, at
a nightclub aftershow. He was in such
a great mood that night. The police
came to try to enforce the midnight
curfew, but the mayor was at the show
and turned them away. He told Prince
he could play as long as he wanted to.
And he *wanted* to *play*. I flew back to
Los Angeles the next day. Our paths
crossed many times over the years and
we remained friends with plans and
intentions of working together again,
but it was not to be. I'm grateful for my
nearly two decades of adventures and
opportunities with him.

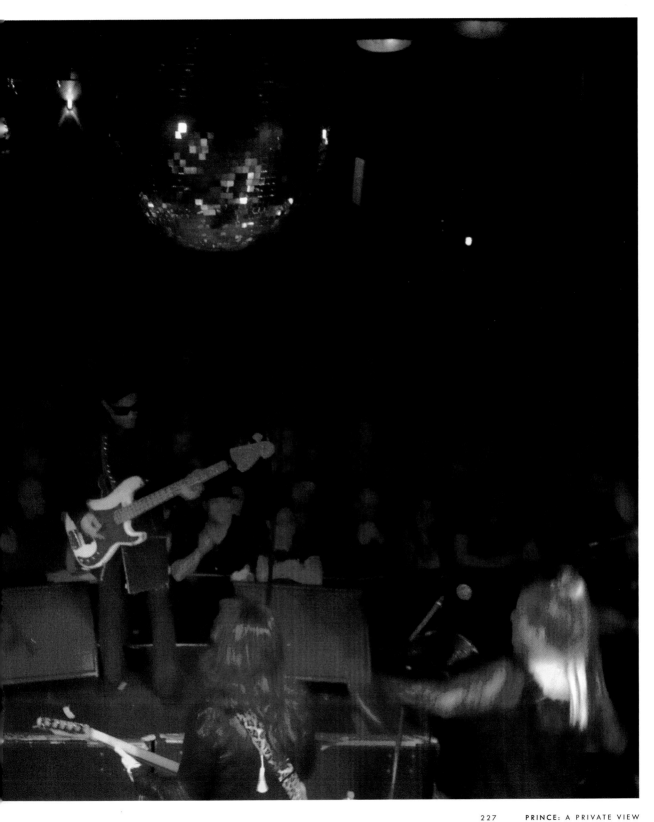

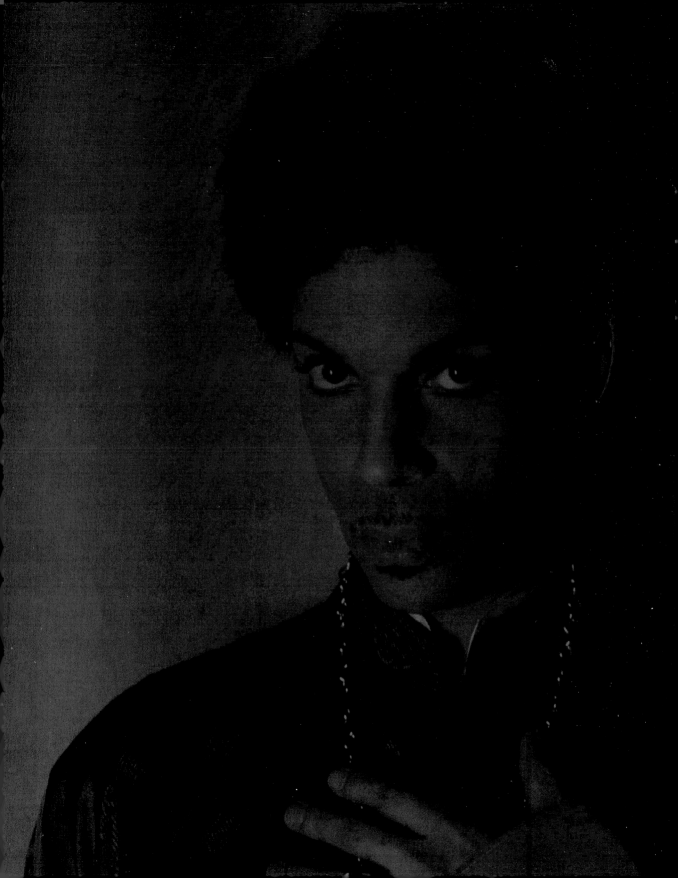

ACKNOWLEDGMENTS

This book would not exist without the support and encouragement of so many people. First and foremost, I have to thank my family, without whose unconditional love and understanding during the years I spent on the road making these images and again when I started the long and time-consuming task of compiling and writing this work, I could not have made it. I thank my wife Keri, who, like Prince, sees no limits, for always standing by my side, for believing in me even when I didn't believe in myself, for energizing me and showing me through her actions that anything is possible. You are my rock and I love you. I thank my children Yara, Sayeed, and Ehsan, for being my number one fans and showing me what pure joy looks like. You give my life purpose and keep me young.

I thank my mother, Forogh Shahidi, who first showed me the magic of an image appearing on photographic paper in her dark-room, and my stepfather Mark Keljik, who sparked my imagination and curiosity of the world through his stories and poems. I thank my father in law Kwame Salter for sharing his wisdom and for investing in me and my first digital camera, which got the ball rolling.

I thank my editor Elizabeth Beier whose sheer excitement for and confidence in this book made me more excited and confident about it, and for her uncanny ability to sift through the chaos that I brought her to find the rose. Thanks to Nicole Williams for keeping me on task and on schedule and for understanding when I wasn't. Thank you to Jonathan Bennett and Rob Grom in design for the countless hours and options for the book. I thank my literary agent David Vigliano for his wisdom and for guiding me through the treacherous waters of the publishing industry. You and your team made it so easy, I may even want to do another book.

Thanks to Sam Jennings for his skill as a designer and for making my images pop off the page. Thank you to Ryan Nord for your legal prowess and for making sure I was well represented. Thank you to the unimaginably talented and kind musicians who took me in and made me feel like a part of the family when I first started on the road with Prince: Maceo Parker, Sheila E, Wendy Melvoin, Morris Hayes, Candy Dulfer, Renato Neto, Rhonda Smith, Chance Howard, John Blackwell, Greg Boyer, Mike Scott,Morris Day, Jerome Benton, and Rose Ann Dimalanta—I'm in awe of your talent and your humility.

A very special thank-you to Beyoncé. When the question of a Foreword was brought up, you were the first person I thought of and I'm so humbled that you agreed to lend your voice to my book. I thought it would take an Icon to reflect on another Icon, and Prince's love for you made you the only choice. I know Prince would have been so thrilled and honored that you were involved.

I thank Manuela Testolini for always being so kind and generous to me. Thank you to Ruth Arzate for having my back during some long days and nights, and for throwing the best parties Hollywood will ever see. Thanks to the smiling faces and kindness of all the people that I met because of Prince: Harve Cook, Takumi Suetsugu, Michele Anthony, Melody Ehsani, Van Jones, Lynn Anderson, Salma Hayek, Mathieu Bitton, Andy Allo, Che Pope, Lynn Mabry, Jeremiah Freed, Stephen Hill, Glenn Kaino, Tamar Davis, Natasha Maddison,

Jeff Ayeroff, Sujata Murthy, Melissa Ekholm, Mike Phillips, Med Abrous, Nandy McClean, Maya McClean, Debbie McGuan, Shelby J, Jeremy Gavin, Anthony Malzone, Tavis Smiley, Kim Berry, Julia Ramadan, Nikka Costa, Cora Coleman, Joshua Dunham, Crystal Zehetner, Sanaa Hamri, Benjamin Trigano, Yvetter Noel Schure, D. J. Rashida, Doug E Fresh, Otis Mohammed, Trevor Guy, Damaris Lewis, Londell McMillan, Trevor Allen, Farah Khalid, Tony Morehead, and so many more. You guys made it fun and worthwhile.

A special thank-you to Prince's sister Tyka Nelson and the rest of Prince's family for their kindness in inviting me to his memorial service and for continuing the celebration of Prince's legacy in such a beautiful and meaningful way at Paisley Park.

I thank the fans worldwide: I haven't met all of you yet but I've seen most of you at the countless concerts and aftershows we've all gone to, and I've felt your presence and heard your voices at these shows. Your passion for Prince and his music is contagious and the kindness you've shown me is remarkable. It is because of you and for you that I decided to make this book. Prince loved and respected you and his spirit will live on eternally in you.

To Prince: I am humbled by the confidence and trust you put in me to be your creative partner and photographer. The years working alongside you are the most cherished of my professional career and I can't think of anything that could possibly top them. Thank you for your mentorship and for your generosity as a friend and collaborator; it has meant the world to me.

PARTY PEOPLE

PHOTO LOG

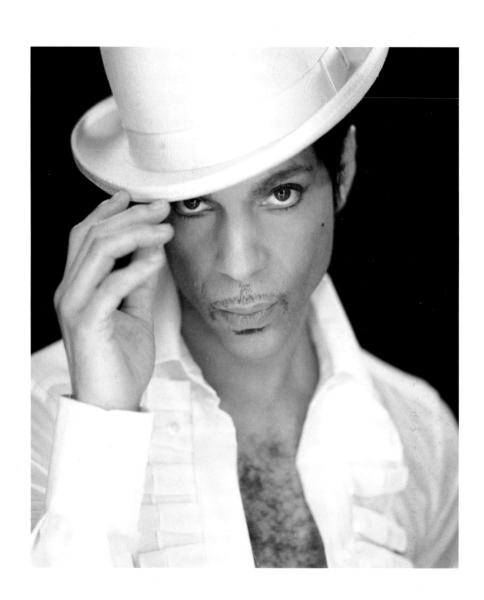